CREATIVE DUOTONE EFFECTS

A Guide to Choosing Successful Color Combinations

RICHARD EMERY

First published in the United States of America by:
Rockport Publishers, Inc.
146 Granite Street
Rockport, Massachusetts 01966
Telephone: (508) 546-9590
Fax: (508) 546-7141

Distributed to the book trade and art trade in the U.S. by:
North Light, an imprint of
F & W Publications
1507 Dana Avenue
Cincinnati, Ohio 45207
Telephone: (513) 531-2222

Other Distribution by:
Rockport Publishers, Inc.
Rockport, Massachusetts 01966

ISBN 1-56496-163-X

10 9 8 7 6 5 4 3 2 1

Creative Duotone Effects was imaged at Final Copy,
Newburyport, Massachusetts.

Manufactured in Singapore by Regent Publishing Services Limited.

CREATIVE DUOTONE EFFECTS

A Guide to Choosing Successful Color Combinations

RICHARD EMERY

ROCKPORT PUBLISHERS • ROCKPORT, MASSACHUSETTS
DISTRIBUTED BY NORTH LIGHT BOOKS • CINCINNATI, OHIO

ACKNOWLEDGEMENTS

Once again we discover new dimensions
in the use of color in graphic design. This book
is part of a series of books on color produced by Rockport
Publishers. It acts as a specification tool and complements
the others in the series in aiding choices in design.

There have been many helpful hands in the creation of this
book. From concept to production, I have received support
and guidance from Barbara States, Laura Herrmann, Pat
O'Maley, Winnie Danenbarger, and Joe Chodat. Each
has contributed his or her expertise, and I am much
indebted to them.

EDITOR/DESIGNER......Richard Emery
ART ASSISTANT......Karen Shea
PRODUCTION COORDINATORS......Barbara States
Pat O'Maley

Except where indicated,
all photography by
Rob Huntley of Lightstream
9 May St., Beverly, MA 01915

 ontents

Foreword

From its first crude beginnings to the highly sophisticated techniques of present day reproduction, the duotone has historically been limited, and the full dimension of its application misunderstood. It has always been a valuable alternative when designing in only two colors, but the degree to which it can be adapted and modified to create different effects has been much neglected.

When I first began to incorporate duotones into my own design work, I was often surprised at the final printed results. The color was either different from what I had expected or the general density didn't match what was intended for the photograph. Talking with printers and service bureaus, I discovered that this variation was due to the process of creating the two separate halftones. The final result depended on what specifications the filmmaker used when asked to create a duotone. Some filmmakers thought that the duotone should be strongly influenced by the second color. Others viewed the duotone effect as a process of tinting black. Either way, the designer was locked into the cameraman's preference. You got what you got. There was no real choice.

Today we know that both the density and the contrast of each separate halftone has a much wider range, and the designer, by harnessing this expanded dimension, can create a multitude of duotone effects.

It became apparent that I needed to look for examples of duotone variations of the same two colors, as well as to check combinations of other two-color schemes. In fact, the different variations might influence the decision on what second color to choose. I searched with no success. There seemed to be no resource where a designer could view examples of variations within the same color scheme along with other possible color combinations. At first, this cooled my desire to be expansive in the use of duotones. If final results could not be controlled, then why take the risk of unsuccessful graphics.

With the arrival of the computerized color image, though, it became possible to more accurately anticipate the results of two-color reproduction. This left only the inaccuracy of screen (monitor) colors relating to the final printed colors. Actual printed samples that would faithfully show the results of these combinations solve this problem. Thus *Creative Duotone Effects* has been created to fill the void.

Creative Duotone Effects helps the graphic artist in two ways: It shows variations within each color scheme, and it shows many other combinations that also work successfully in the duotone process. The book offers two versions of each two-color combination with the obvious implied variations between them (slightly changing the percentages to lighten, darken, or increase the color influence of either one of the colors).This presents the opportunity of showing a larger selection of color combinations and therefore more options for the designer. The two choices within each combination show a stronger influence of the first color and then a stronger influence of the second. As an added bonus (especially for designers working in CMYK desktop

publishing) each color has printed beneath it the percentage breakdowns of the four process colors used to create it. This makes for less experimenting on the computer and more direct application to the design. Thus, not only the design industry but the computer world as well can continue their electronic wizardry with a quick decision-making process at their finger tips.

The beauty of this color work has been both inspirational and illuminating. Perhaps the most interesting discovery that I made in this process was uncovering some wonderfully subtle combinations that I would never have imagined, especially in the two-color (non-black) section. These new colors have already found their way into my work, and my two-color designs now take on a new dimension. I invite you to look through this book and imagine all the possibilities that could now assist you in your own personal approach to design.

Richard S. Emery
President, Richard Emery Design, Inc.

How To Use This Book

One of the most effective ways to broaden the effect of two-color design is through the creative use of duotones (two-color photographs). Duotones add density and detail to black-and-white photographs, and give them an added sense of color. The duotone effect is achieved by creating a halftone of the same image in each of two colors, and then superimposing the images.

This effect has been used for many years and has met with reasonable success, though often with unexpected results. There are two major difficulties inherent in this process:

1. When designing with duotones, it is nearly impossible to accurately visualize the final results before they are on the press. Proofing systems can offer an approximation of the effect, but never quite the final image as it will appear in print.

2. The duotone process extends beyond the simple application of two colors on a photograph. Desktop designers are just beginning to discover the range of color that they have to work

with—from subtle tinting to aggressive shading. The photograph can have the appearance of a light color tint added to a black halftone, or it can have the effect of a strong, single-color (other than black) photo (strong green, strong blue, etc.)

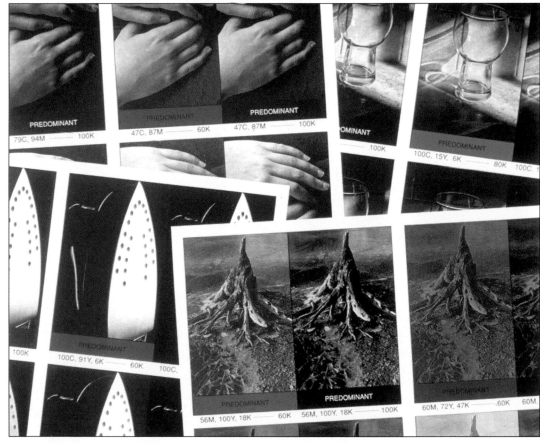

Both of these considerations are addressed in the following pages. There are reproductions of over 840 different color combinations. They include a section showing black with a second color, *Fig. 1.*, one showing two non-black colors, and one showing the effect of ghosting in duotone. This gives the designer the opportunity to see the duotone effect as it will appear when printed.

Second, each color combination is reproduced in two variations to show the degree of difference that can be achieved. The picture on the left shows the photograph with the first color predominating, and the one on the right with black or a second color predominating. The designer can match the colors in the boxes below each photograph and can visualize the final effect. In the examples shown in Section One the first color always ranges from white highlights to solid dark areas, whereas the second color (black) ranges from white to solid in the right hand photo and white to 60 or 80 percent in the left. This demonstrates the effect of cutting back the intensity of the second color. These percentages are duly noted below each photograph.

An added bonus for desktop designers preparing design comprehensives is the labeling of each example with the breakdown of process colors that can be used to create each color.

Black-and-white photography only has the range of tone value from white to black—with all the degrees of gray in between. To reproduce a black-and-white photo it must be

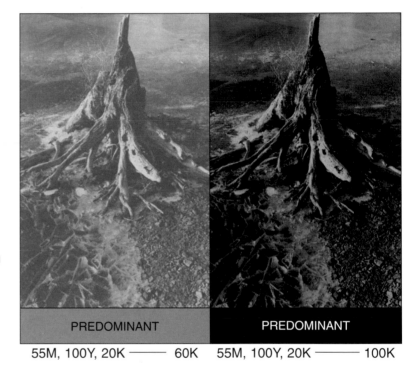

PREDOMINANT PREDOMINANT

55M, 100Y, 20K ——— 60K 55M, 100Y, 20K ——— 100K

Fig. 1. An example of how this book deals with the duotone process. The photo on the left is reproduced with a 0-100% color halftone overprinting a 0–60% range black halftone. The photo on the right is reproduced with the same color halftone, this time overprinting a full range 0–100% black halftone. The color swatch beneath each photo designates which color predominates. Below this is the process-color breakdown for creating these effects in CMYK desktop. (See page 15 for more information.)

Fig. 2

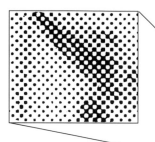

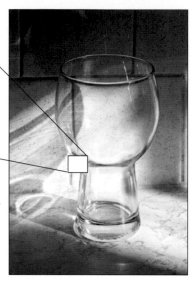

Fig. 3

Fig. 2 is a tiny detail from Fig. 3 showing through enlargement its dot pattern. When reduced back to its original size the dot pattern creates the effect of a continuous tone image (Fig. 3.).

transformed into a series of tiny dots of various sizes *(Fig. 2)*. The size of the dot determines the darkness of the area; the bigger the dot the darker the tone. The range that these dots can cover is 0 percent (white) to 100 percent (solid black). Thus the eye perceives the image as a continuous tone photograph *(Fig. 3)*.

Fig. 4 shows the superimposition of the two dot-pictures (halftones) to create the duotone.

When creating a duotone, the same photograph is transformed twice into dot pictures, so that one may be superimposed over the other to create added color and depth *(Fig 4)*. As you can see, the dots are arranged in neat geometric rows. If the rows of the superimposed images were to run along the same axis there would be an unfortunate optical illusion of geometric patterns (moire). To avoid this, the second dot picture is created with the dot lines at a different bias than the first.

Given that each of the dot pictures has the tonal range possibility of 0 to 100 percent, it is also possible to change either one of those percentages to a different calibration and thus change the dark-to-light effect of the photograph *(Fig. 5)*. Thus, controlling the percentages controls the effect of the final reproduction. Dealing with two colors at a time offers twice the range of possibilities.

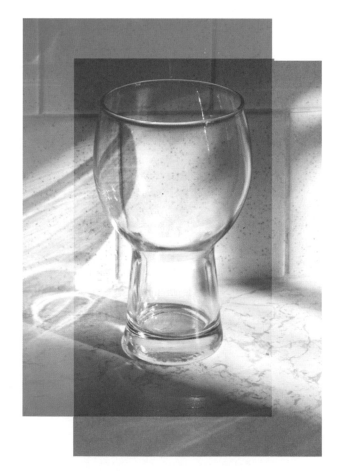

Fig. 4

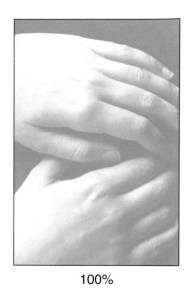
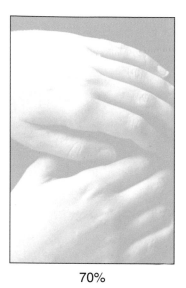
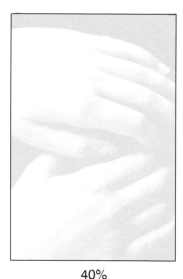

Fig. 5 shows three different percentage curves; as the percentage decreases, the effect becomes softer and the contrast lessens.

Fig. 5

| 100% | 70% | 40% |

To use this book as a design tool return to page 13, *Fig.1.* Assume that you have chosen these two colors for your design. If you want a strong presence of color in your picture use the example on the left (color predominant) and match the swatch below the picture with any color matching system. If you are using CMYK color (process color combinations) use the numbers below the color swatch. There are two sets of numbers separated by a long dash. The figures to the left of the dash represent the CMYK breakdown that creates the first color. The number to the right of the dash represents the darkest level in the second color (in this case—black 60 percent).

If you want the color to merely enhance the black (tinting), use the example on the right in *Fig. 1.* (black predominant) showing the full 0 to 100 percent range of both colors. Obviously with each of these examples you can vary the degree of black to change the effect beyond what is shown. You can also alter the percentage of the non-black color for a slightly different effect. If you are creating these colors in CMYK, establish the combination first, then reduce it by whatever percentage you want.

The third and fourth sections of the book feature combinations that do not include black. Here the CMYK percentages are provided for each color in its solid state, and also for its reduced percentage when the other color is to be predominant. This is shown by a bracketed figure below the CMYK designation *(Fig.6).* This reduction figure represents either pure color or CMYK color.

Fig. 6

| PREDOMINANT |

45M, 100Y, 10K ——————— 60K

60

Fig. 6 shows the reduced percentage (60 percent) of the CMYK color that makes the other color predominant.

CREATIVE DUOTONE EFFECTS

*A Visual Reference for Choosing Successful
Color Combinations*

GREAT DUOTONES

To understand the successful use of duotones it is helpful to see actual examples created by professional designers. In the following twelve pages we have reproduced many diverse applications to demonstrate the different ways the duotone can enhance design work with black-and-white photography, or work with printing limited to two colors.

It is interesting to note that this two-color effect is applicable whether the design is based on two colors, or uses the full-color CMYK palette. Examples of both appear here.

As you examine these examples notice how varied the uses are. Sometimes the effect merely increases the detail and density of the existing black photo, giving it a clearer, brighter quality. The designer can also create a photo that comes alive as a new color unto itself, or capitalize on the variety of duotones offered here. Use this book as a tool in choosing new duotone combinations, or in extending the range of old favorites.

First check out these examples and then proceed into the book and choose your own combinations. With this tool you will feel emboldened to use the duotone process more frequently and to capitalize on the extended range it offers you.

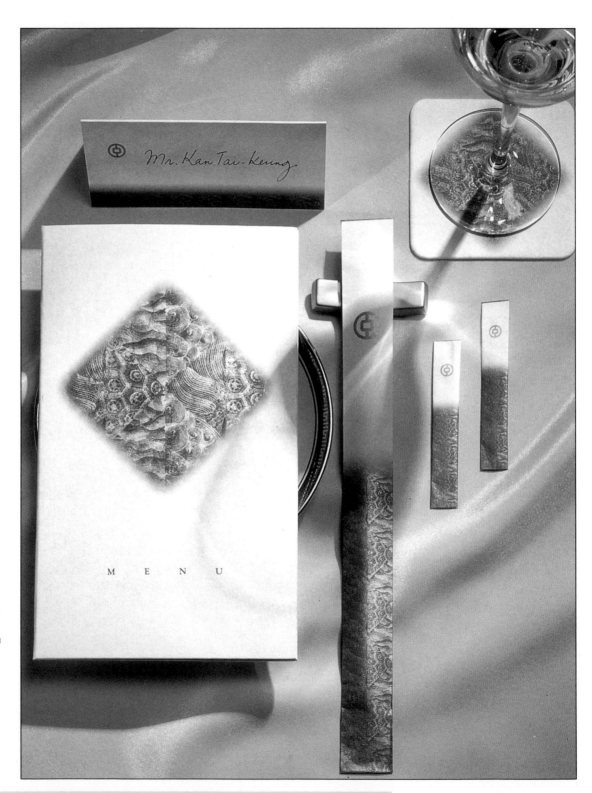

Client: Bank of China
Design Firm: Kan Tai-keung Design &
 Associates Ltd
Art Directors: Kan Tai-keung/Freeman
 Lau Siu Hong/Eddy Yu Chi Kong
Designer: Joyce Ho Ngai Sing
Photographers: Kan Tai-keung/
 C K Wong

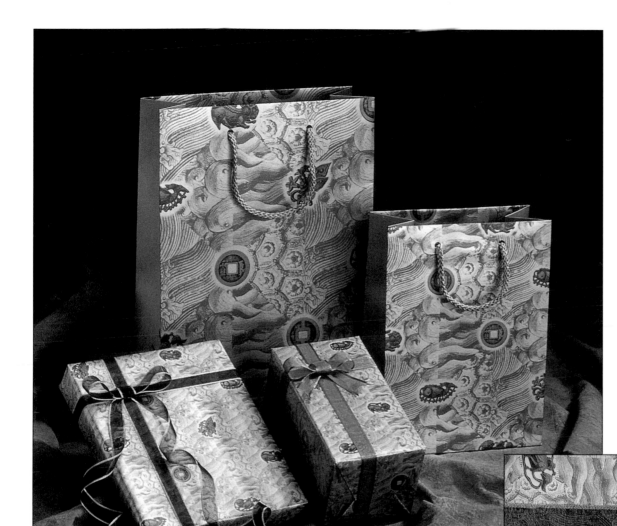

Client: Bank of China
Design Firm: Kan Tai-keung Design &
 Associates Ltd
Art Directors: Kan Tai-keung/Freeman
 Lau Siu Hong/Eddy Yu Chi Kong
Designer: Joyce Ho Ngai Sing
Photographers: Kan Tai-keung/
 C K Wong

The pieces displayed on these two pages were designed as a gift pack for the Bank of China. They clearly show how two-color reproduction can enhance the product image and add a classic look to an otherwise non-graphic situation. Whether it be wrapping paper, carrying bags, or items to accompany a table setting, the entire package presents strong graphic continuity and classic imagery.

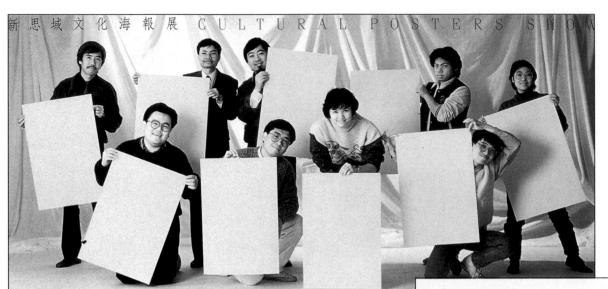

Client: S S Design and Production
Design Firm: Kan tai-keung Design
 & Associates, Ltd
Art Director: Kan Tai-keung
Designer: Freeman Lau Siu Hong
Photographer: C K Wong

Above is a perfect example of a second color used subtly to enhance and give greater clarity to a black photograph. This was designed for a cultural poster show and the duotone allowed a single photograph to be the complete design piece.

Right, an exciting use of a duotone combined with added colors creates a montage effect. This is an instance where black-and-white photography can be combined with other colors to create an image that is successful and looks completely intentional.

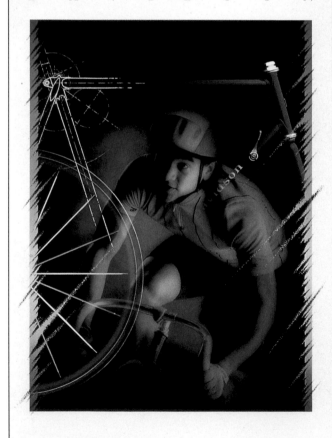

Client: Davidson Cycles
Design Firm: Hornall Anderson Design Works
Art Director: Jack Anderson
Designers: Jack Anderson/Jani Drewfs/
 Mary Hermes
Photographer: Tom Collicott

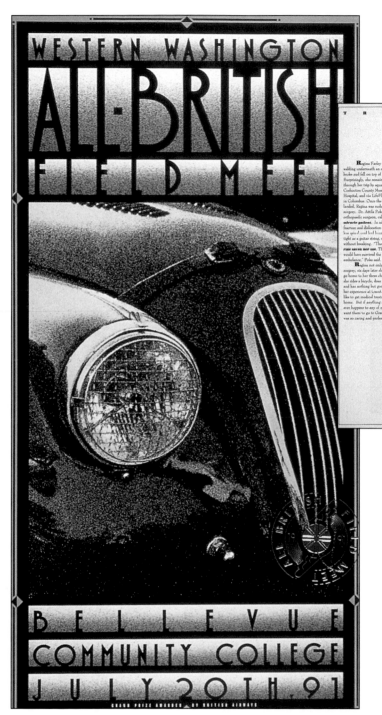

Client: All-British Field Meet
Design Firm: Hornall Anderson Design Works
Art Director: Jack Anderson
Designers: Jack Anderson/David Bates

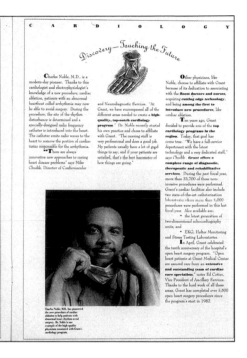

Client: Grant Medical Center
Design Firm: Rickabaugh Graphics
Art Director: Eric Rickabaugh
Designer: Mark Krumel
Illustrator: Michael Linley
Photographer: Greg Sailor

Left, a wonderful use of duotone with a rough poster-ized effect gives greater contrast to the photograph and combines well with the detailed gold medallion.

Above, a two-page spread uses the second color in the drawings and typography while deepening and broad-ening the images in the photos.

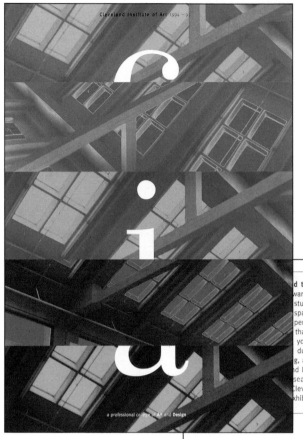

Here the design firm of Nesnadny & Schwartz has created a superb example of 2-color reproduction. Although this piece was printed in 4-color process with a match fifth color, each element was reduced to a 2-color effect. Whether the choice was black and a second color or two non-black colors, the combination of the different images demonstrates design options for black-and-white photography.

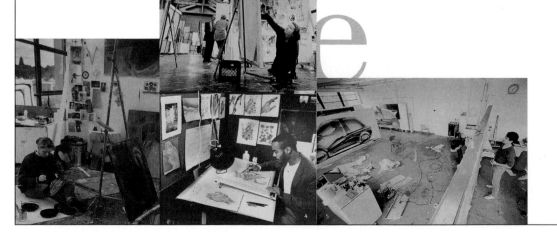

d time. Your working environment helps to shape your ward it. We strive to make all CIA facilities optimal for studios are on a par with professional studios. Most spaces assigned to each student working in a major— per student, depending on the department. The studios that you can work at your own pace. With a substantial you gain a sense of control and input into your own duplicated. About half of our major studios are g, along with academic and foundation classrooms. Also d Memorial Library, the most extensive art library in the seat auditoriums; and the Reinberger Galleries, the Cleveland xhibitions

by noted outside artists, as well as shows by students, faculty, and alumni. Students can gather in the lounge/canteen in the Gund Building, and can frame their work in the wood shop downstairs. The rest of our studios are in the McCullough Center, a 1913 Ford Model T factory that's been renovated with windows on all sides and a 40-foot-long skylight, flooding the enormous studios with natural light. The high ceilings, wide corridors, and freight elevator allow students to work as large as they choose. A privately owned supply store is conveniently located on the first floor, as is the student coffeehouse, which offers exhibit space, reading areas, and performance space. On the third floor are a student-run gallery, student lounge, and 100-seat auditorium. Between our two buildings, you'll find plenty of space to work, learn, exhibit, view art, and just hang out.

Client: Cleveland Institute of Art
Design Firm: Nesnadny & Schwartz
Creative Directors: Joyce Nesnadny/Mark Schwartz
Designers: Joyce Nesnadny/Brian Lavy
Photographers: Mark Schwartz/Robert A. Muller

In this case Nesnadny & Schwartz uses the duotone process to achieve a density of black-and-white reproduction that cannot be reached with just one black halftone. Combining black with a gray second color creates a much greater sense of detail and contrast, and the effect of a richer deeper black contrasts well with the accompanying colors.

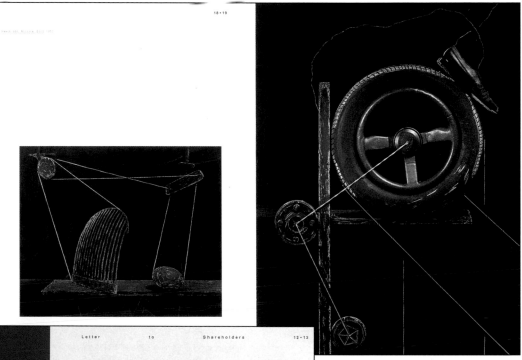

Client: The Progressive Corporation
Design Firm: Nesnadny & Schwartz
Art Directors: Mark Schwartz/Joyce Nesnadny
Designers: Joyce Nesnadny/Michelle Moehler/Mark Schwartz
Photographer: Zeke Berman
Illustrators: Merriam-Webster, Inc./ Brian Lavy

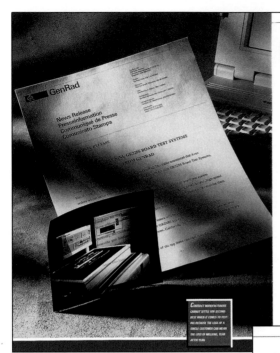

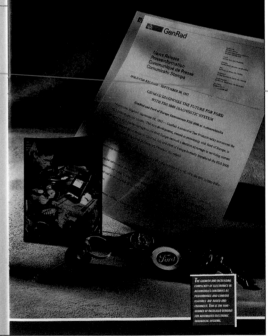

Client: GenRad
Design Firm: Bodzioch Design
Art Director: Leon Bodzioch
Designer: Leon Bodzioch
Photographer: White-Packert
Photography

These examples show the degree of display that is possible with duotones: Because of the added detail and density, photos can be made significantly larger and more dramatic—thus commanding increased viewer attention. The use of a deep second color also contributes greater density to the photo.

Client: Art Direction Magazine
Design Firm: Platinum Design, Inc.
Art Director: Vickie Peslak
Designers: Vickie Peslak/Melissa
 Norton
Photographer: James Wojcik

Many duotones grouped together can become a single, colorful image. Each photograph was created in a different 2-color image, butted together and placed over a warm grey background image.

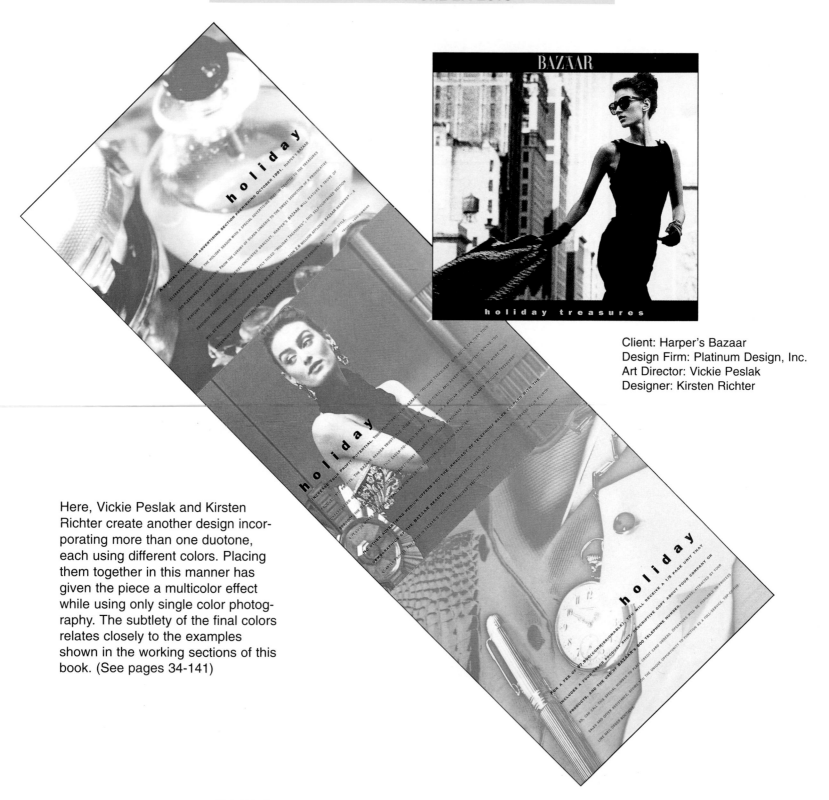

Client: Harper's Bazaar
Design Firm: Platinum Design, Inc.
Art Director: Vickie Peslak
Designer: Kirsten Richter

Here, Vickie Peslak and Kirsten Richter create another design incorporating more than one duotone, each using different colors. Placing them together in this manner has given the piece a multicolor effect while using only single color photography. The subtlety of the final colors relates closely to the examples shown in the working sections of this book. (See pages 34-141)

Client: Accounting Today/Faulkner & Grey
Design Firm: Platinum Design, Inc.
Art Director: Vickie Peslak
Designer: Sandra Quinn

Here a combination of duotones, typography, and simple graphics creates a strong impact from just two colors and gets good mileage from the combination of images.

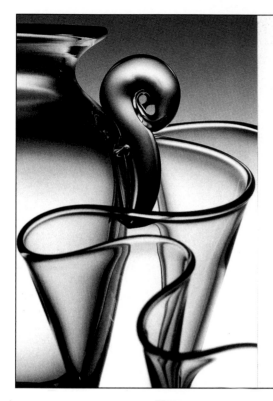

THE WORLD OF HAND-FORMED GLASS

From the very first puff of air blown into a gob of molten crystal to form a bowl or vase, every piece of Steuben is a masterpiece of subtlety and refinement. Blowing, turning, twisting, the molten glass must be shaped just so, with the minute flick of a wrist, or turn of the hand. Slowly, surely, the glass begins to form and a creation emerges.

This is the art of hand-formed glass as practiced at Steuben today, using methods and tools very like those used for thousands of years. Each piece of Steuben is made by a team of experienced glassworkers–called a "shop"–who work together in choreographed movements to create the final product. Each member performs a specialized role, with the "gaffer," or most senior member, making the final intricate steps in the shaping process. Often a shop will spend years mastering a single art of glass blowing, the using other formidable create solid crystal objects animals, candlesticks, and During the shaping of any bowl, vase, or animal, the continuously rotated to Timing is everything. heavy, it cannot be touched at any time. Instead, it is shaped only with water-soaked wooden tools or metal shears.

design. In addition to the teams also work together "off-hand" techniques to such as our well-known decorative designs. object, whether it's a molten glass must be prevent it from collapsing. Viscous, hot, and quite by the glassworker's hands

Cameo glass ewer, Islamic, probably Iran about 10th century A.D.

Observers watching the hand-forming process at Steuben often report feeling transported to another era, for although the purity of Steuben crystal is possible only through 20th century technology, many of the methods used to form the glass remain virtually unchanged from those of centuries ago. In an age-old process of apprenticeship, each glassworker trains for years to learn his craft and must work his way through the team to reach the position of "gaffer." Few companies today can boast this legacy of skill.

If you would like to place an order or to inquire about our services, please call us at 800 424-4240.

Client: Steuben
Design Firm: Matsumoto Incorporated
Art Director: Takaaki Matsumoto
Designer: Takaaki Matsumoto
Photographer: Mikio Sekita

On each of these two-page spreads the duotones are created by using black with grey as a second color. The basic color of the final image remains black, but the two superimposed halftones create twice the detail and density of the original photo. This process is especially effective when using photos that have high contrast with bright highlights and dark areas of detail.

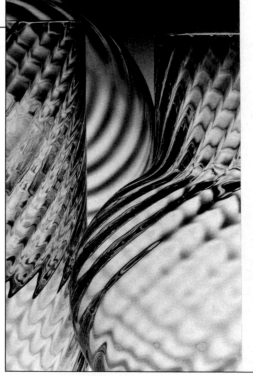

THE SEQUENCE COLLECTIONS™

In keeping with our long history of innovation in glass design and technology, Steuben is pleased to introduce the *Sequence Collections*, sophisticated home accessories created for daily use. Made by our glassworkers in the Steuben factory with the quality and expert craftsmanship for which we are renowned, the *Sequence Collections* are a look toward the future for a new generation of glass collectors. Contemporary, sometimes whimsical, and always stylishly elegant, they are the ultimate balance of design and functionality.

Just as we have worked with master artists throughout our history, Steuben has invited international designers and architects from around the globe to design our *Sequence Collections*. The first series, *Whirlwind*, was designed by Italian master Massimo Vignelli. Inspired by Venetian glassmaking techniques, airy and full of move-daily use, relaxed enter-The second series, exclusively for Steuben glass artists Philip Guggisberg. Pairing crystal, the collection is

Whirlwind is composed of six distinctive bar and serving pieces. Light, ment, it is ideal for taining or gift-giving. *Aurora*, was created by contemporary Baldwin and Monica solid pewter with at once modern and

Verre de Soie Bowl by Frederick Carder, 1916. Turquoise glass prunts and applied threading.

classic. Smooth, clean lines, and the glassmaking skill of trapping air between a ring of glass during the forming process bespeak the quality of the work. Our team of in-house designers collaborated in the creation of *Interplay*, the third series in the *Sequence Collections*. Expressing the timeless relationship between the cube and sphere, *Interplay* offers strong and simple shapes for the home and office.

And this is just the beginning. Look for additions to our *Sequence Collections* throughout the year. Please note that the *Sequence Collections* are not available at all Steuben retail locations. In such cases, they may be special ordered.

To place an order or for further information, please call us at 800 424-4240.

129

Client: Faire du Charme
Design Firm: Platinum Design, Inc.
Art Director: Victoria Peslak
Designers: Victoria Peslak/Ava
 Schlesinger
Photographer: Thomas Hooper

These two pieces display excellent use of the duotone. The top piece presents a strong, compelling photographic full-bleed background with minimal text. The duotone contributes to the romantic message. The bottom piece is a nice combination of duotones with strong color companion backgrounds that create a colorful presentation.

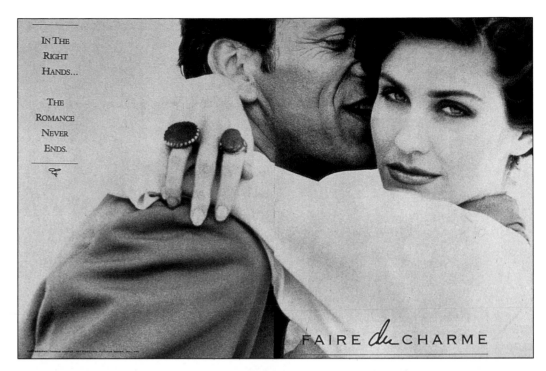

Client: Hewitt School
Design Firm: Platinum Design, Inc.
Art Directors: Victoria Peslak/Ava
 Schlesinger
Designers: Ava Schlesinger/Kathleen
 Phelps
Photographer: Lisa Garcia

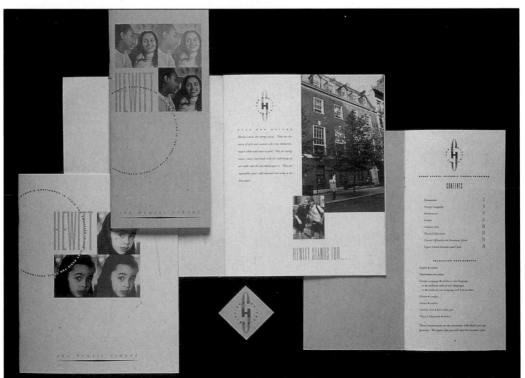

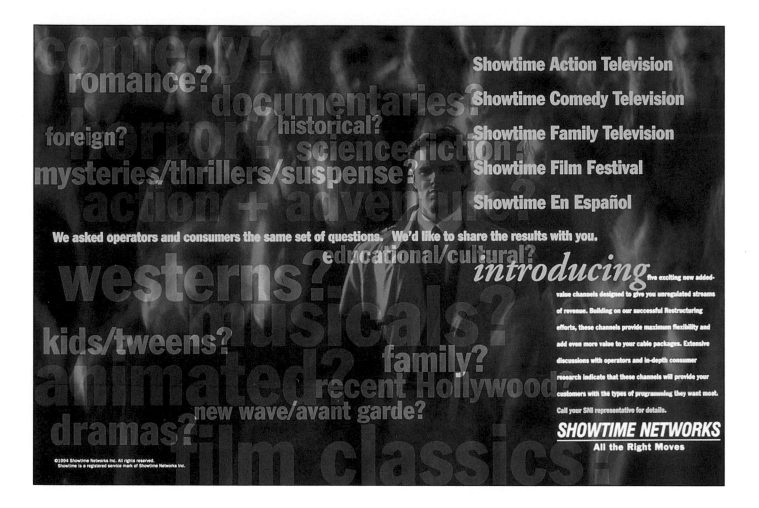

Client: Showtime Networks
Design Firm: Platinum Design, Inc.
Art Director: Victoria Peslak
Designer: Kathleen Phelps

Here, photography and typography create a striking duotone background for this advertisement, demonstrating that the duotone process works equally well with graphics and typography. It also shows how well the resulting duotone color works with the color of the type. This advertisement, designed by Kathleen Phelps, used this commanding image to successfully launch several new channels for the client.

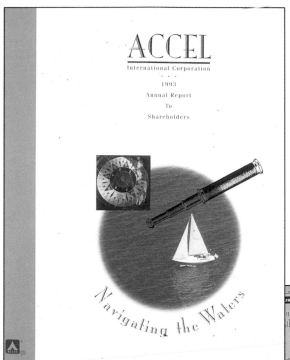

Mark Krumel created this design using different color duotones with a surrounding background color to achieve a marine effect. He has also allowed the photographic edges to fade into the background.

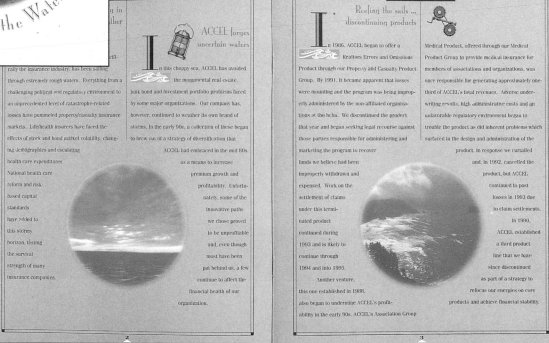

Client: ACCEL International Corp.
Design Firm: Rickabaugh Graphics
Art Director: Eric Rickabaugh
Designer: Mark Krumel
Photographer: Larry Hamill

CREATIVE DUOTONE EFFECTS

A Visual Guide to Choosing Successful Color Combinations

SELECTOR

Black and a Second Color

This section covers the use of black combined with a second color. The black color is the only color to change in the two examples of each combination. The second color stays the same, with the darkest level of black ranging from 100 percent to 60/80 percent. When the black is at 100 percent, it has the strongest influence on the final color (black will be predominant). At 60/80 percent, the second color will have the strongest influence (the color will be predominant). Of course, these percentages can be altered to change the density and strength of the final color; the colors shown here will give an excellent starting point.

Remember, when designing in two colors, match the color swatch shown below each combination to the color-matching system you use. This will provide results that closely match the picture shown. If you are printing in four process colors and/or using the CMYK desktop system, use the percentages displayed below each picture to achieve the same results.

Since black plus a second color is the most common duotone application, this section will perhaps be the most extensively used. The two sections following this provide creative options quite different from these traditional applications.

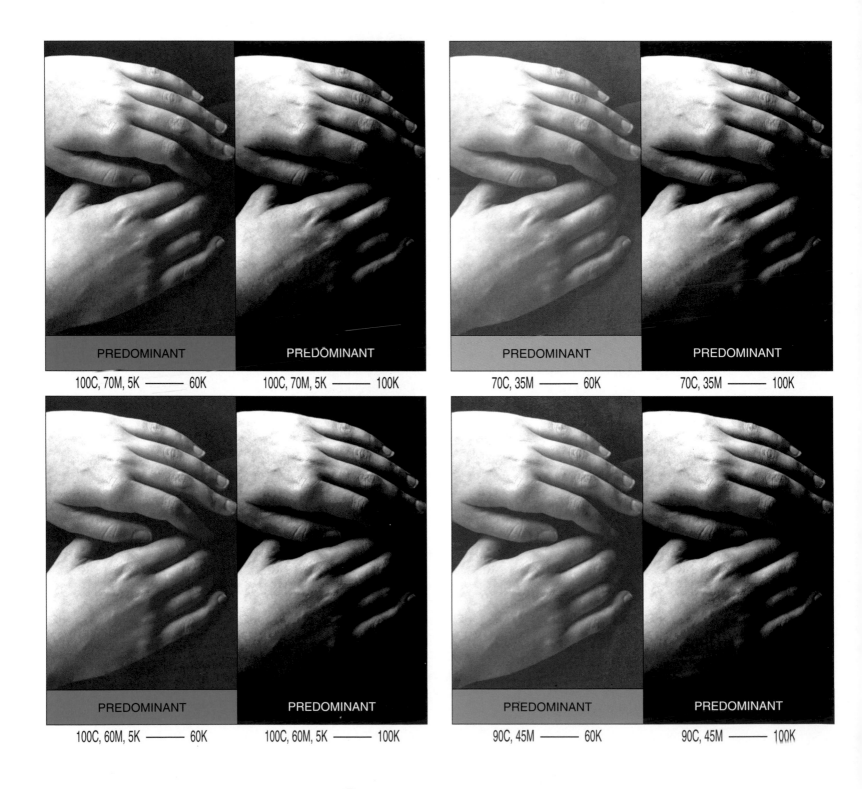

PREDOMINANT

PREDOMINANT

100C, 70M, 5K ——— 60K

100C, 70M, 5K ——— 100K

PREDOMINANT

PREDOMINANT

70C, 35M ——— 60K

70C, 35M ——— 100K

PREDOMINANT

PREDOMINANT

100C, 60M, 5K ——— 60K

100C, 60M, 5K ——— 100K

PREDOMINANT

PREDOMINANT

90C, 45M ——— 60K

90C, 45M ——— 100K

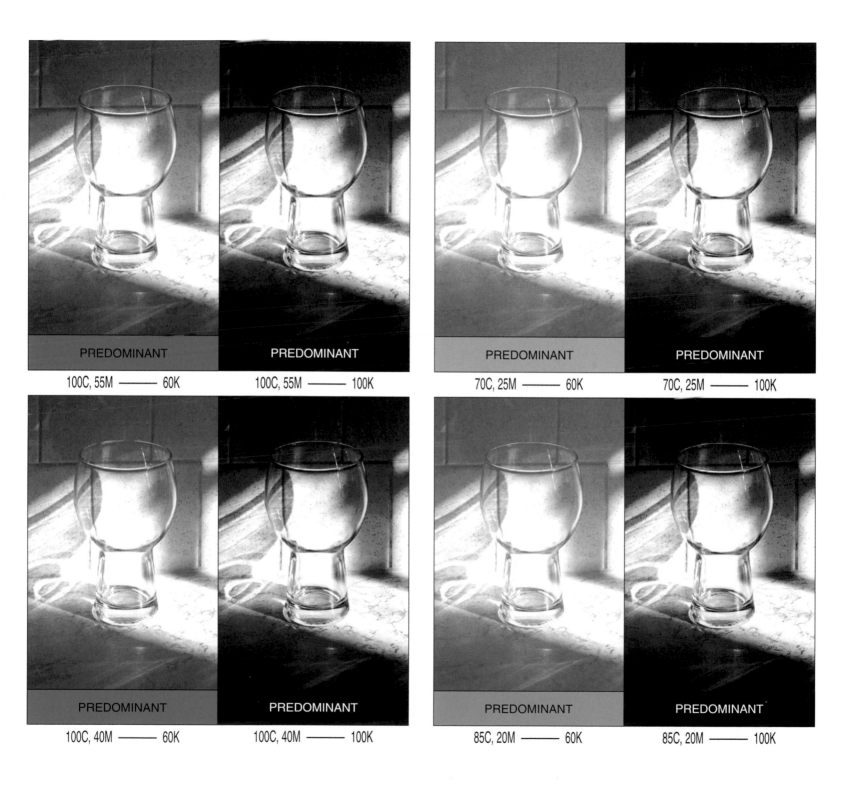

PREDOMINANT

100C, 55M ——— 60K

PREDOMINANT

100C, 55M ——— 100K

PREDOMINANT

70C, 25M ——— 60K

PREDOMINANT

70C, 25M ——— 100K

PREDOMINANT

100C, 40M ——— 60K

PREDOMINANT

100C, 40M ——— 100K

PREDOMINANT

85C, 20M ——— 60K

PREDOMINANT

85C, 20M ——— 100K

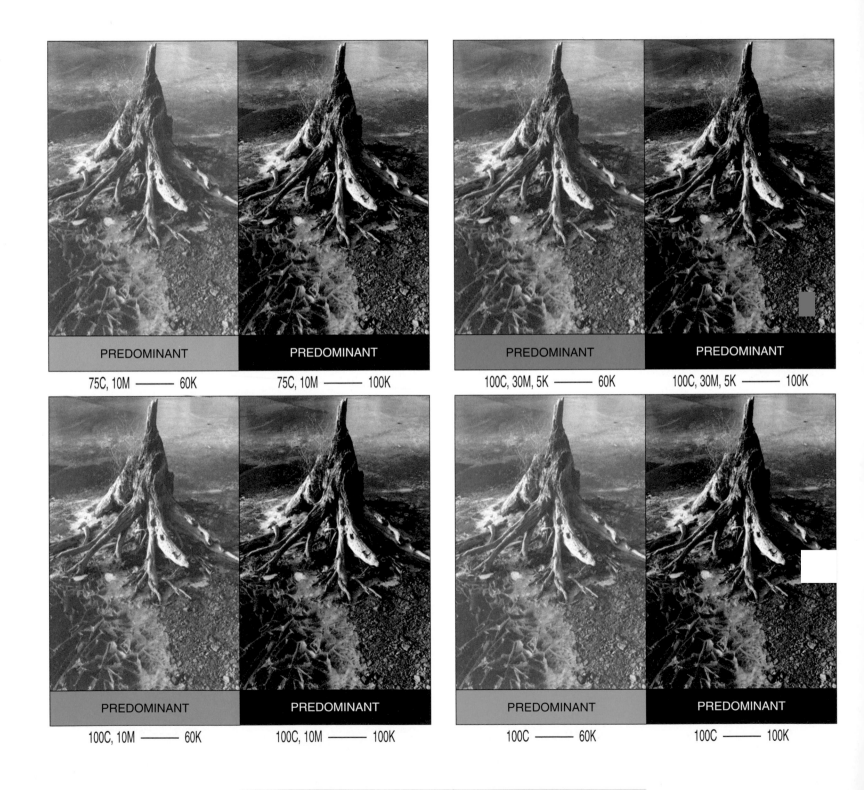

PREDOMINANT
PREDOMINANT
PREDOMINANT
PREDOMINANT

75C, 10M ——— 60K
75C, 10M ——— 100K
100C, 30M, 5K ——— 60K
100C, 30M, 5K ——— 100K

PREDOMINANT
PREDOMINANT
PREDOMINANT
PREDOMINANT

100C, 10M ——— 60K
100C, 10M ——— 100K
100C ——— 60K
100C ——— 100K

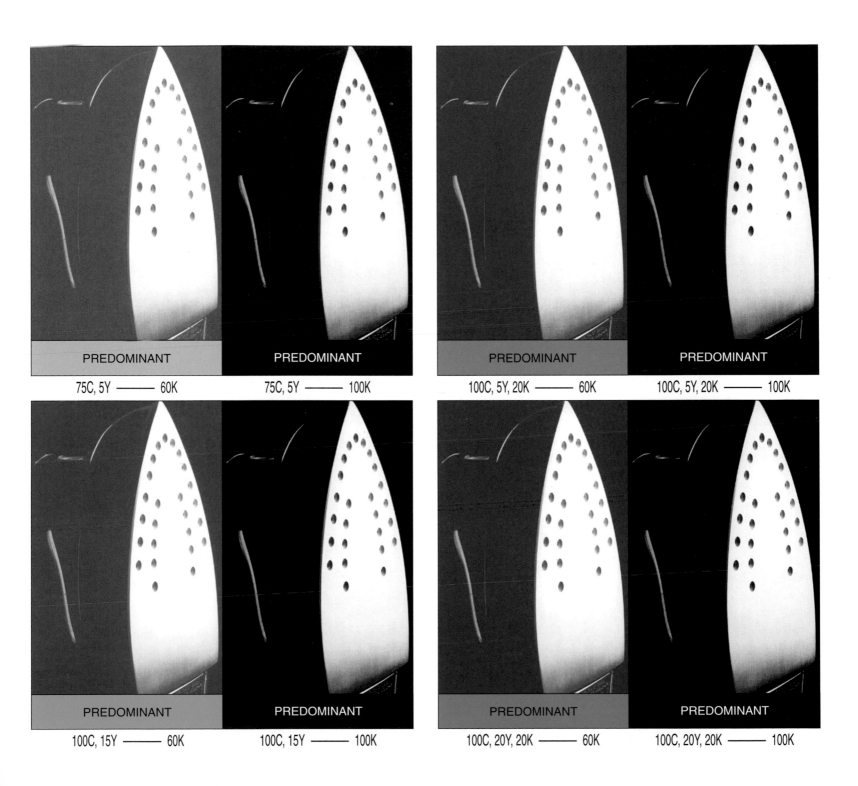

PREDOMINANT

75C, 5Y —— 60K

PREDOMINANT

75C, 5Y —— 100K

PREDOMINANT

100C, 5Y, 20K —— 60K

PREDOMINANT

100C, 5Y, 20K —— 100K

PREDOMINANT

100C, 15Y —— 60K

PREDOMINANT

100C, 15Y —— 100K

PREDOMINANT

100C, 20Y, 20K —— 60K

PREDOMINANT

100C, 20Y, 20K —— 100K

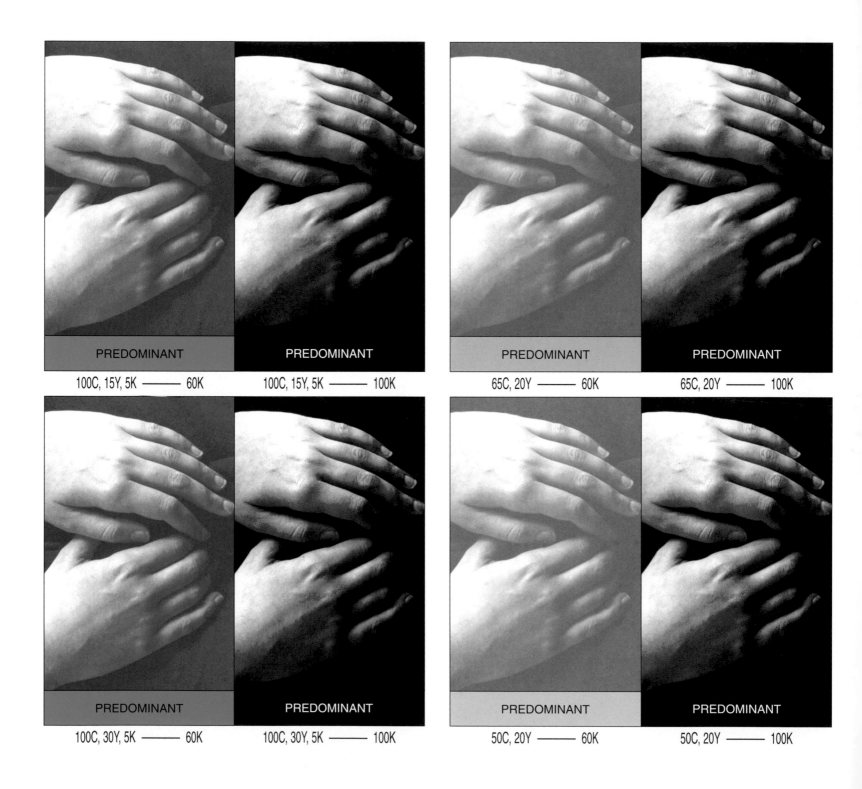

PREDOMINANT

PREDOMINANT

100C, 15Y, 5K ——— 60K

100C, 15Y, 5K ——— 100K

PREDOMINANT

PREDOMINANT

65C, 20Y ——— 60K

65C, 20Y ——— 100K

PREDOMINANT

PREDOMINANT

100C, 30Y, 5K ——— 60K

100C, 30Y, 5K ——— 100K

PREDOMINANT

PREDOMINANT

50C, 20Y ——— 60K

50C, 20Y ——— 100K

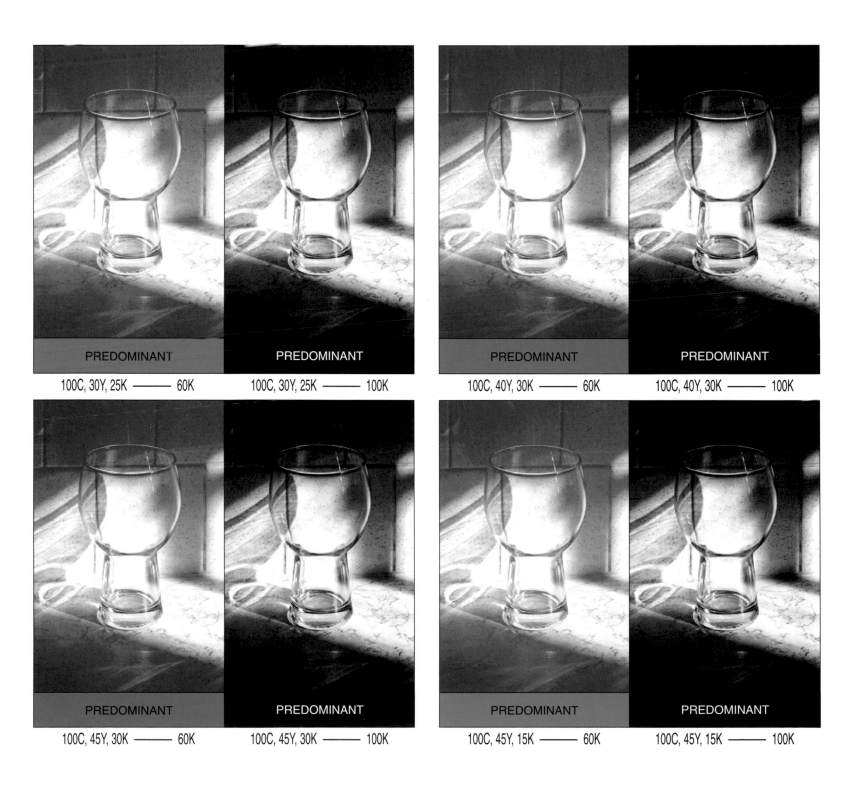

PREDOMINANT

100C, 30Y, 25K ———— 60K

PREDOMINANT

100C, 30Y, 25K ———— 100K

PREDOMINANT

100C, 40Y, 30K ———— 60K

PREDOMINANT

100C, 40Y, 30K ———— 100K

PREDOMINANT

100C, 45Y, 30K ———— 60K

PREDOMINANT

100C, 45Y, 30K ———— 100K

PREDOMINANT

100C, 45Y, 15K ———— 60K

PREDOMINANT

100C, 45Y, 15K ———— 100K

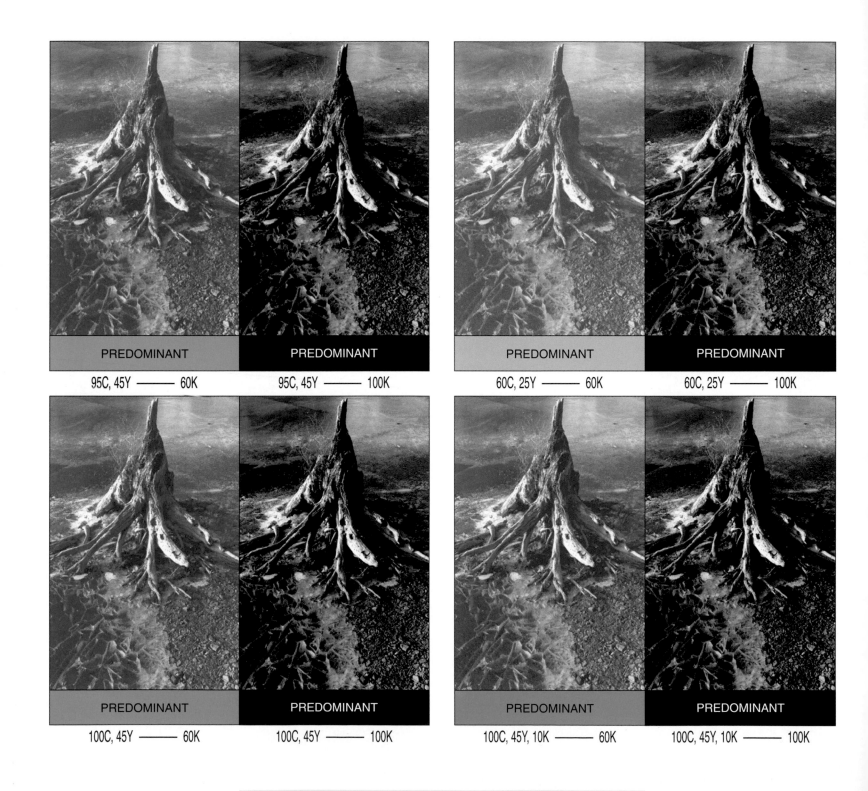

PREDOMINANT PREDOMINANT

95C, 45Y —————— 60K 95C, 45Y —————— 100K

PREDOMINANT PREDOMINANT

60C, 25Y —————— 60K 60C, 25Y —————— 100K

PREDOMINANT PREDOMINANT

100C, 45Y —————— 60K 100C, 45Y —————— 100K

PREDOMINANT PREDOMINANT

100C, 45Y, 10K —————— 60K 100C, 45Y, 10K —————— 100K

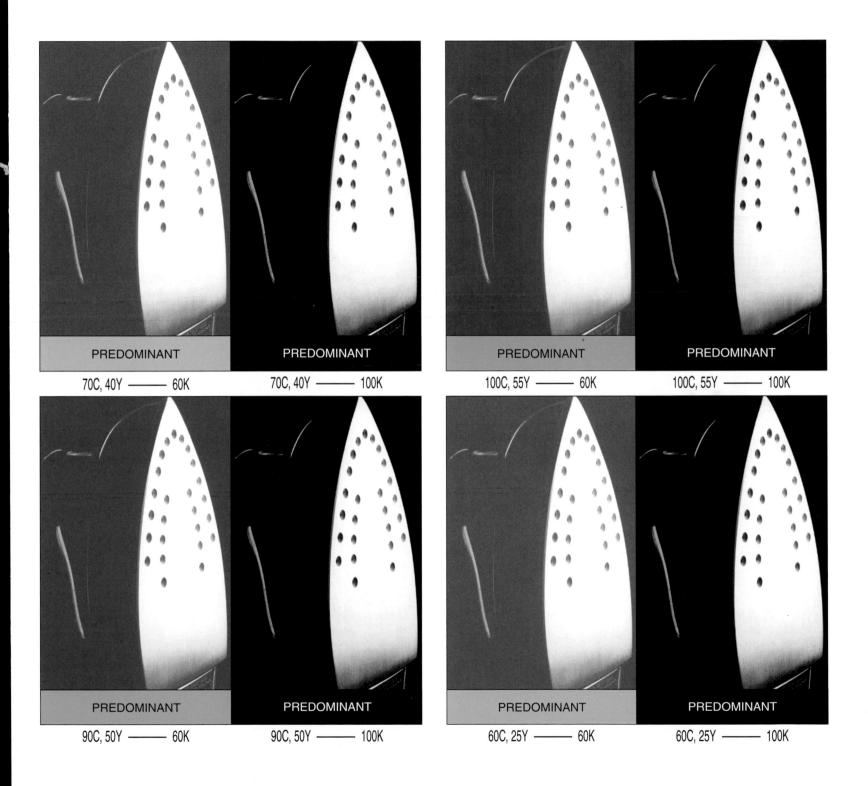

PREDOMINANT

70C, 40Y —— 60K

PREDOMINANT

70C, 40Y —— 100K

PREDOMINANT

100C, 55Y —— 60K

PREDOMINANT

100C, 55Y —— 100K

PREDOMINANT

90C, 50Y —— 60K

PREDOMINANT

90C, 50Y —— 100K

PREDOMINANT

60C, 25Y —— 60K

PREDOMINANT

60C, 25Y —— 100K

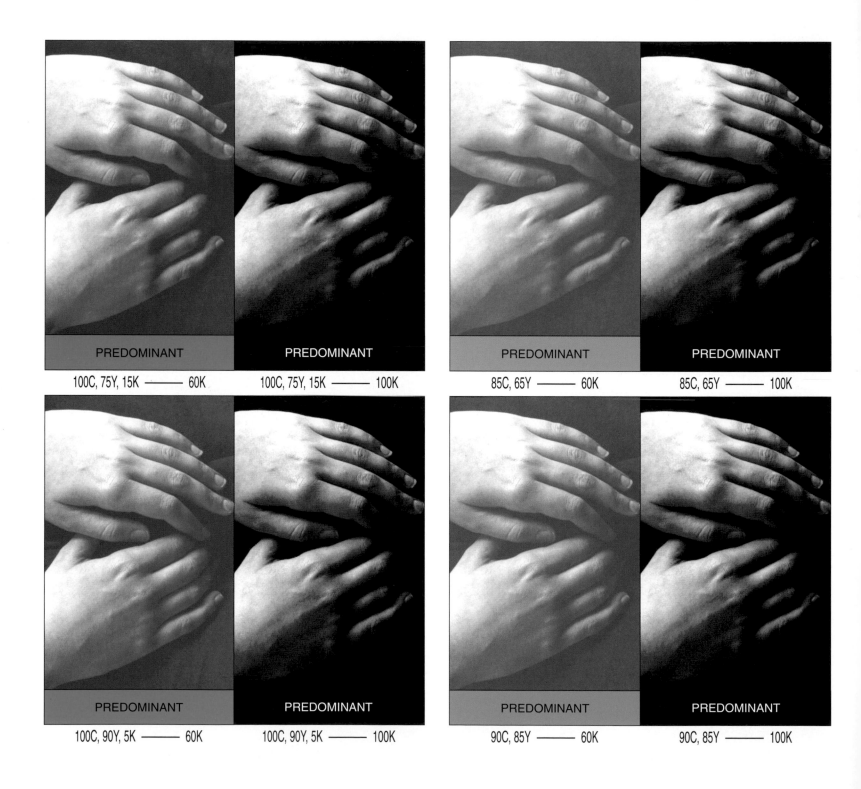

PREDOMINANT PREDOMINANT

100C, 75Y, 15K —— 60K 100C, 75Y, 15K —— 100K

PREDOMINANT PREDOMINANT

85C, 65Y —— 60K 85C, 65Y —— 100K

PREDOMINANT PREDOMINANT

100C, 90Y, 5K —— 60K 100C, 90Y, 5K —— 100K

PREDOMINANT PREDOMINANT

90C, 85Y —— 60K 90C, 85Y —— 100K

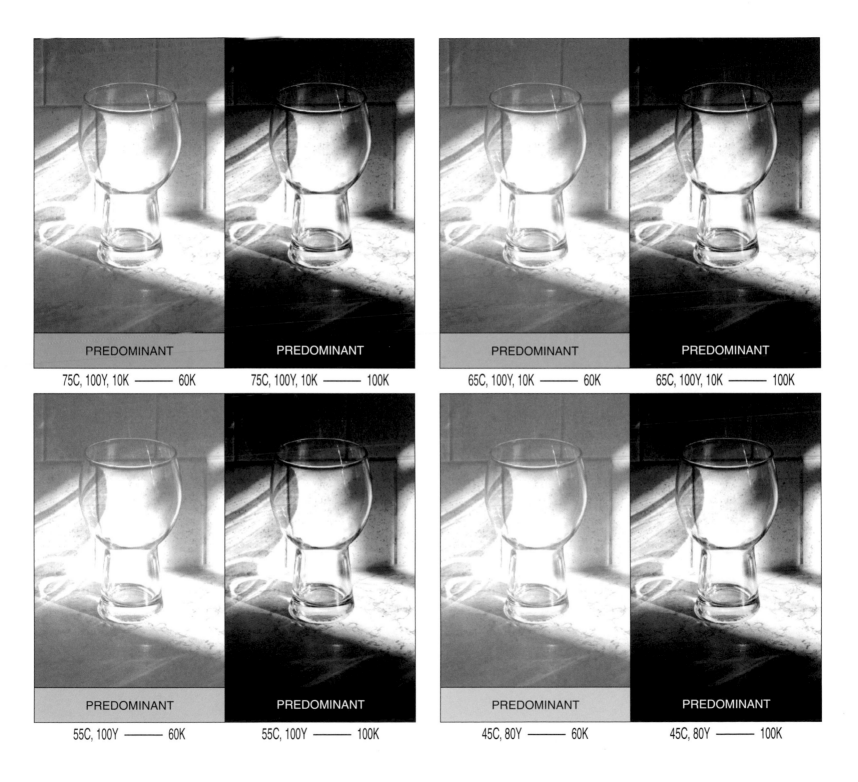

PREDOMINANT

PREDOMINANT

75C, 100Y, 10K ——— 60K

75C, 100Y, 10K ——— 100K

PREDOMINANT

PREDOMINANT

65C, 100Y, 10K ——— 60K

65C, 100Y, 10K ——— 100K

PREDOMINANT

PREDOMINANT

55C, 100Y ——— 60K

55C, 100Y ——— 100K

PREDOMINANT

PREDOMINANT

45C, 80Y ——— 60K

45C, 80Y ——— 100K

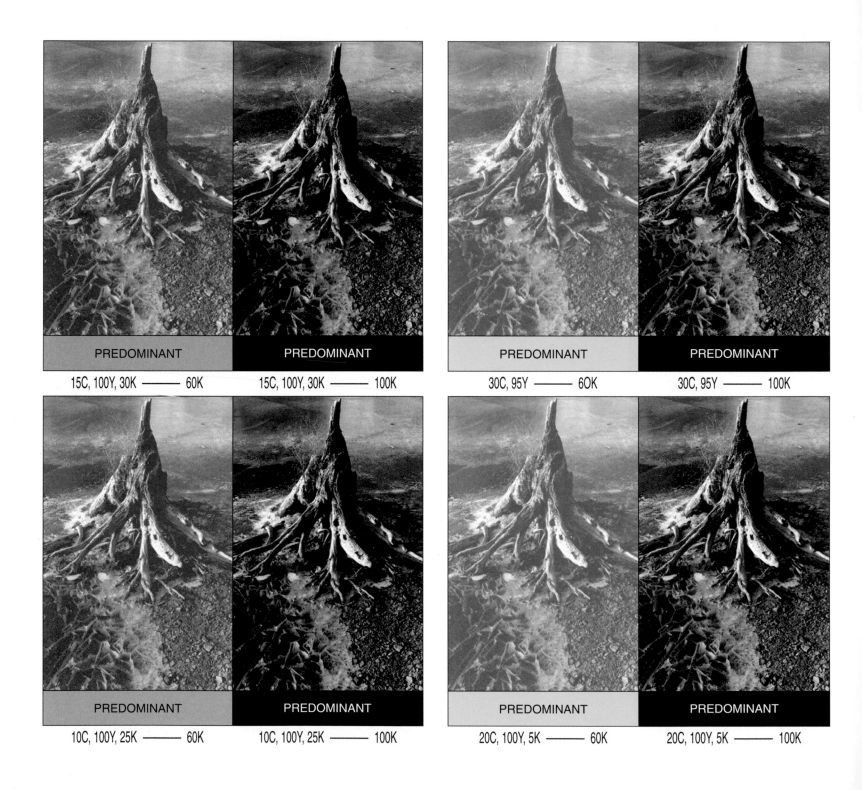

PREDOMINANT PREDOMINANT

15C, 100Y, 30K ——— 60K 15C, 100Y, 30K ——— 100K

PREDOMINANT PREDOMINANT

30C, 95Y ——— 6OK 30C, 95Y ——— 100K

PREDOMINANT PREDOMINANT

10C, 100Y, 25K ——— 60K 10C, 100Y, 25K ——— 100K

PREDOMINANT PREDOMINANT

20C, 100Y, 5K ——— 60K 20C, 100Y, 5K ——— 100K

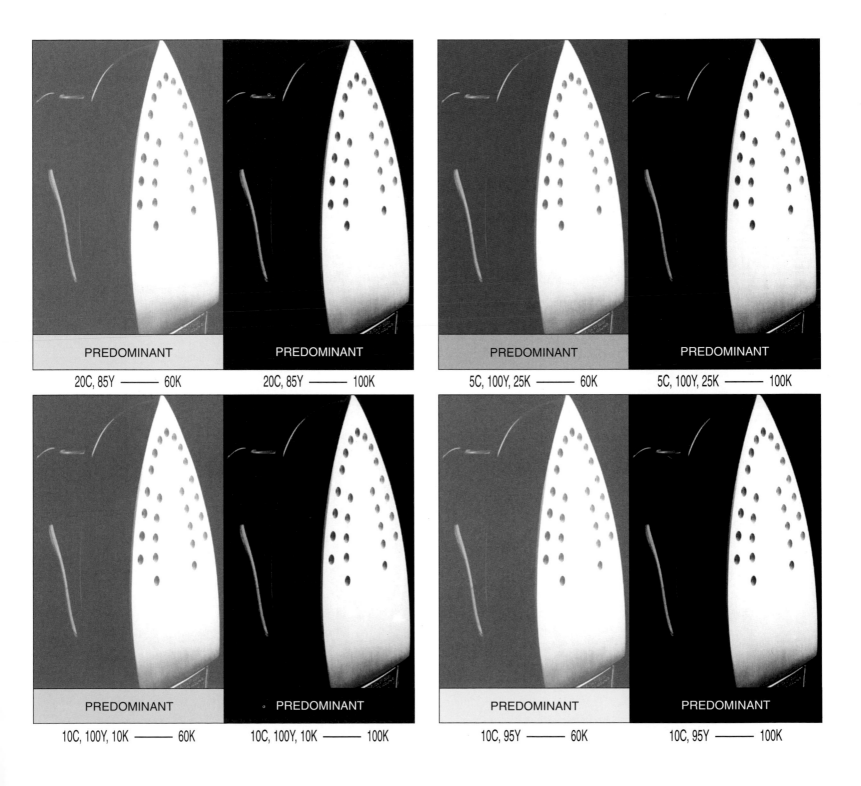

PREDOMINANT

PREDOMINANT

PREDOMINANT

PREDOMINANT

20C, 85Y ——— 60K

20C, 85Y ——— 100K

5C, 100Y, 25K ——— 60K

5C, 100Y, 25K ——— 100K

PREDOMINANT

PREDOMINANT

PREDOMINANT

PREDOMINANT

10C, 100Y, 10K ——— 60K

10C, 100Y, 10K ——— 100K

10C, 95Y ——— 60K

10C, 95Y ——— 100K

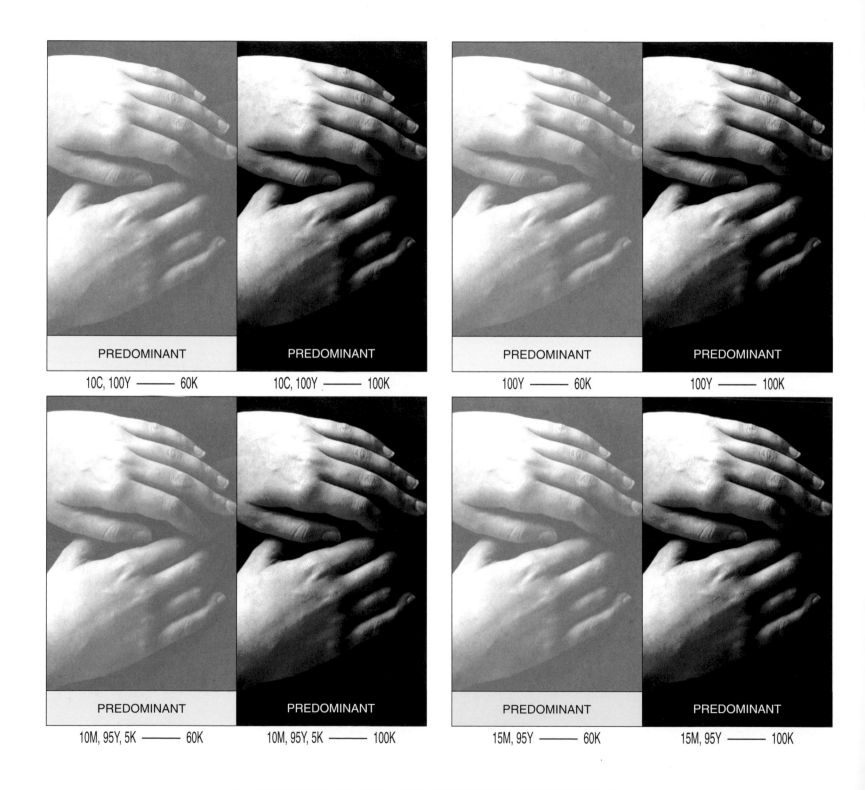

PREDOMINANT

PREDOMINANT

10C, 100Y ——— 60K

10C, 100Y ——— 100K

PREDOMINANT

PREDOMINANT

100Y ——— 60K

100Y ——— 100K

PREDOMINANT

PREDOMINANT

10M, 95Y, 5K ——— 60K

10M, 95Y, 5K ——— 100K

PREDOMINANT

PREDOMINANT

15M, 95Y ——— 60K

15M, 95Y ——— 100K

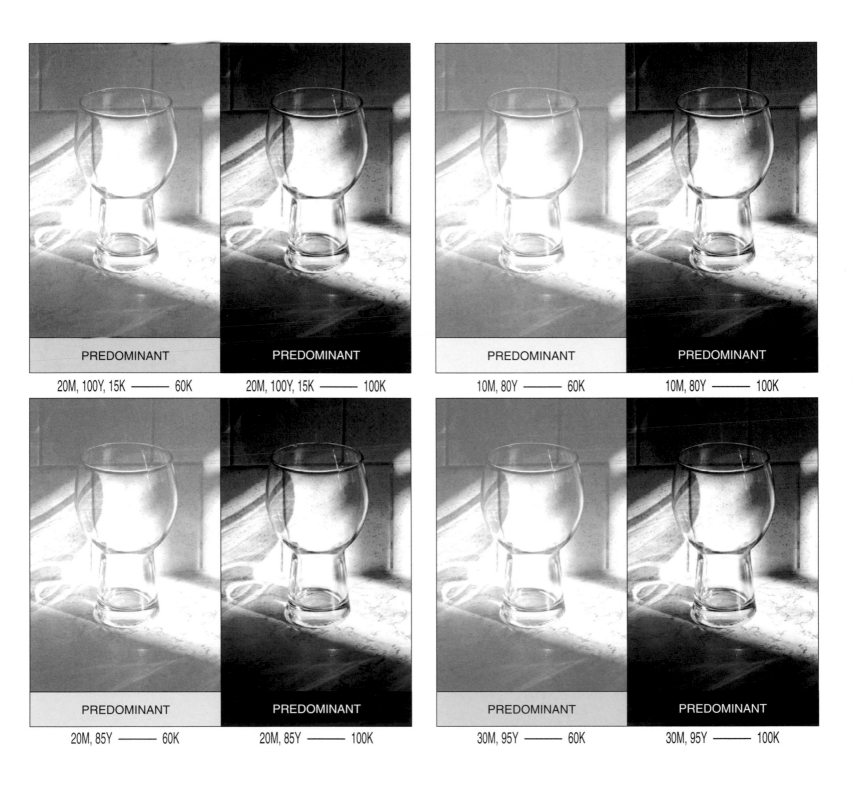

PREDOMINANT

20M, 100Y, 15K ——— 60K

PREDOMINANT

20M, 100Y, 15K ——— 100K

PREDOMINANT

10M, 80Y ——— 60K

PREDOMINANT

10M, 80Y ——— 100K

PREDOMINANT

20M, 85Y ——— 60K

PREDOMINANT

20M, 85Y ——— 100K

PREDOMINANT

30M, 95Y ——— 60K

PREDOMINANT

30M, 95Y ——— 100K

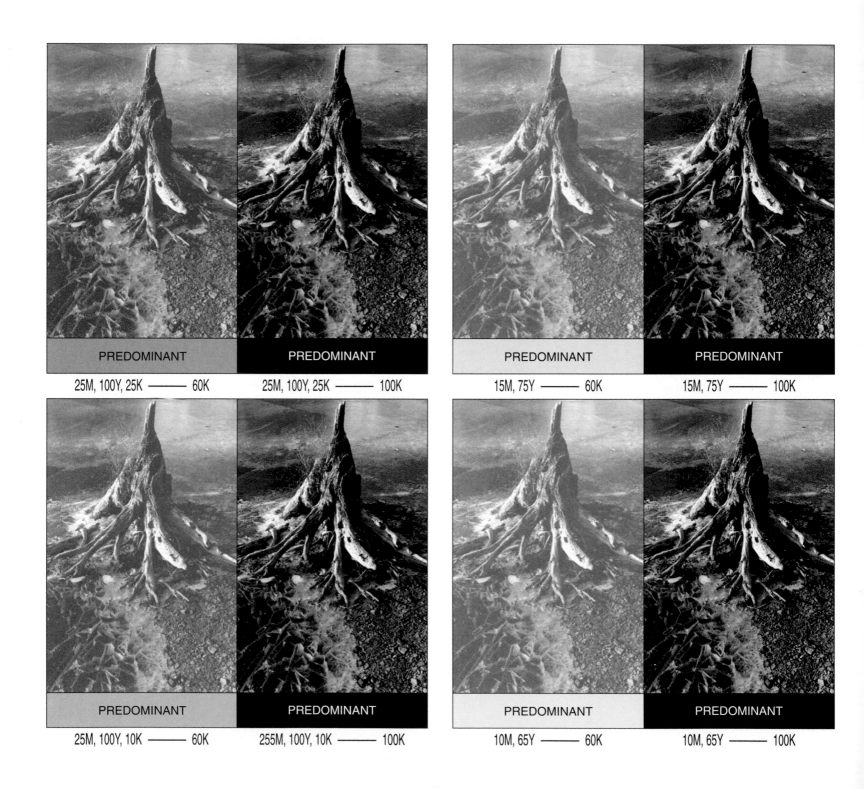

PREDOMINANT PREDOMINANT PREDOMINANT PREDOMINANT

25M, 100Y, 25K ——— 60K 25M, 100Y, 25K ——— 100K 15M, 75Y ——— 60K 15M, 75Y ——— 100K

PREDOMINANT PREDOMINANT PREDOMINANT PREDOMINANT

25M, 100Y, 10K ——— 60K 255M, 100Y, 10K ——— 100K 10M, 65Y ——— 60K 10M, 65Y ——— 100K

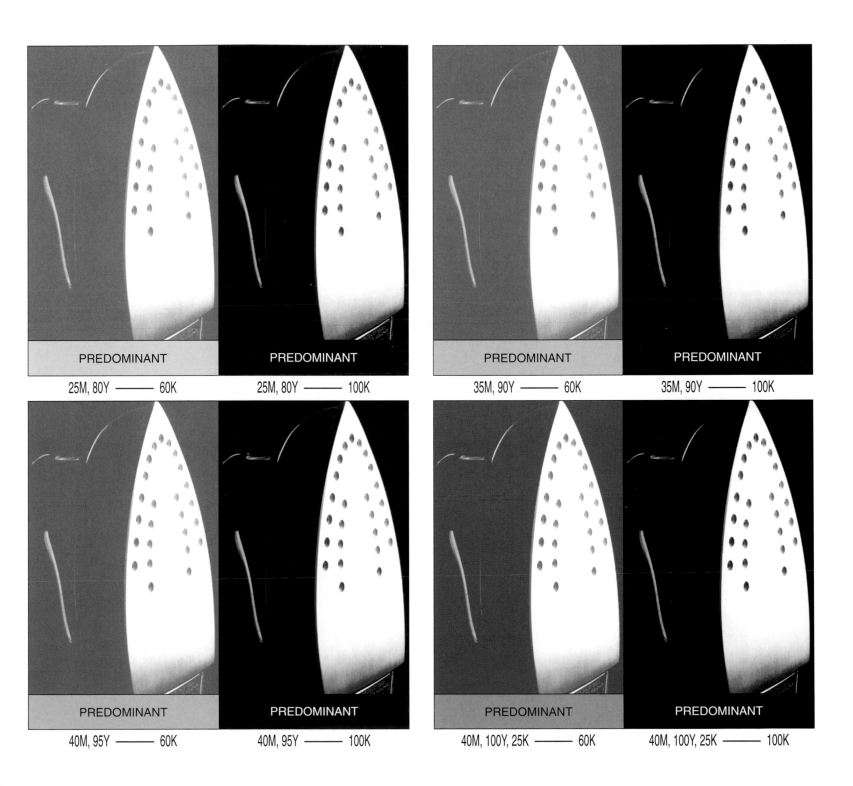

PREDOMINANT

25M, 80Y ——— 60K

PREDOMINANT

25M, 80Y ——— 100K

PREDOMINANT

35M, 90Y ——— 60K

PREDOMINANT

35M, 90Y ——— 100K

PREDOMINANT

40M, 95Y ——— 60K

PREDOMINANT

40M, 95Y ——— 100K

PREDOMINANT

40M, 100Y, 25K ——— 60K

PREDOMINANT

40M, 100Y, 25K ——— 100K

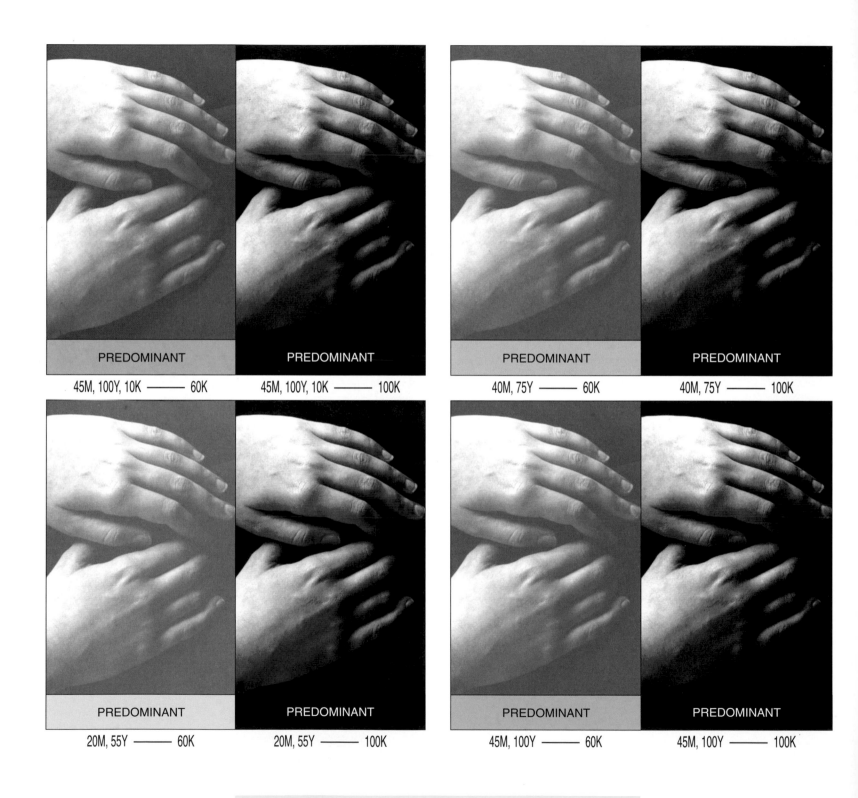

PREDOMINANT

PREDOMINANT

PREDOMINANT

PREDOMINANT

45M, 100Y, 10K ——— 60K

45M, 100Y, 10K ——— 100K

40M, 75Y ——— 60K

40M, 75Y ——— 100K

PREDOMINANT

PREDOMINANT

PREDOMINANT

PREDOMINANT

20M, 55Y ——— 60K

20M, 55Y ——— 100K

45M, 100Y ——— 60K

45M, 100Y ——— 100K

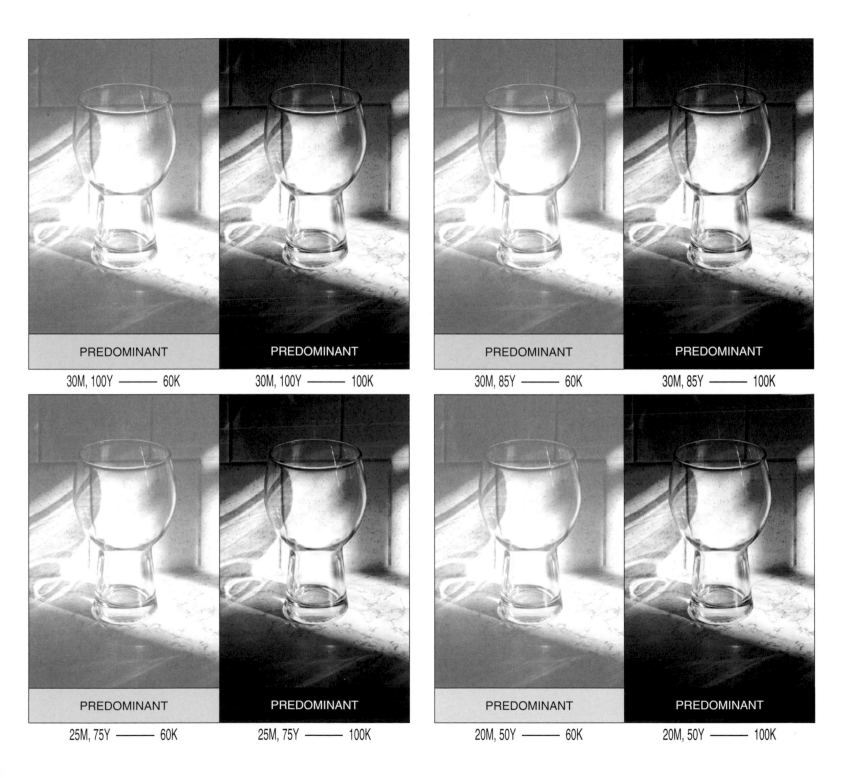

PREDOMINANT

PREDOMINANT

30M, 100Y ——— 60K

30M, 100Y ——— 100K

PREDOMINANT

PREDOMINANT

30M, 85Y ——— 60K

30M, 85Y ——— 100K

PREDOMINANT

PREDOMINANT

25M, 75Y ——— 60K

25M, 75Y ——— 100K

PREDOMINANT

PREDOMINANT

20M, 50Y ——— 60K

20M, 50Y ——— 100K

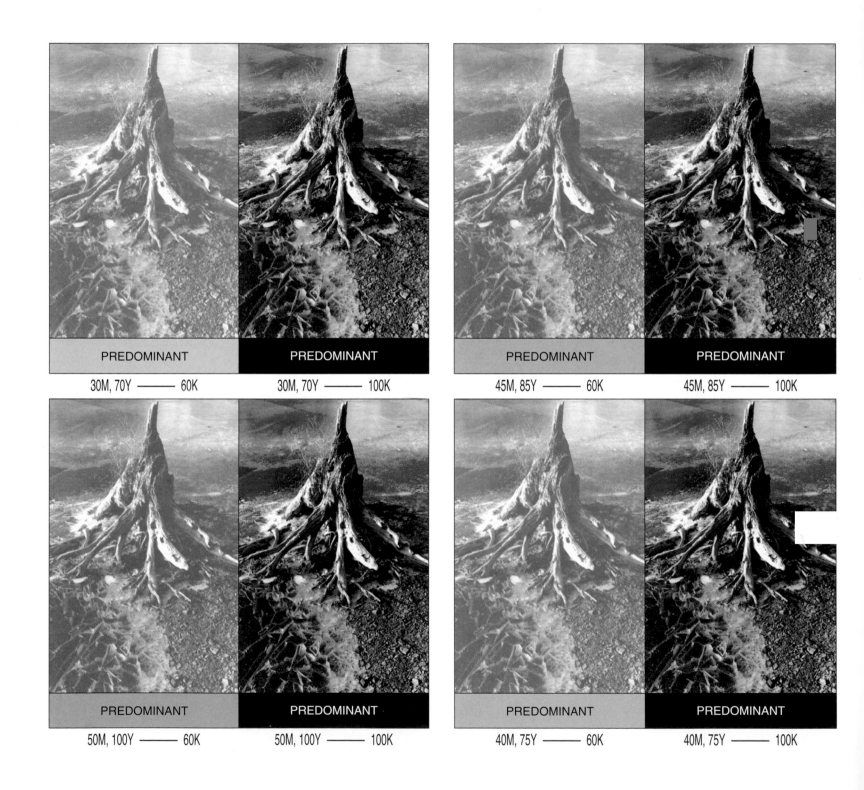

PREDOMINANT

30M, 70Y ——— 60K

PREDOMINANT

30M, 70Y ——— 100K

PREDOMINANT

45M, 85Y ——— 60K

PREDOMINANT

45M, 85Y ——— 100K

PREDOMINANT

50M, 100Y ——— 60K

PREDOMINANT

50M, 100Y ——— 100K

PREDOMINANT

40M, 75Y ——— 60K

PREDOMINANT

40M, 75Y ——— 100K

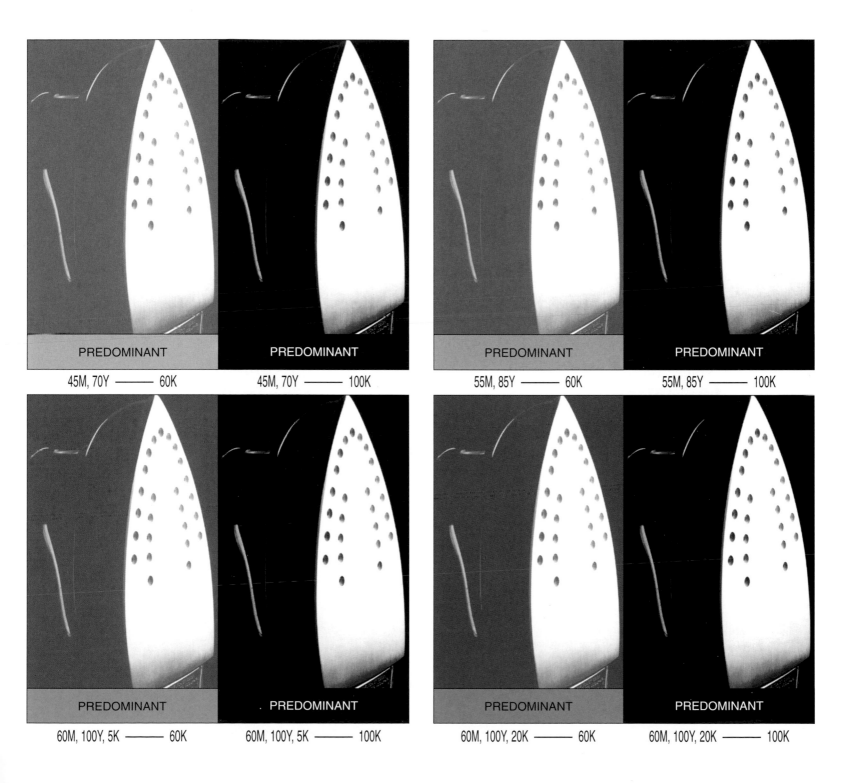

PREDOMINANT | PREDOMINANT | PREDOMINANT | PREDOMINANT

45M, 70Y ——— 60K 45M, 70Y ——— 100K 55M, 85Y ——— 60K 55M, 85Y ——— 100K

PREDOMINANT | PREDOMINANT | PREDOMINANT | PREDOMINANT

60M, 100Y, 5K ——— 60K 60M, 100Y, 5K ——— 100K 60M, 100Y, 20K ——— 60K 60M, 100Y, 20K ——— 100K

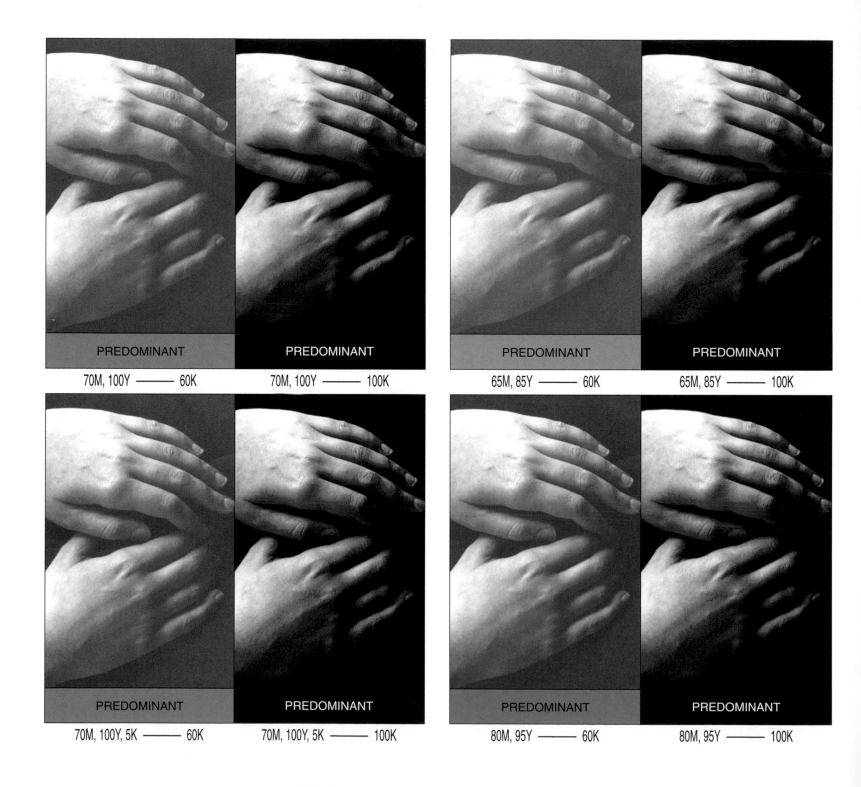

PREDOMINANT
70M, 100Y ——— 60K

PREDOMINANT
70M, 100Y ——— 100K

PREDOMINANT
65M, 85Y ——— 60K

PREDOMINANT
65M, 85Y ——— 100K

PREDOMINANT
70M, 100Y, 5K ——— 60K

PREDOMINANT
70M, 100Y, 5K ——— 100K

PREDOMINANT
80M, 95Y ——— 60K

PREDOMINANT
80M, 95Y ——— 100K

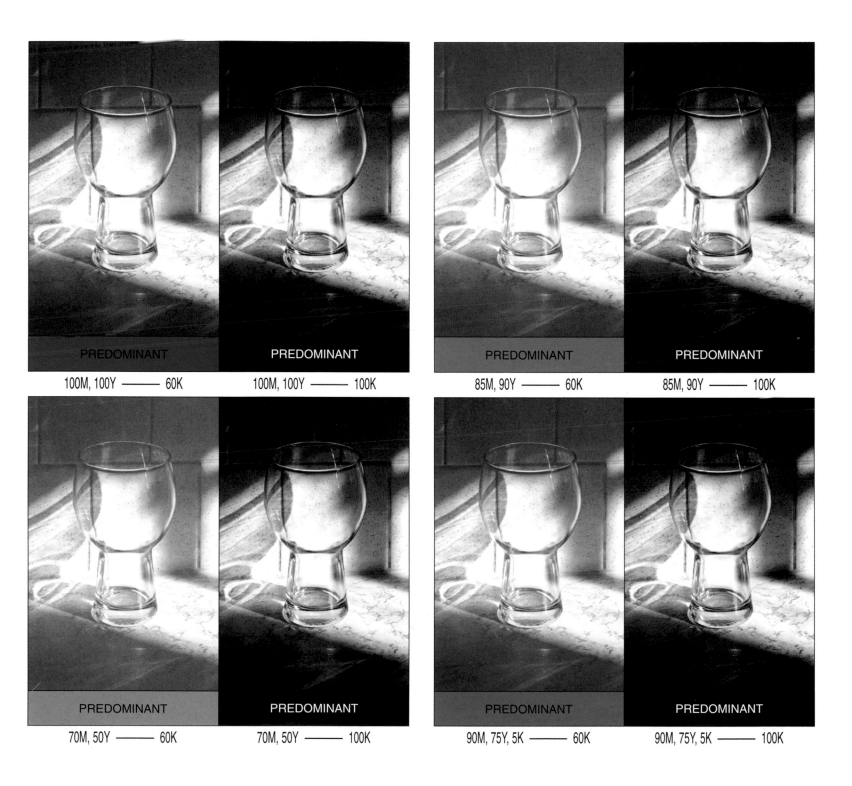

PREDOMINANT

100M, 100Y ——— 60K

PREDOMINANT

100M, 100Y ——— 100K

PREDOMINANT

85M, 90Y ——— 60K

PREDOMINANT

85M, 90Y ——— 100K

PREDOMINANT

70M, 50Y ——— 60K

PREDOMINANT

70M, 50Y ——— 100K

PREDOMINANT

90M, 75Y, 5K ——— 60K

PREDOMINANT

90M, 75Y, 5K ——— 100K

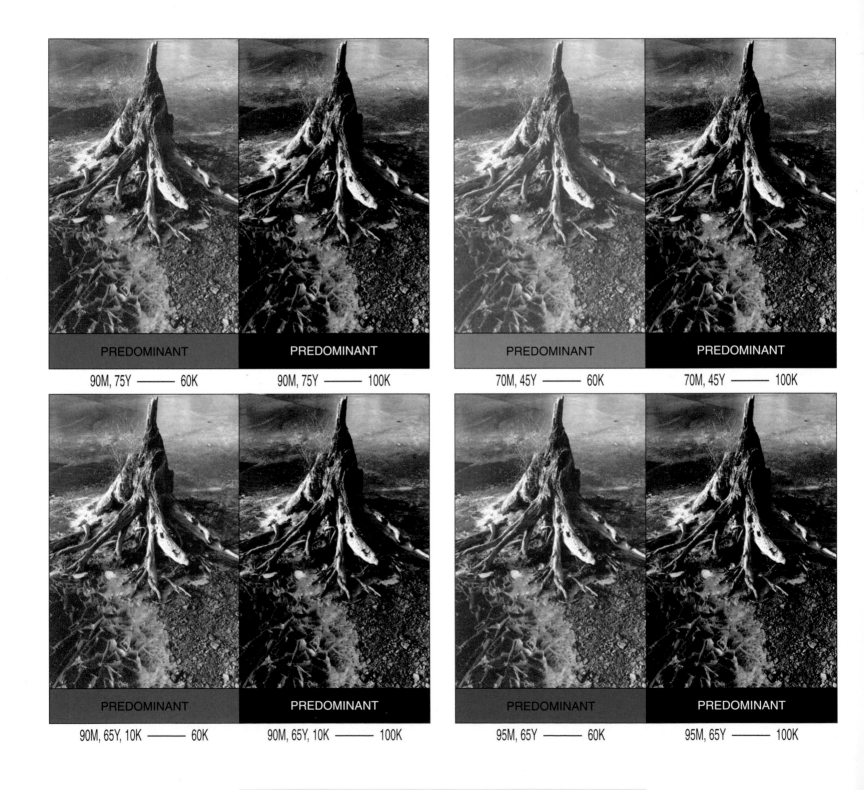

PREDOMINANT

PREDOMINANT

90M, 75Y ———— 60K

90M, 75Y ———— 100K

PREDOMINANT

PREDOMINANT

70M, 45Y ———— 60K

70M, 45Y ———— 100K

PREDOMINANT

PREDOMINANT

90M, 65Y, 10K ———— 60K

90M, 65Y, 10K ———— 100K

PREDOMINANT

PREDOMINANT

95M, 65Y ———— 60K

95M, 65Y ———— 100K

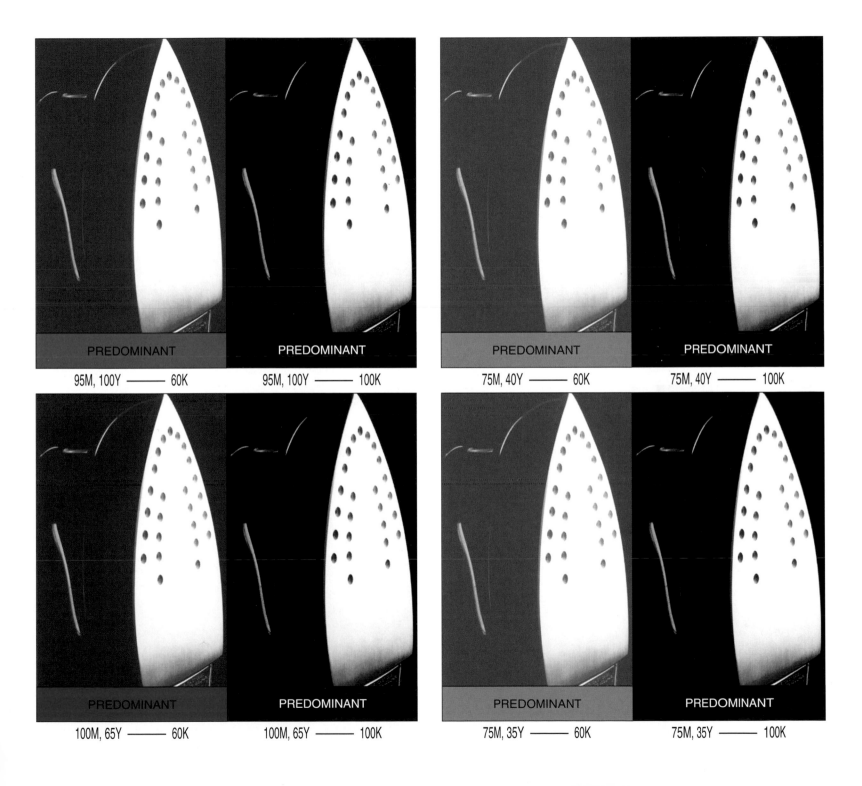

PREDOMINANT
95M, 100Y ——— 60K

PREDOMINANT
95M, 100Y ——— 100K

PREDOMINANT
75M, 40Y ——— 60K

PREDOMINANT
75M, 40Y ——— 100K

PREDOMINANT
100M, 65Y ——— 60K

PREDOMINANT
100M, 65Y ——— 100K

PREDOMINANT
75M, 35Y ——— 60K

PREDOMINANT
75M, 35Y ——— 100K

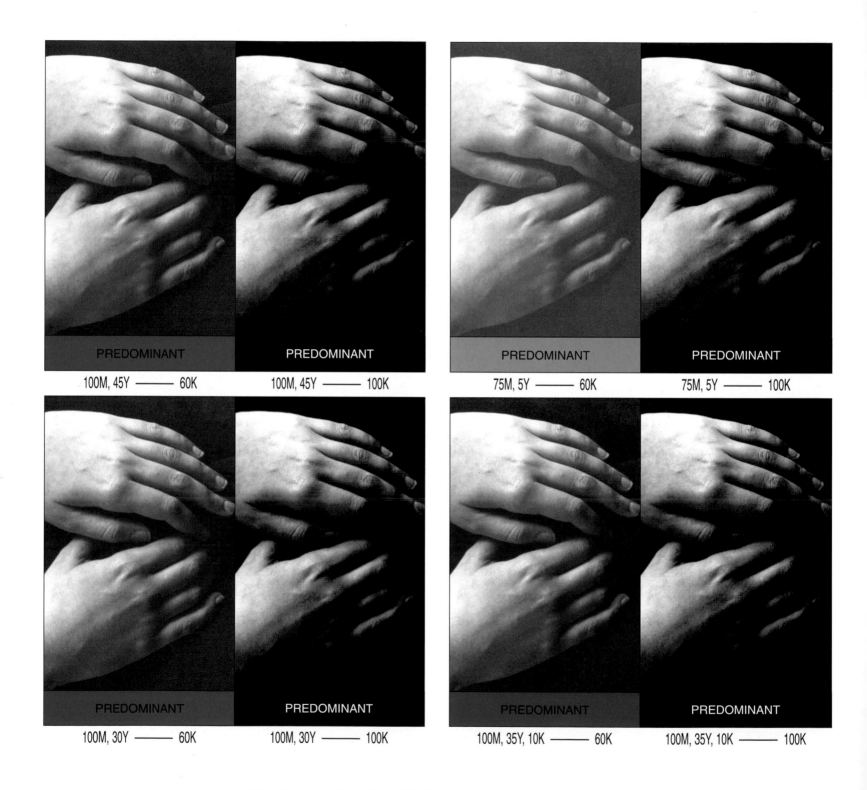

PREDOMINANT

PREDOMINANT

100M, 45Y ——— 60K

100M, 45Y ——— 100K

PREDOMINANT

PREDOMINANT

75M, 5Y ——— 60K

75M, 5Y ——— 100K

PREDOMINANT

PREDOMINANT

100M, 30Y ——— 60K

100M, 30Y ——— 100K

PREDOMINANT

PREDOMINANT

100M, 35Y, 10K ——— 60K

100M, 35Y, 10K ——— 100K

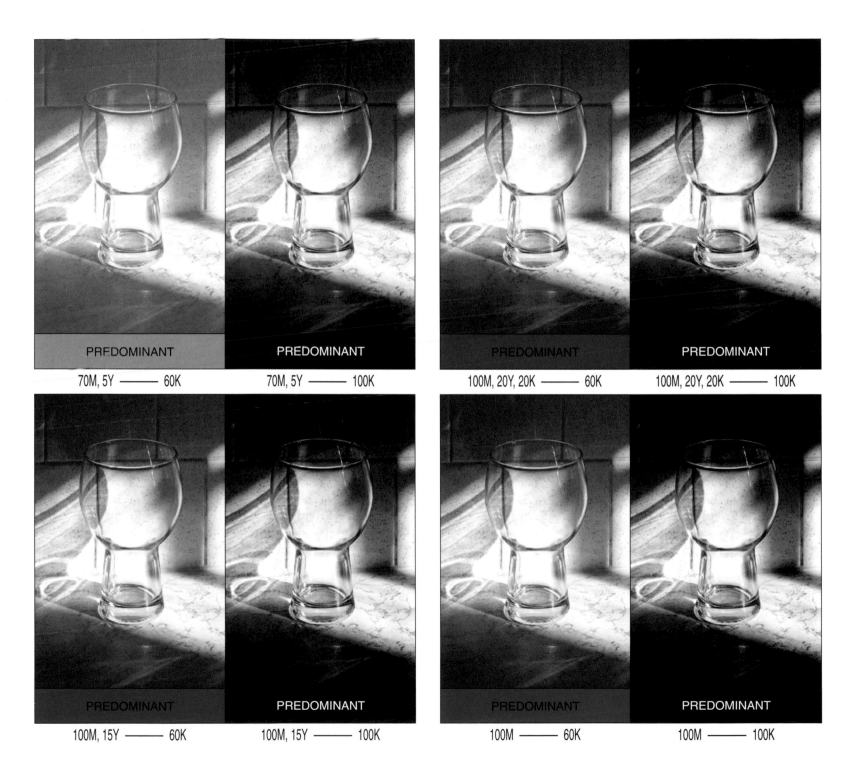

PREDOMINANT

70M, 5Y ——— 60K

PREDOMINANT

70M, 5Y ——— 100K

PREDOMINANT

100M, 20Y, 20K ——— 60K

PREDOMINANT

100M, 20Y, 20K ——— 100K

PREDOMINANT

100M, 15Y ——— 60K

PREDOMINANT

100M, 15Y ——— 100K

PREDOMINANT

100M ——— 60K

PREDOMINANT

100M ——— 100K

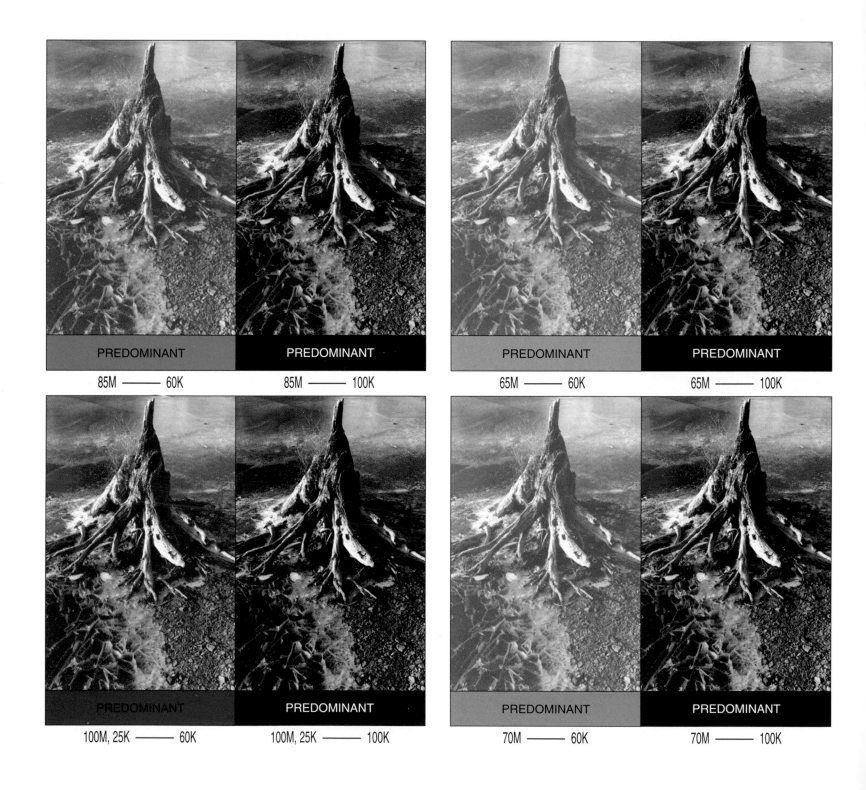

PREDOMINANT

PREDOMINANT

85M —— 60K

85M —— 100K

PREDOMINANT

PREDOMINANT

65M —— 60K

65M —— 100K

PREDOMINANT

PREDOMINANT

100M, 25K —— 60K

100M, 25K —— 100K

PREDOMINANT

PREDOMINANT

70M —— 60K

70M —— 100K

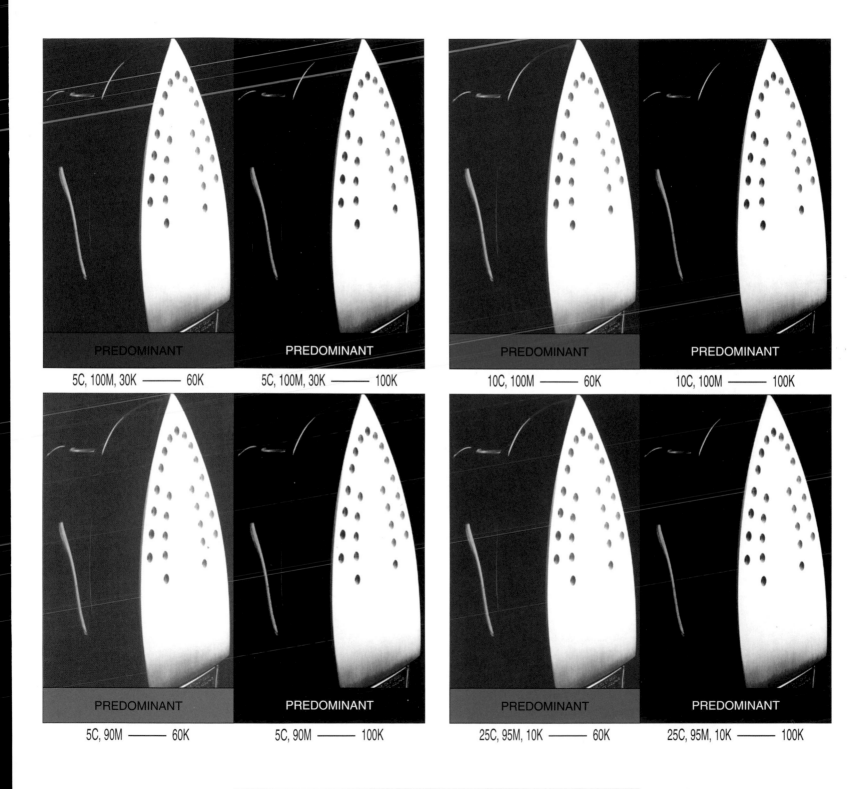

PREDOMINANT

5C, 100M, 30K ——— 60K

PREDOMINANT

5C, 100M, 30K ——— 100K

PREDOMINANT

10C, 100M ——— 60K

PREDOMINANT

10C, 100M ——— 100K

PREDOMINANT

5C, 90M ——— 60K

PREDOMINANT

5C, 90M ——— 100K

PREDOMINANT

25C, 95M, 10K ——— 60K

PREDOMINANT

25C, 95M, 10K ——— 100K

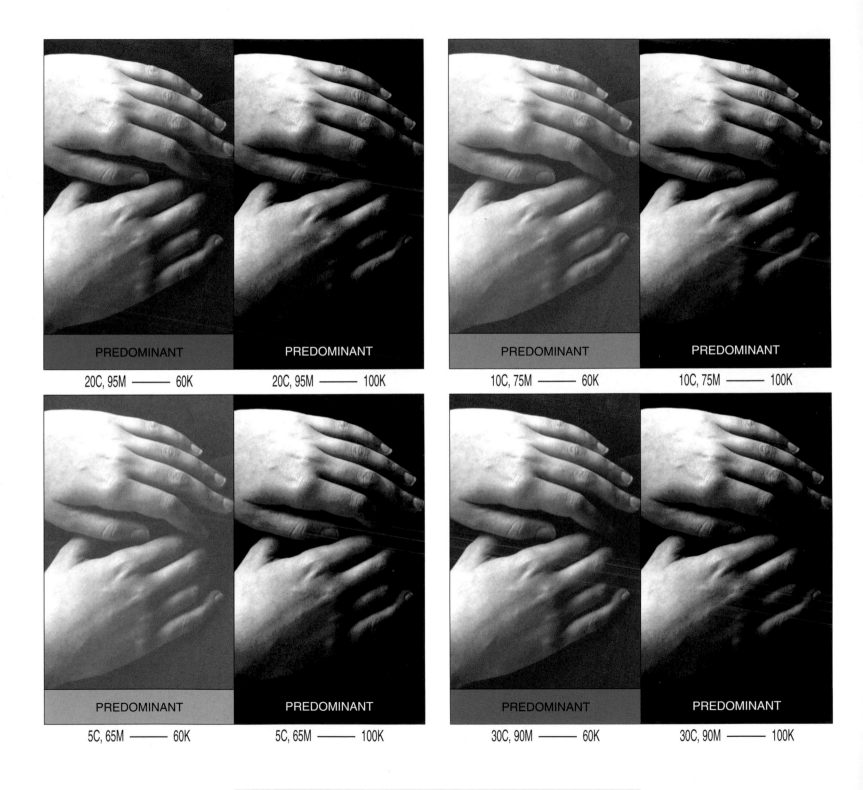

PREDOMINANT

PREDOMINANT

PREDOMINANT

PREDOMINANT

20C, 95M ——— 60K

20C, 95M ——— 100K

10C, 75M ——— 60K

10C, 75M ——— 100K

PREDOMINANT

PREDOMINANT

PREDOMINANT

PREDOMINANT

5C, 65M ——— 60K

5C, 65M ——— 100K

30C, 90M ——— 60K

30C, 90M ——— 100K

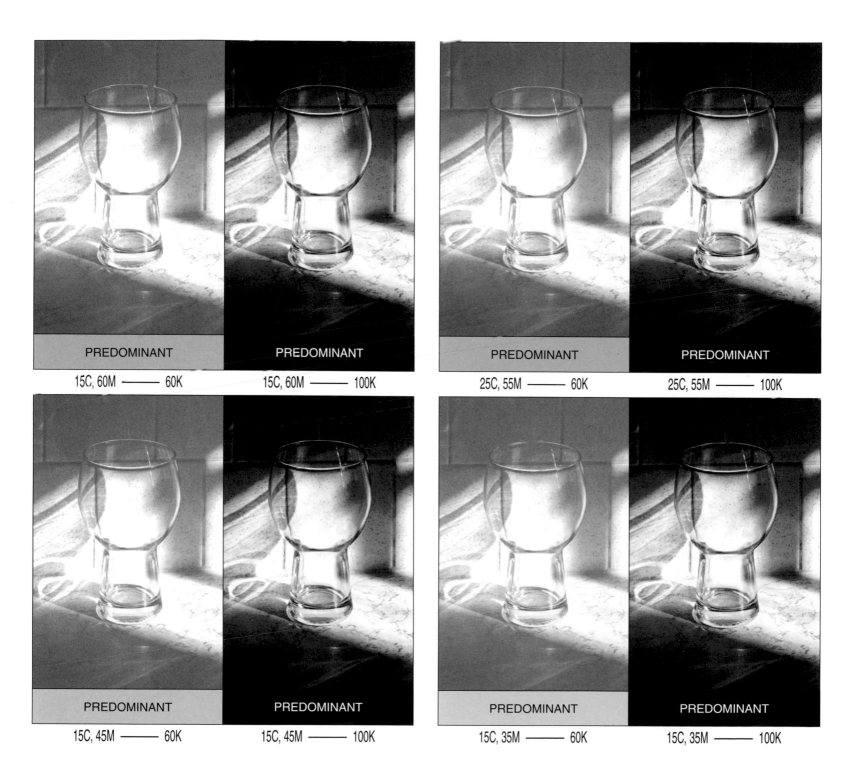

PREDOMINANT

PREDOMINANT

15C, 60M ——— 60K

15C, 60M ——— 100K

PREDOMINANT

PREDOMINANT

25C, 55M ——— 60K

25C, 55M ——— 100K

PREDOMINANT

PREDOMINANT

15C, 45M ——— 60K

15C, 45M ——— 100K

PREDOMINANT

PREDOMINANT

15C, 35M ——— 60K

15C, 35M ——— 100K

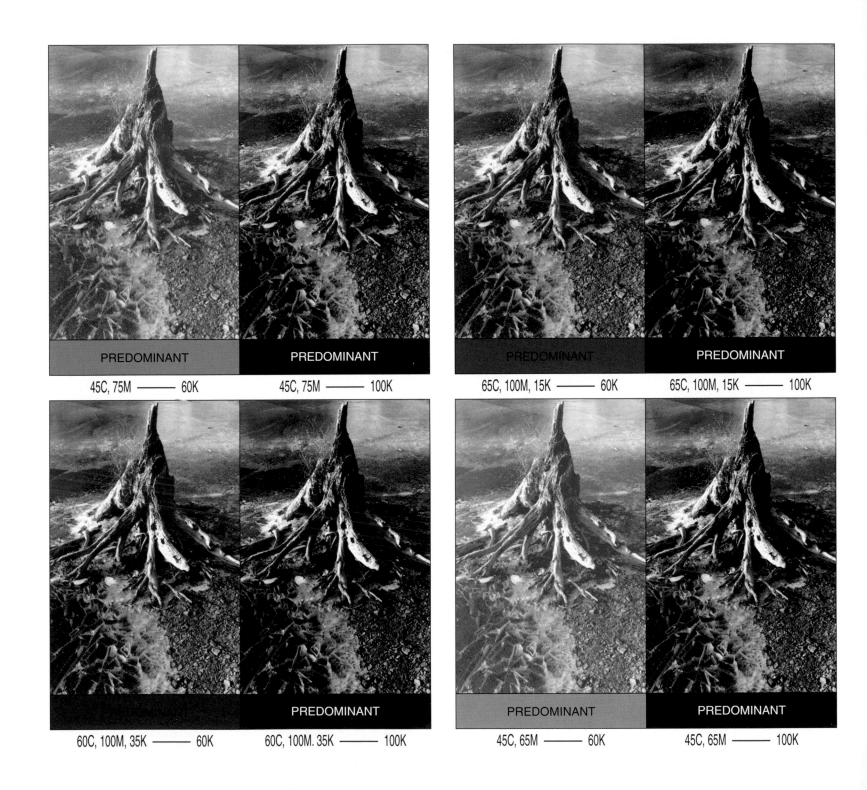

PREDOMINANT

PREDOMINANT

PREDOMINANT

PREDOMINANT

45C, 75M ——— 60K

45C, 75M ——— 100K

65C, 100M, 15K ——— 60K

65C, 100M, 15K ——— 100K

PREDOMINANT

PREDOMINANT

PREDOMINANT

60C, 100M, 35K ——— 60K

60C, 100M. 35K ——— 100K

45C, 65M ——— 60K

45C, 65M ——— 100K

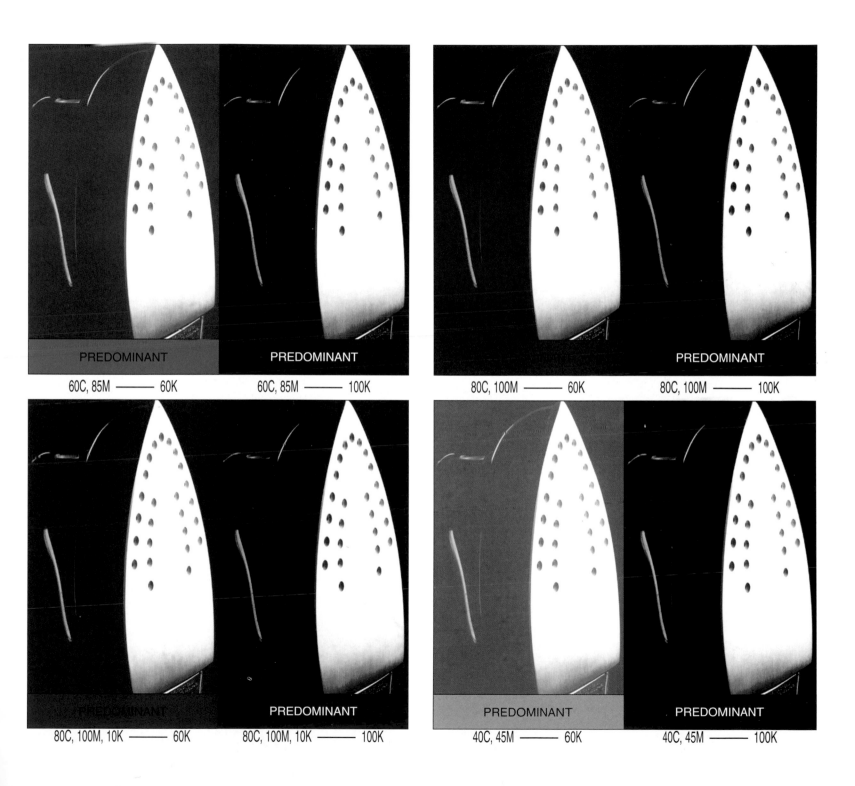

PREDOMINANT

PREDOMINANT

60C, 85M —— 60K

60C, 85M —— 100K

PREDOMINANT

PREDOMINANT

80C, 100M —— 60K

80C, 100M —— 100K

PREDOMINANT

PREDOMINANT

80C, 100M, 10K —— 60K

80C, 100M, 10K —— 100K

PREDOMINANT

PREDOMINANT

40C, 45M —— 60K

40C, 45M —— 100K

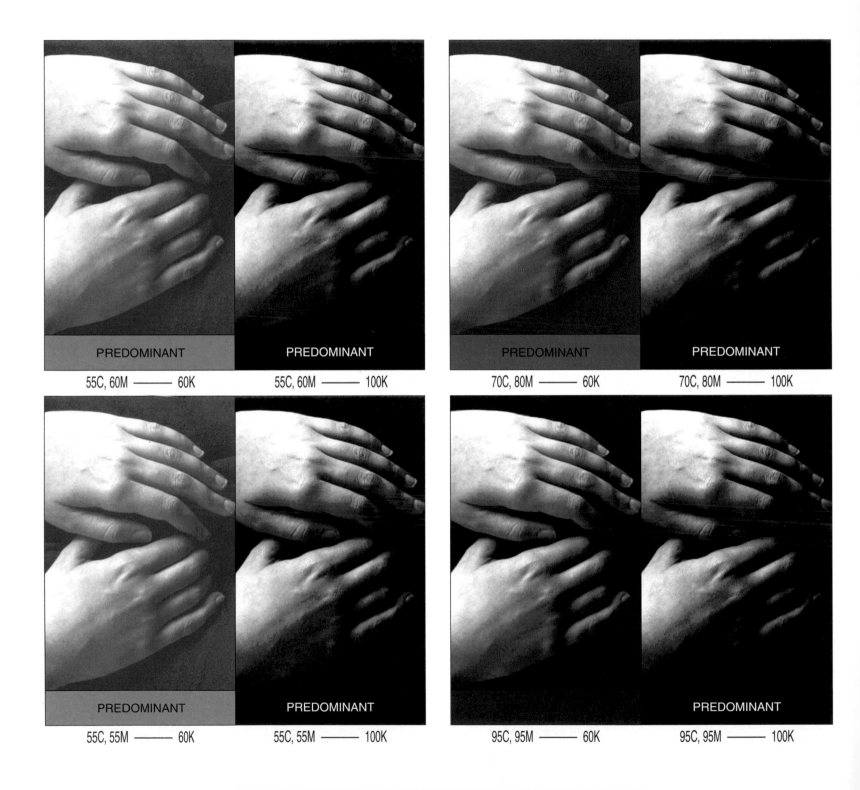

PREDOMINANT

PREDOMINANT

55C, 60M —— 60K

55C, 60M —— 100K

PREDOMINANT

PREDOMINANT

70C, 80M —— 60K

70C, 80M —— 100K

PREDOMINANT

PREDOMINANT

55C, 55M —— 60K

55C, 55M —— 100K

PREDOMINANT

PREDOMINANT

95C, 95M —— 60K

95C, 95M —— 100K

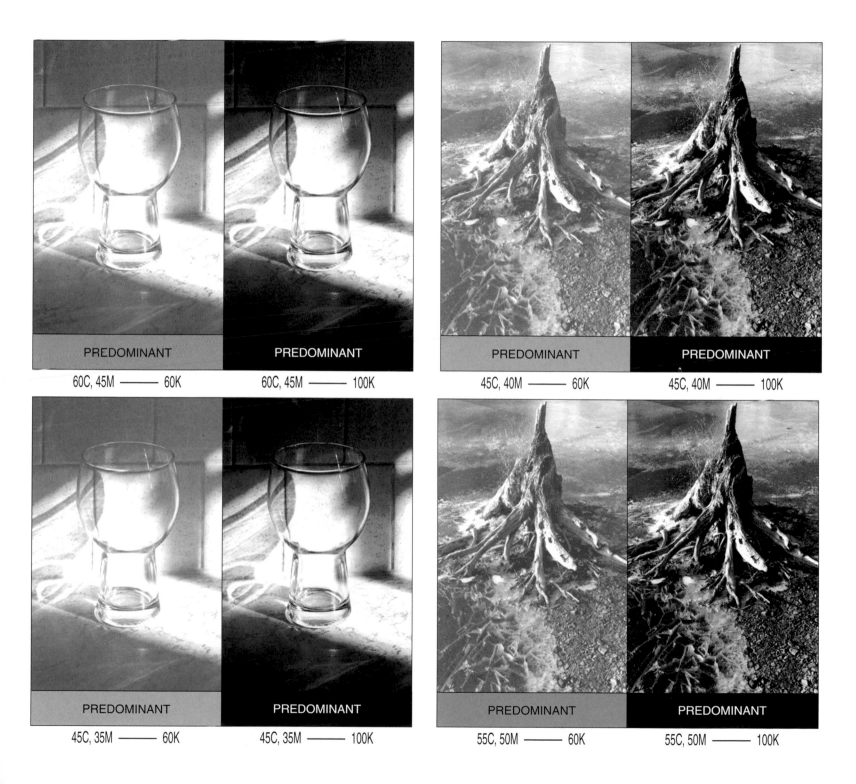

PREDOMINANT

60C, 45M ——— 60K

PREDOMINANT

60C, 45M ——— 100K

PREDOMINANT

45C, 40M ——— 60K

PREDOMINANT

45C, 40M ——— 100K

PREDOMINANT

45C, 35M ——— 60K

PREDOMINANT

45C, 35M ——— 100K

PREDOMINANT

55C, 50M ——— 60K

PREDOMINANT

55C, 50M ——— 100K

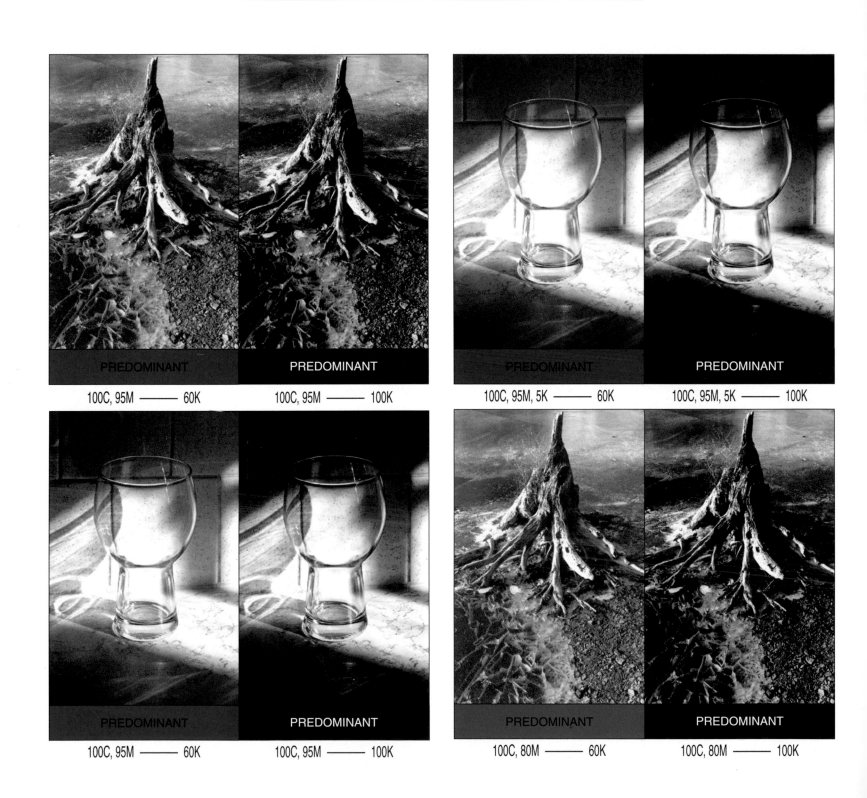

PREDOMINANT

100C, 95M ——— 60K

PREDOMINANT

100C, 95M ——— 100K

PREDOMINANT

100C, 95M, 5K ——— 60K

PREDOMINANT

100C, 95M, 5K ——— 100K

PREDOMINANT

100C, 95M ——— 60K

PREDOMINANT

100C, 95M ——— 100K

PREDOMINANT

100C, 80M ——— 60K

PREDOMINANT

100C, 80M ——— 100K

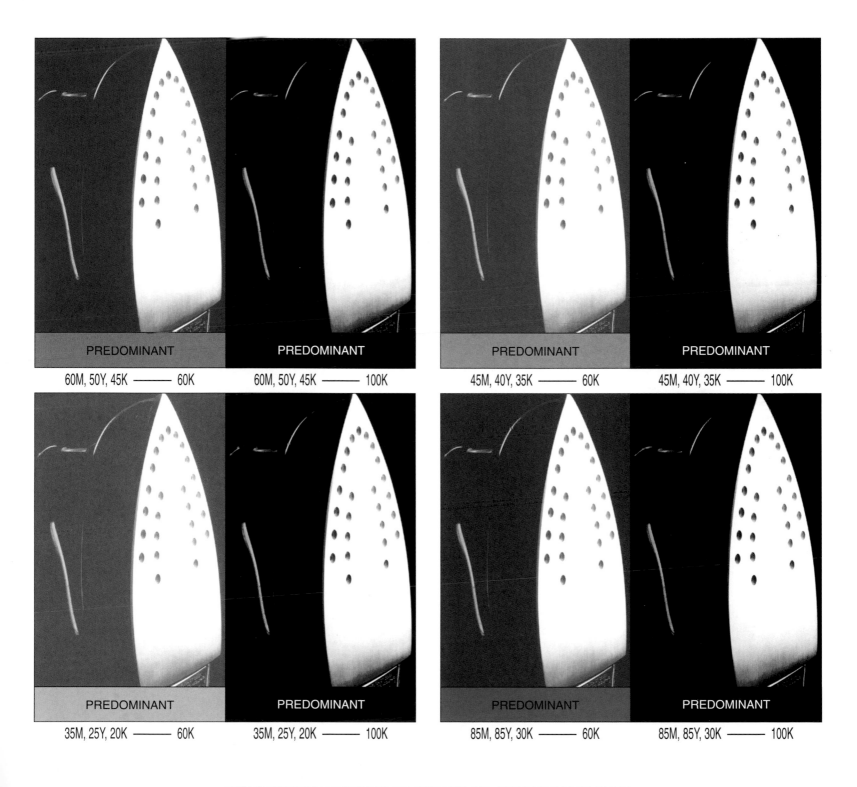

PREDOMINANT

60M, 50Y, 45K ——— 60K

PREDOMINANT

60M, 50Y, 45K ——— 100K

PREDOMINANT

45M, 40Y, 35K ——— 60K

PREDOMINANT

45M, 40Y, 35K ——— 100K

PREDOMINANT

35M, 25Y, 20K ——— 60K

PREDOMINANT

35M, 25Y, 20K ——— 100K

PREDOMINANT

85M, 85Y, 30K ——— 60K

PREDOMINANT

85M, 85Y, 30K ——— 100K

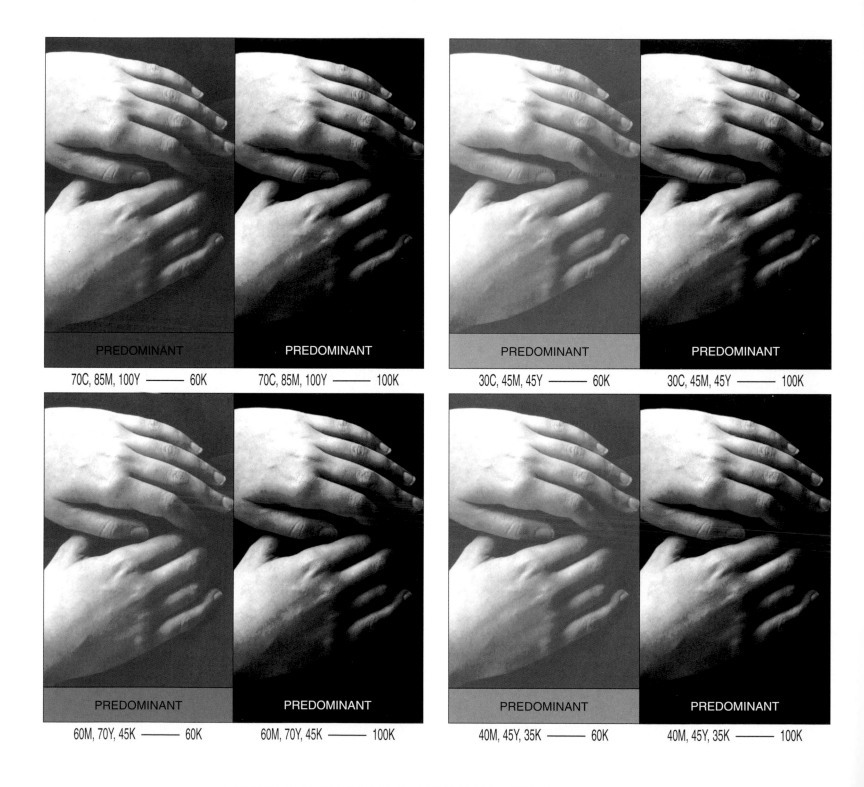

PREDOMINANT

70C, 85M, 100Y ——— 60K

PREDOMINANT

70C, 85M, 100Y ——— 100K

PREDOMINANT

30C, 45M, 45Y ——— 60K

PREDOMINANT

30C, 45M, 45Y ——— 100K

PREDOMINANT

60M, 70Y, 45K ——— 60K

PREDOMINANT

60M, 70Y, 45K ——— 100K

PREDOMINANT

40M, 45Y, 35K ——— 60K

PREDOMINANT

40M, 45Y, 35K ——— 100K

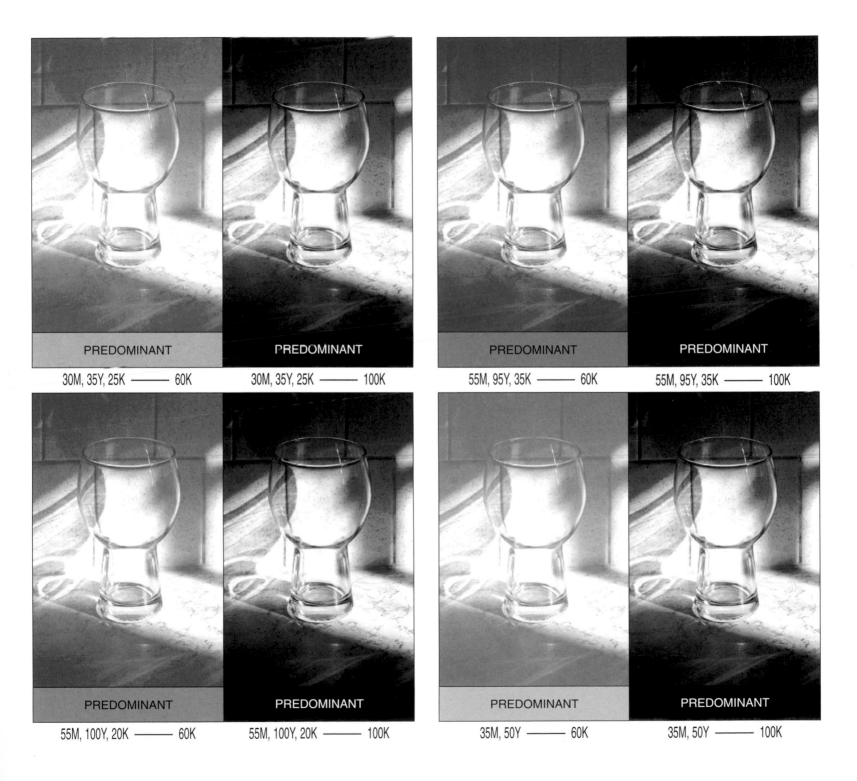

PREDOMINANT

PREDOMINANT

30M, 35Y, 25K ——— 60K

30M, 35Y, 25K ——— 100K

PREDOMINANT

PREDOMINANT

55M, 95Y, 35K ——— 60K

55M, 95Y, 35K ——— 100K

PREDOMINANT

PREDOMINANT

55M, 100Y, 20K ——— 60K

55M, 100Y, 20K ——— 100K

PREDOMINANT

PREDOMINANT

35M, 50Y ——— 60K

35M, 50Y ——— 100K

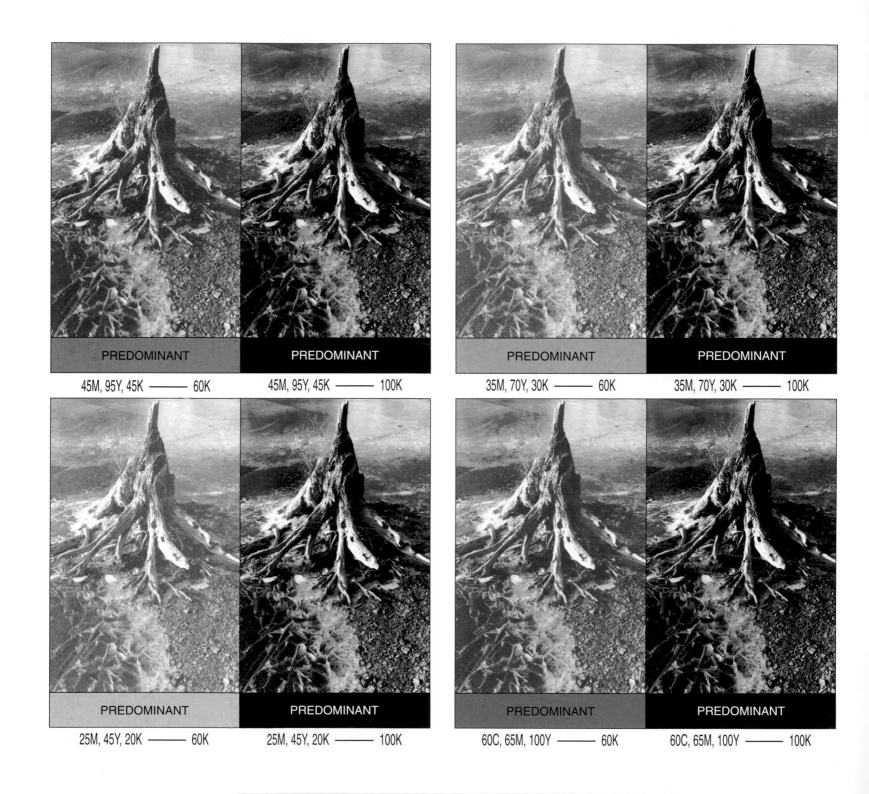

PREDOMINANT PREDOMINANT

45M, 95Y, 45K ——— 60K 45M, 95Y, 45K ——— 100K

PREDOMINANT PREDOMINANT

35M, 70Y, 30K ——— 60K 35M, 70Y, 30K ——— 100K

PREDOMINANT PREDOMINANT

25M, 45Y, 20K ——— 60K 25M, 45Y, 20K ——— 100K

PREDOMINANT PREDOMINANT

60C, 65M, 100Y ——— 60K 60C, 65M, 100Y ——— 100K

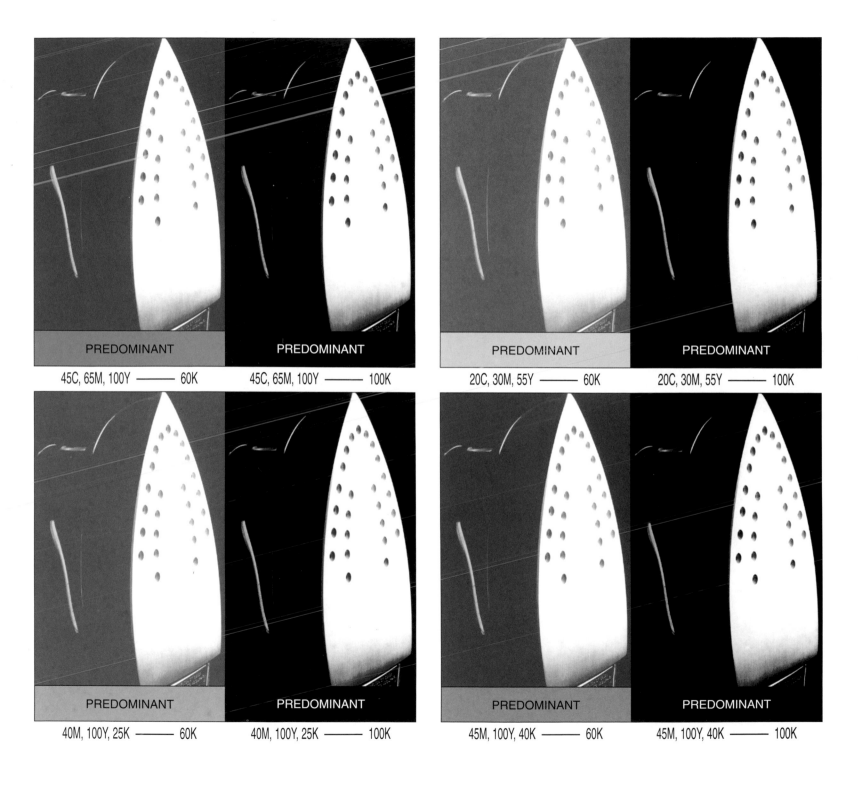

PREDOMINANT

PREDOMINANT

45C, 65M, 100Y ——— 60K

45C, 65M, 100Y ——— 100K

PREDOMINANT

PREDOMINANT

20C, 30M, 55Y ——— 60K

20C, 30M, 55Y ——— 100K

PREDOMINANT

PREDOMINANT

40M, 100Y, 25K ——— 60K

40M, 100Y, 25K ——— 100K

PREDOMINANT

PREDOMINANT

45M, 100Y, 40K ——— 60K

45M, 100Y, 40K ——— 100K

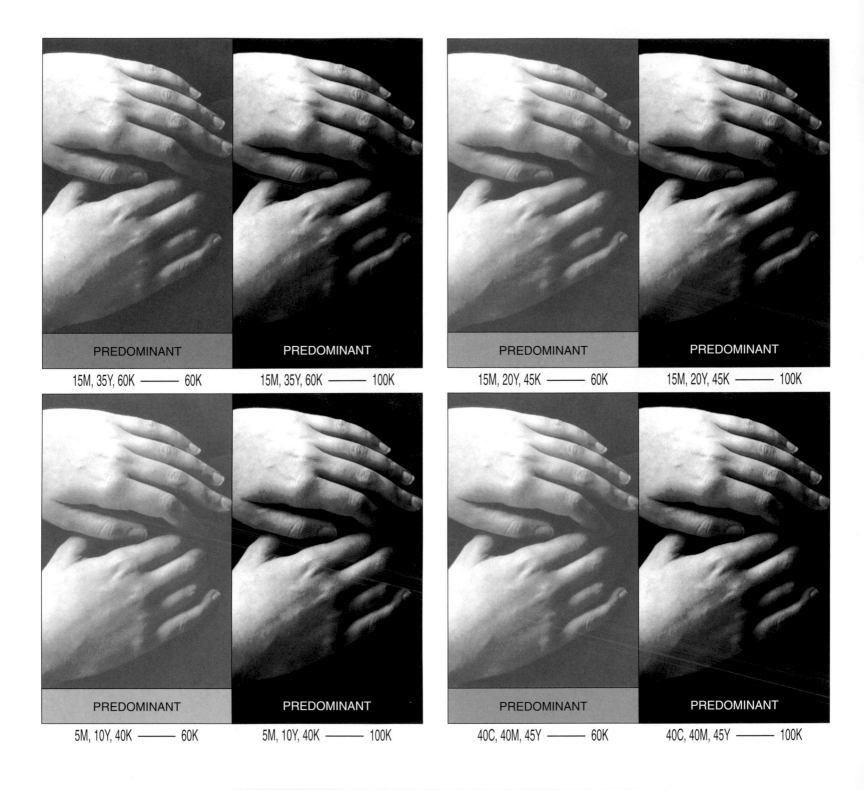

PREDOMINANT

PREDOMINANT

PREDOMINANT

PREDOMINANT

15M, 35Y, 60K ——— 60K 15M, 35Y, 60K ——— 100K 15M, 20Y, 45K ——— 60K 15M, 20Y, 45K ——— 100K

PREDOMINANT

PREDOMINANT

PREDOMINANT

PREDOMINANT

5M, 10Y, 40K ——— 60K 5M, 10Y, 40K ——— 100K 40C, 40M, 45Y ——— 60K 40C, 40M, 45Y ——— 100K

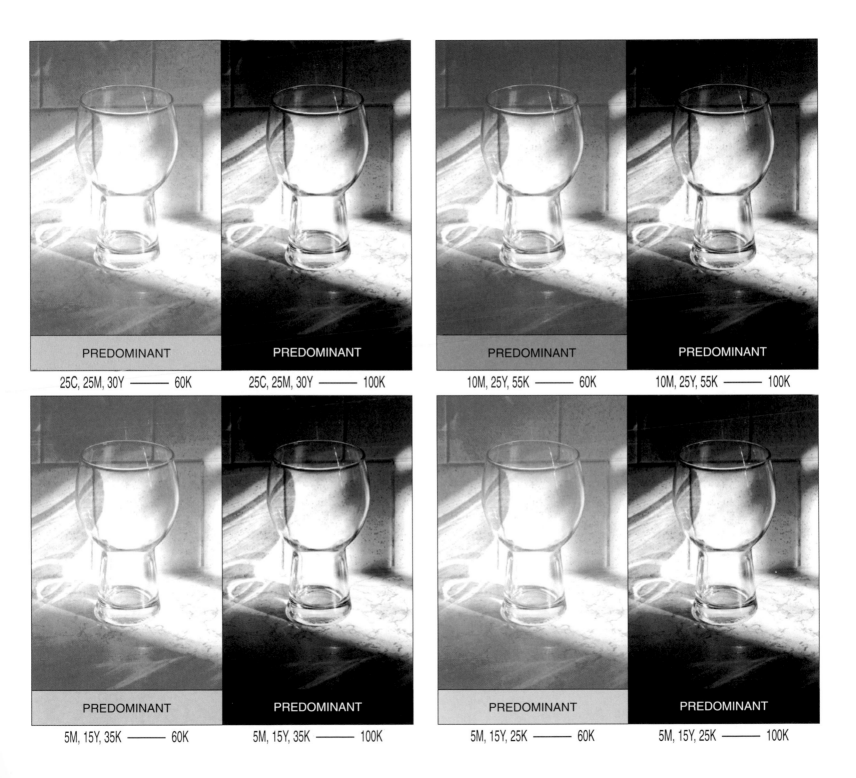

PREDOMINANT

PREDOMINANT

25C, 25M, 30Y ——— 60K

25C, 25M, 30Y ——— 100K

PREDOMINANT

PREDOMINANT

10M, 25Y, 55K ——— 60K

10M, 25Y, 55K ——— 100K

PREDOMINANT

PREDOMINANT

5M, 15Y, 35K ——— 60K

5M, 15Y, 35K ——— 100K

PREDOMINANT

PREDOMINANT

5M, 15Y, 25K ——— 60K

5M, 15Y, 25K ——— 100K

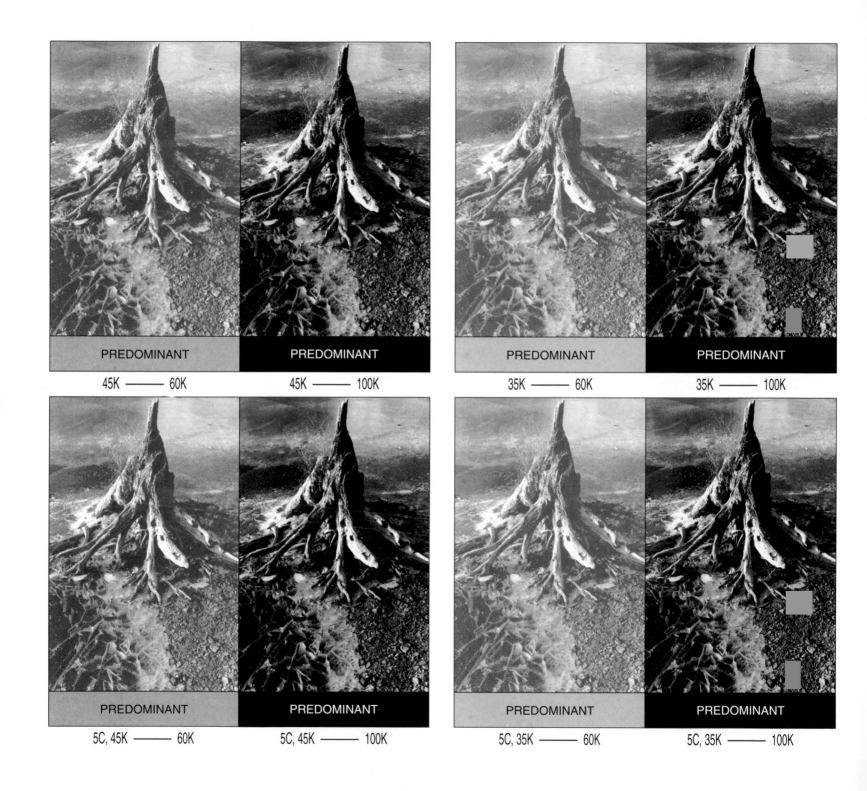

PREDOMINANT | PREDOMINANT | PREDOMINANT | PREDOMINANT

45K ——— 60K | 45K ——— 100K | 35K ——— 60K | 35K ——— 100K

PREDOMINANT | PREDOMINANT | PREDOMINANT | PREDOMINANT

5C, 45K ——— 60K | 5C, 45K ——— 100K | 5C, 35K ——— 60K | 5C, 35K ——— 100K

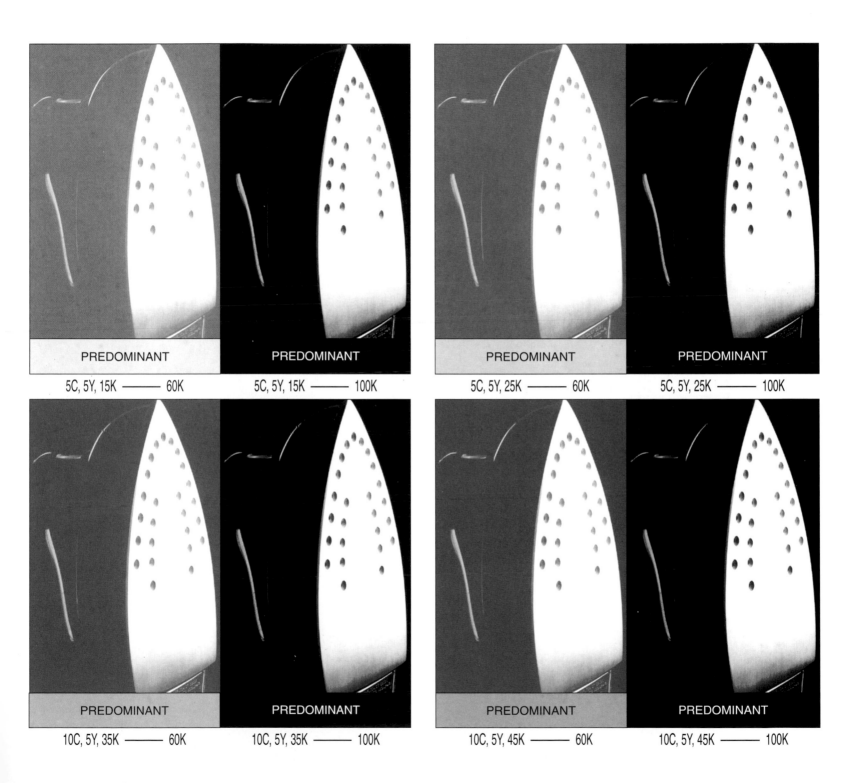

PREDOMINANT PREDOMINANT PREDOMINANT PREDOMINANT

5C, 5Y, 15K —— 60K 5C, 5Y, 15K —— 100K 5C, 5Y, 25K —— 60K 5C, 5Y, 25K —— 100K

PREDOMINANT PREDOMINANT PREDOMINANT PREDOMINANT

10C, 5Y, 35K —— 60K 10C, 5Y, 35K —— 100K 10C, 5Y, 45K —— 60K 10C, 5Y, 45K —— 100K

CREATIVE DUOTONE EFFECTS

A Visual Guide to Choosing Successful Color Combinations

SELECTOR

Two Non-Black Colors

This section covers the use of two non-black colors. These combinations add a richness to the photograph that cannot be duplicated in either single-color halftones or black-plus-second-color duotones. You will be amazed by the strong and dramatic results achieved by these duotones. They create a density of color and value that cannot be matched. Thus, through their clarity and strength, the photographs themselves become one of the major elements of communication.

Again, remember, when designing in two colors match the color swatch shown below each combination to the color matching system you use. This will provide results that closely mimic the picture shown. If you are printing in four process colors and/or using the CMYK desktop system, use the percentages displayed below each picture to achieve the same results.

This section will undoubtedly have some of the biggest surprises in the book, while the section following offers some possibilities toward solving a specific problem.

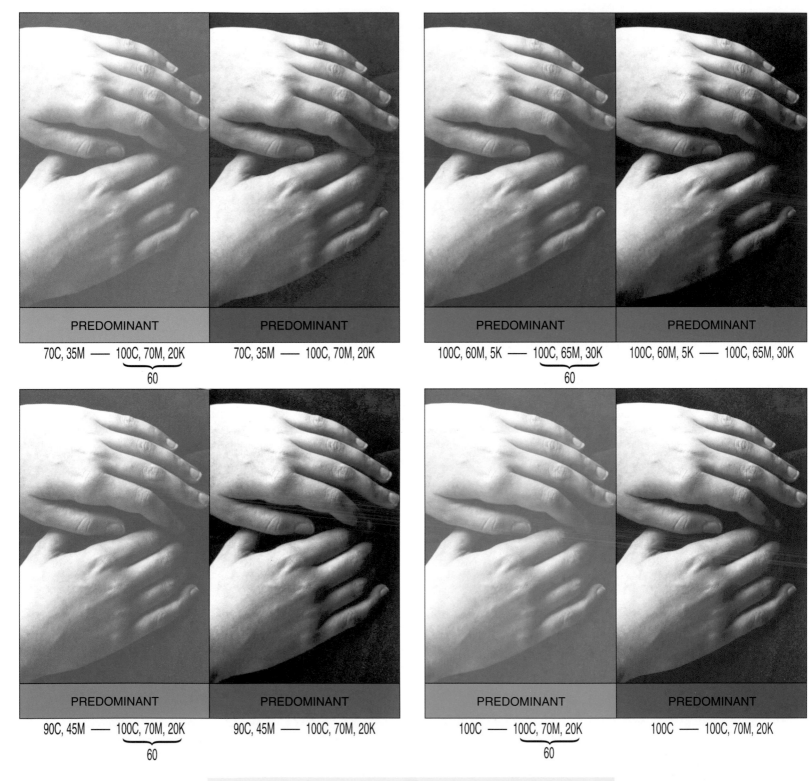

PREDOMINANT

PREDOMINANT

70C, 35M —— 100C, 70M, 20K
60

70C, 35M —— 100C, 70M, 20K

PREDOMINANT

PREDOMINANT

100C, 60M, 5K —— 100C, 65M, 30K
60

100C, 60M, 5K —— 100C, 65M, 30K

PREDOMINANT

PREDOMINANT

90C, 45M —— 100C, 70M, 20K
60

90C, 45M —— 100C, 70M, 20K

PREDOMINANT

PREDOMINANT

100C —— 100C, 70M, 20K
60

100C —— 100C, 70M, 20K

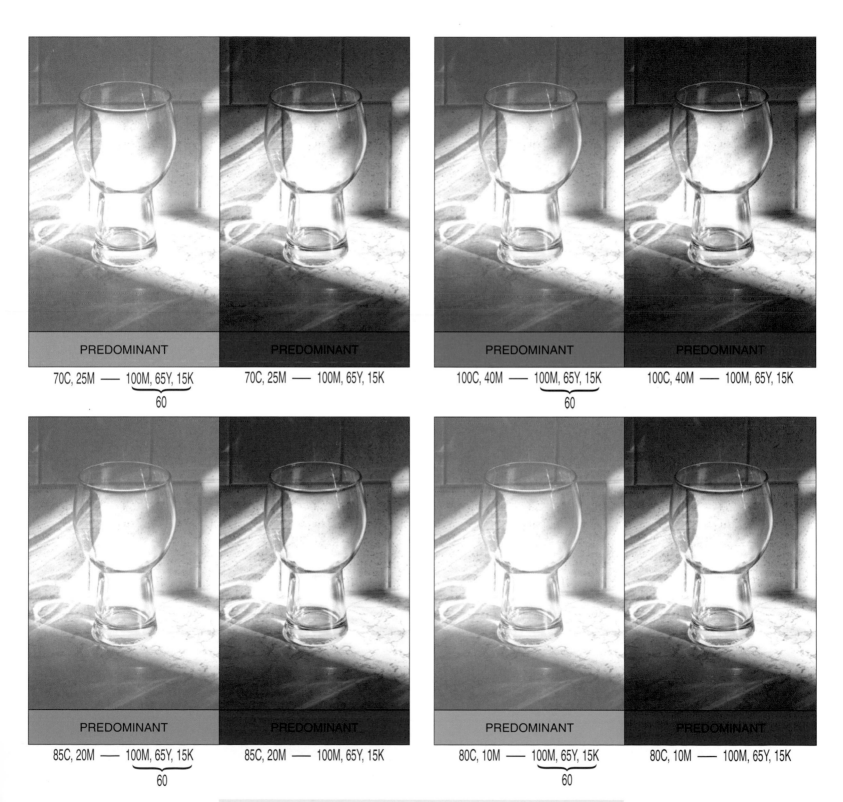

PREDOMINANT | PREDOMINANT

70C, 25M —— 100M, 65Y, 15K
60

70C, 25M —— 100M, 65Y, 15K

PREDOMINANT | PREDOMINANT

100C, 40M —— 100M, 65Y, 15K
60

100C, 40M —— 100M, 65Y, 15K

PREDOMINANT | PREDOMINANT

85C, 20M —— 100M, 65Y, 15K
60

85C, 20M —— 100M, 65Y, 15K

PREDOMINANT | PREDOMINANT

80C, 10M —— 100M, 65Y, 15K
60

80C, 10M —— 100M, 65Y, 15K

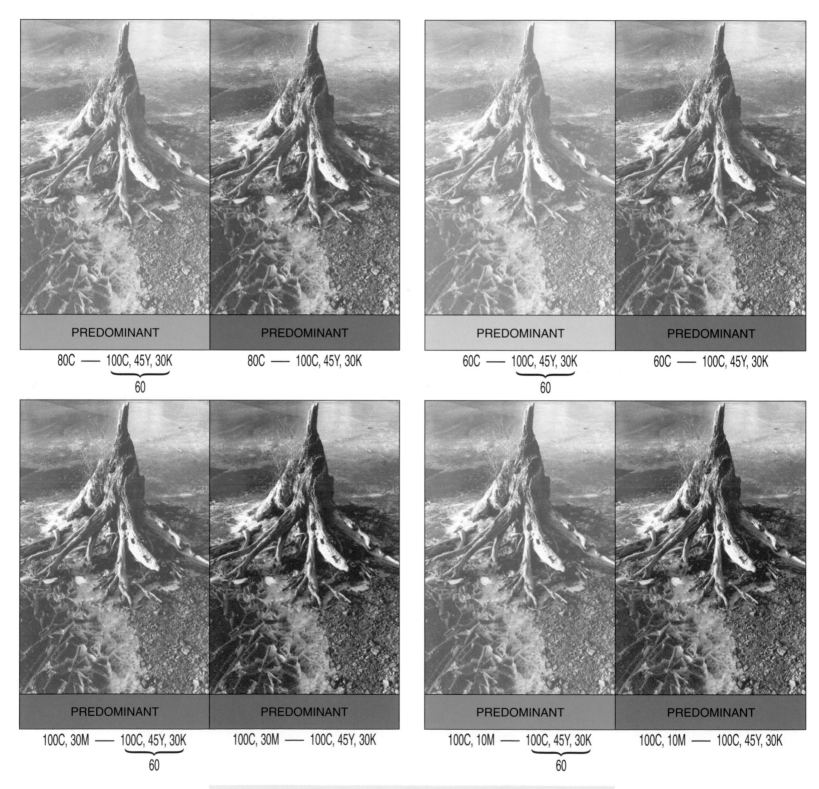

PREDOMINANT

80C —— 100C, 45Y, 30K
60

PREDOMINANT

80C —— 100C, 45Y, 30K

PREDOMINANT

60C —— 100C, 45Y, 30K
60

PREDOMINANT

60C —— 100C, 45Y, 30K

PREDOMINANT

100C, 30M —— 100C, 45Y, 30K
60

PREDOMINANT

100C, 30M —— 100C, 45Y, 30K

PREDOMINANT

100C, 10M —— 100C, 45Y, 30K
60

PREDOMINANT

100C, 10M —— 100C, 45Y, 30K

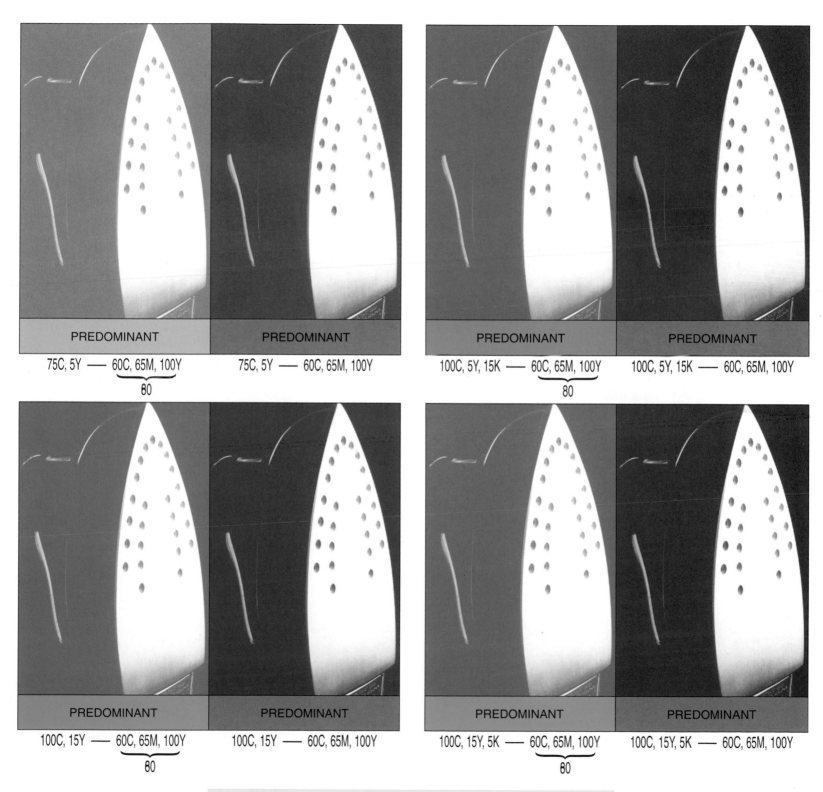

PREDOMINANT

PREDOMINANT

75C, 5Y —— 60C, 65M, 100Y

75C, 5Y —— 60C, 65M, 100Y

80

PREDOMINANT

PREDOMINANT

100C, 5Y, 15K —— 60C, 65M, 100Y

100C, 5Y, 15K —— 60C, 65M, 100Y

80

PREDOMINANT

PREDOMINANT

100C, 15Y —— 60C, 65M, 100Y

100C, 15Y —— 60C, 65M, 100Y

80

PREDOMINANT

PREDOMINANT

100C, 15Y, 5K —— 60C, 65M, 100Y

100C, 15Y, 5K —— 60C, 65M, 100Y

80

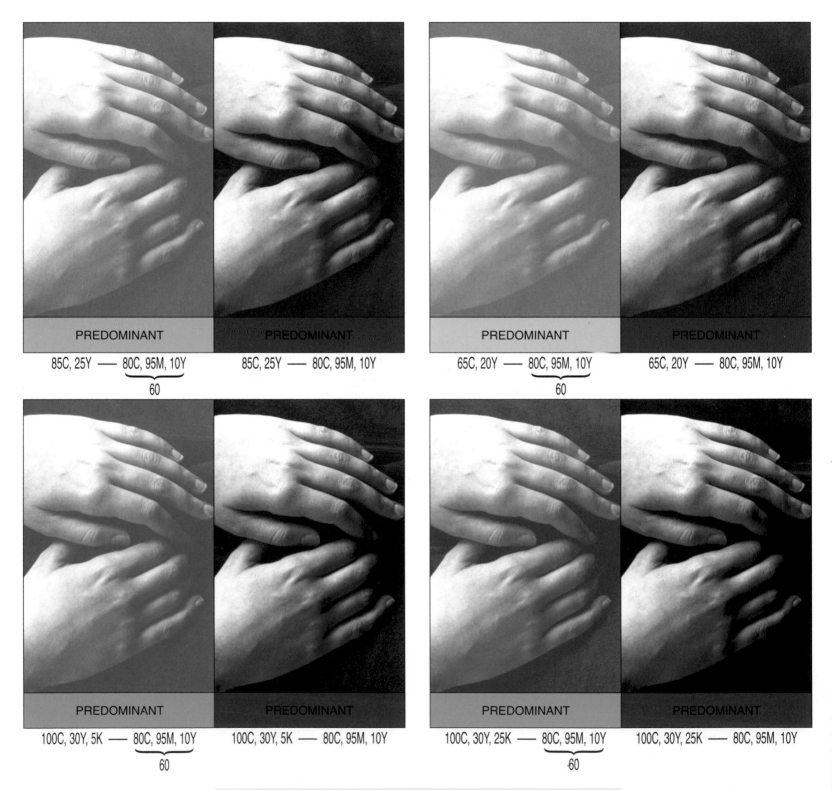

PREDOMINANT

85C, 25Y —— 80C, 95M, 10Y
60

PREDOMINANT

85C, 25Y —— 80C, 95M, 10Y

PREDOMINANT

65C, 20Y —— 80C, 95M, 10Y
60

PREDOMINANT

65C, 20Y —— 80C, 95M, 10Y

PREDOMINANT

100C, 30Y, 5K —— 80C, 95M, 10Y
60

PREDOMINANT

100C, 30Y, 5K —— 80C, 95M, 10Y

PREDOMINANT

100C, 30Y, 25K —— 80C, 95M, 10Y
60

PREDOMINANT

100C, 30Y, 25K —— 80C, 95M, 10Y

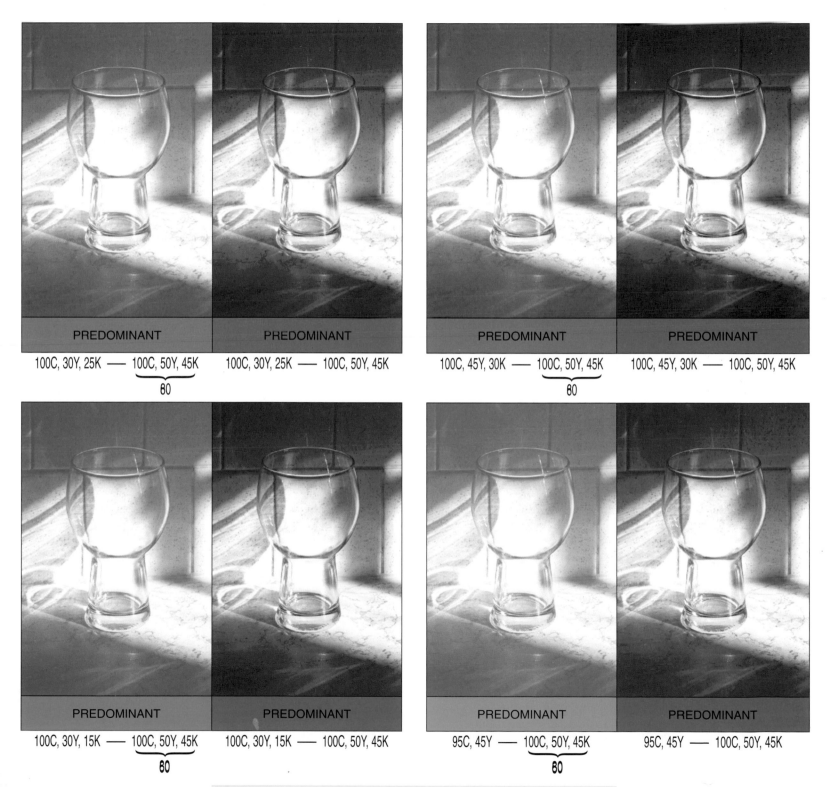

PREDOMINANT

PREDOMINANT

100C, 30Y, 25K —— 100C, 50Y, 45K 100C, 30Y, 25K —— 100C, 50Y, 45K

BO

PREDOMINANT

PREDOMINANT

100C, 45Y, 30K —— 100C, 50Y, 45K 100C, 45Y, 30K —— 100C, 50Y, 45K

BO

PREDOMINANT

PREDOMINANT

100C, 30Y, 15K —— 100C, 50Y, 45K 100C, 30Y, 15K —— 100C, 50Y, 45K

BO

PREDOMINANT

PREDOMINANT

95C, 45Y —— 100C, 50Y, 45K 95C, 45Y —— 100C, 50Y, 45K

BO

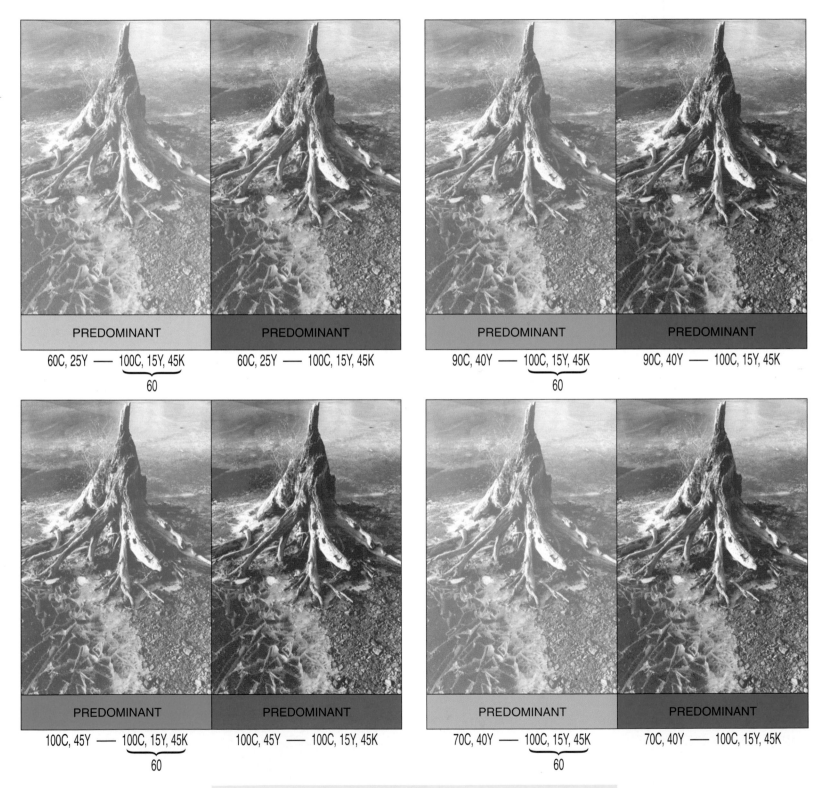

PREDOMINANT

60C, 25Y —— 100C, 15Y, 45K
60

PREDOMINANT

60C, 25Y —— 100C, 15Y, 45K

PREDOMINANT

90C, 40Y —— 100C, 15Y, 45K
60

PREDOMINANT

90C, 40Y —— 100C, 15Y, 45K

PREDOMINANT

100C, 45Y —— 100C, 15Y, 45K
60

PREDOMINANT

100C, 45Y —— 100C, 15Y, 45K

PREDOMINANT

70C, 40Y —— 100C, 15Y, 45K
60

PREDOMINANT

70C, 40Y —— 100C, 15Y, 45K

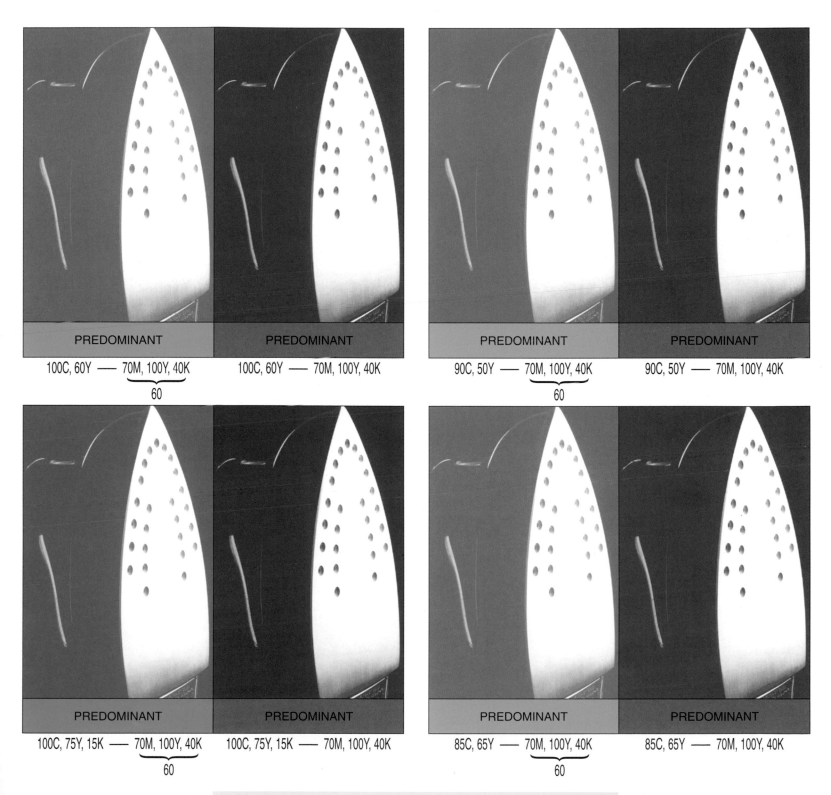

PREDOMINANT

100C, 60Y —— 70M, 100Y, 40K
60

PREDOMINANT

100C, 60Y —— 70M, 100Y, 40K

PREDOMINANT

90C, 50Y —— 70M, 100Y, 40K
60

PREDOMINANT

90C, 50Y —— 70M, 100Y, 40K

PREDOMINANT

100C, 75Y, 15K —— 70M, 100Y, 40K
60

PREDOMINANT

100C, 75Y, 15K —— 70M, 100Y, 40K

PREDOMINANT

85C, 65Y —— 70M, 100Y, 40K
60

PREDOMINANT

85C, 65Y —— 70M, 100Y, 40K

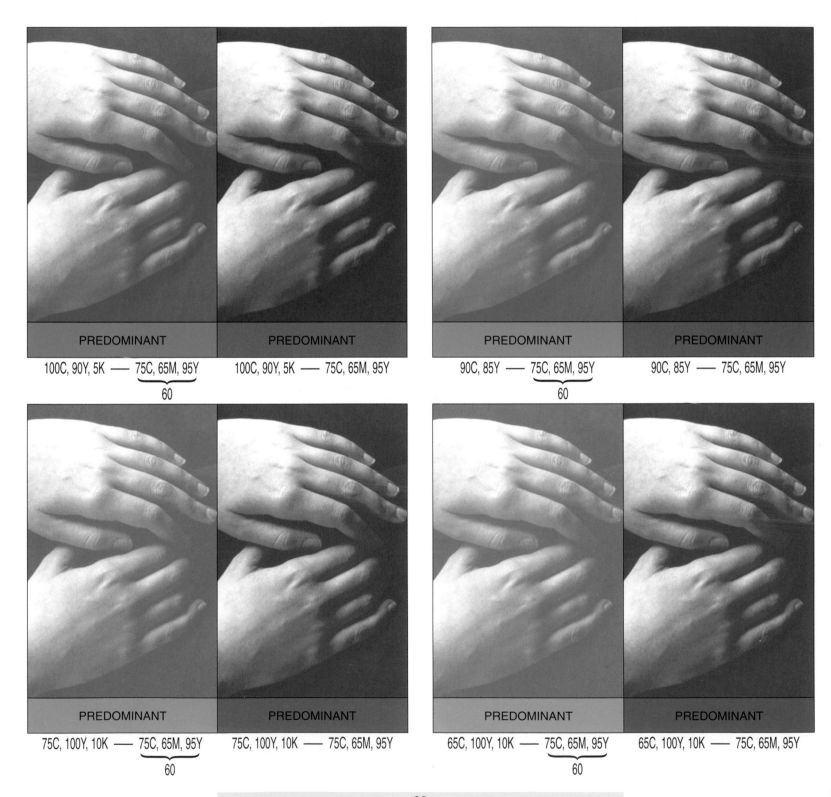

PREDOMINANT

100C, 90Y, 5K —— 75C, 65M, 95Y

60

PREDOMINANT

100C, 90Y, 5K —— 75C, 65M, 95Y

PREDOMINANT

90C, 85Y —— 75C, 65M, 95Y

60

PREDOMINANT

90C, 85Y —— 75C, 65M, 95Y

PREDOMINANT

75C, 100Y, 10K —— 75C, 65M, 95Y

60

PREDOMINANT

75C, 100Y, 10K —— 75C, 65M, 95Y

PREDOMINANT

65C, 100Y, 10K —— 75C, 65M, 95Y

60

PREDOMINANT

65C, 100Y, 10K —— 75C, 65M, 95Y

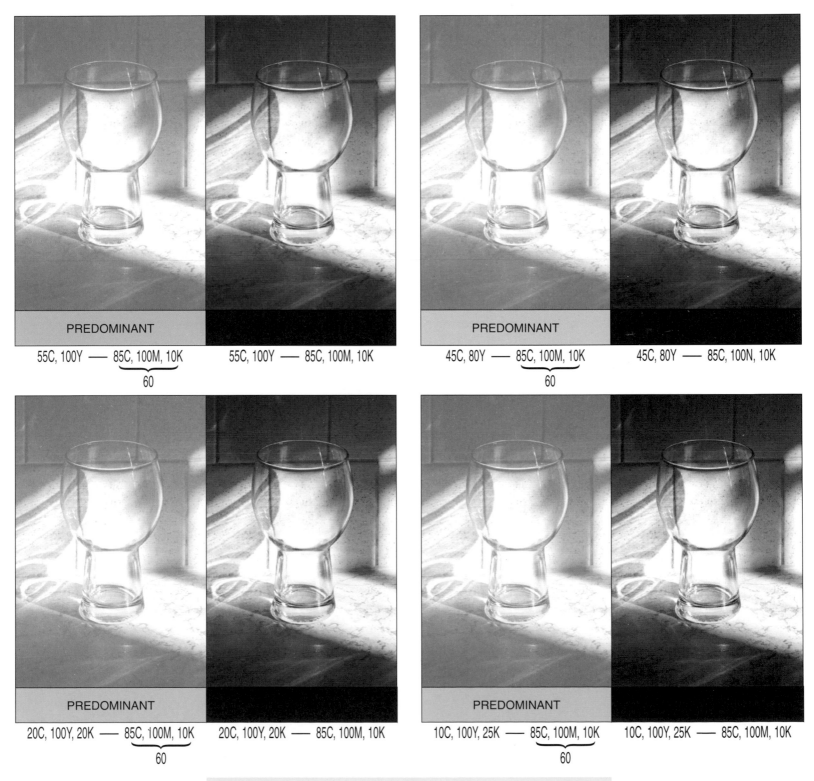

PREDOMINANT

55C, 100Y —— 85C, 100M, 10K
60

55C, 100Y —— 85C, 100M, 10K

PREDOMINANT

45C, 80Y —— 85C, 100M, 10K
60

45C, 80Y —— 85C, 100N, 10K

PREDOMINANT

20C, 100Y, 20K —— 85C, 100M, 10K
60

20C, 100Y, 20K —— 85C, 100M, 10K

PREDOMINANT

10C, 100Y, 25K —— 85C, 100M, 10K
60

10C, 100Y, 25K —— 85C, 100M, 10K

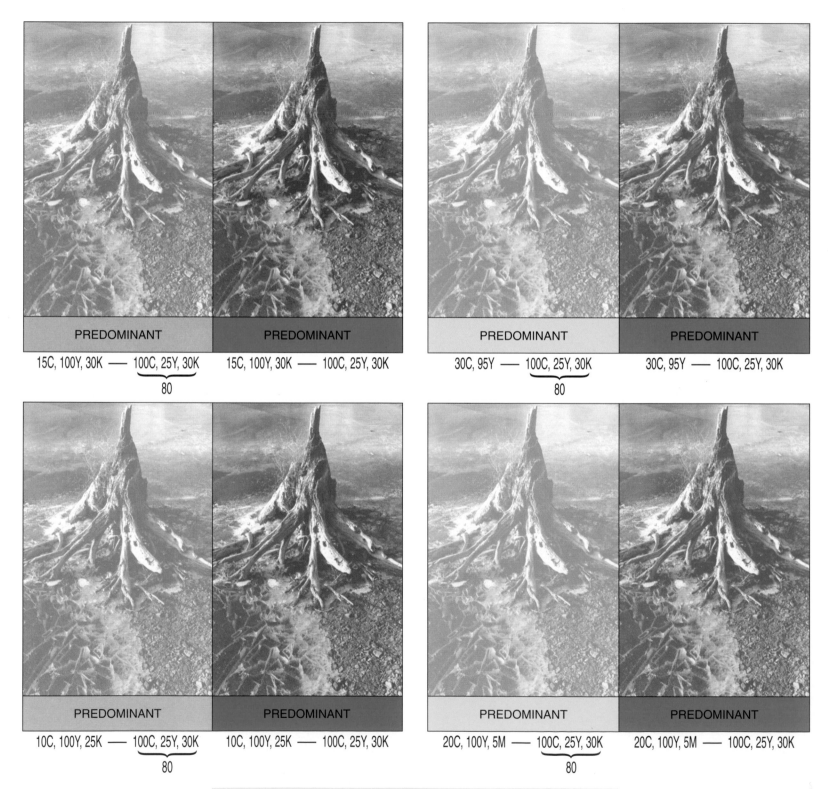

PREDOMINANT — PREDOMINANT

15C, 100Y, 30K —— 100C, 25Y, 30K 15C, 100Y, 30K —— 100C, 25Y, 30K
80

PREDOMINANT — PREDOMINANT

30C, 95Y —— 100C, 25Y, 30K 30C, 95Y —— 100C, 25Y, 30K
80

PREDOMINANT — PREDOMINANT

10C, 100Y, 25K —— 100C, 25Y, 30K 10C, 100Y, 25K —— 100C, 25Y, 30K
80

PREDOMINANT — PREDOMINANT

20C, 100Y, 5M —— 100C, 25Y, 30K 20C, 100Y, 5M —— 100C, 25Y, 30K
80

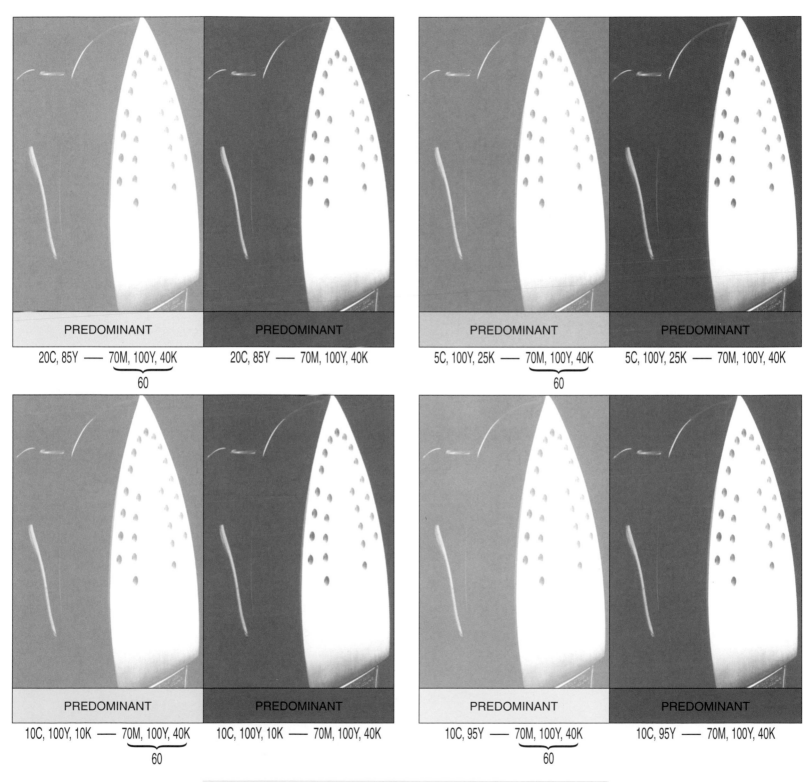

PREDOMINANT

20C, 85Y —— 70M, 100Y, 40K
60

PREDOMINANT

20C, 85Y —— 70M, 100Y, 40K

PREDOMINANT

5C, 100Y, 25K —— 70M, 100Y, 40K
60

PREDOMINANT

5C, 100Y, 25K —— 70M, 100Y, 40K

PREDOMINANT

10C, 100Y, 10K —— 70M, 100Y, 40K
60

PREDOMINANT

10C, 100Y, 10K —— 70M, 100Y, 40K

PREDOMINANT

10C, 95Y —— 70M, 100Y, 40K
60

PREDOMINANT

10C, 95Y —— 70M, 100Y, 40K

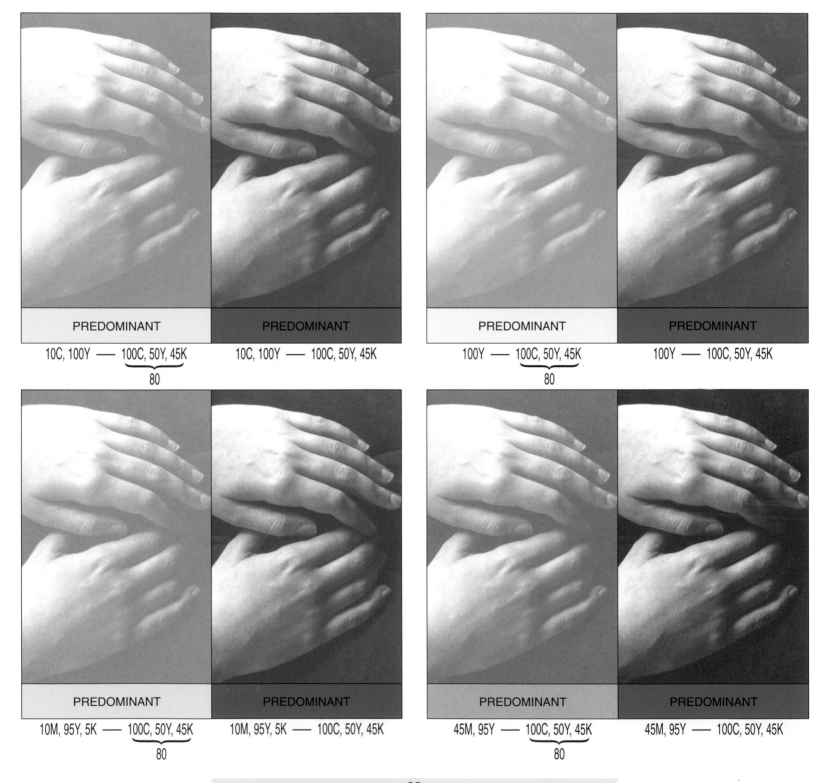

PREDOMINANT

10C, 100Y —— 100C, 50Y, 45K
80

PREDOMINANT

10C, 100Y —— 100C, 50Y, 45K

PREDOMINANT

100Y —— 100C, 50Y, 45K
80

PREDOMINANT

100Y —— 100C, 50Y, 45K

PREDOMINANT

10M, 95Y, 5K —— 100C, 50Y, 45K
80

PREDOMINANT

10M, 95Y, 5K —— 100C, 50Y, 45K

PREDOMINANT

45M, 95Y —— 100C, 50Y, 45K
80

PREDOMINANT

45M, 95Y —— 100C, 50Y, 45K

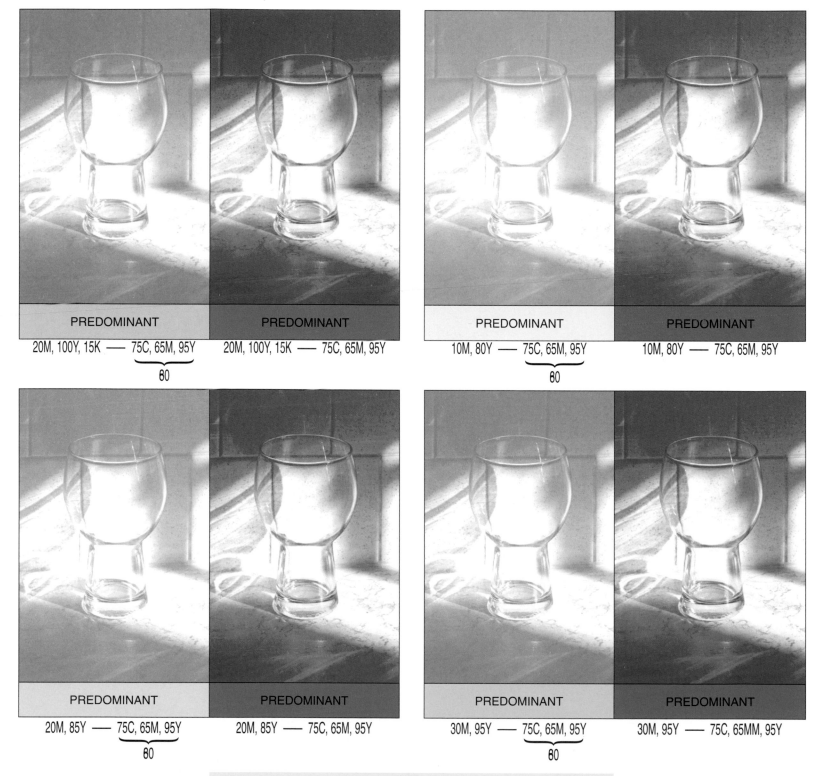

PREDOMINANT

PREDOMINANT

20M, 100Y, 15K —— 75C, 65M, 95Y

20M, 100Y, 15K —— 75C, 65M, 95Y

60

PREDOMINANT

PREDOMINANT

10M, 80Y —— 75C, 65M, 95Y

10M, 80Y —— 75C, 65M, 95Y

60

PREDOMINANT

PREDOMINANT

20M, 85Y —— 75C, 65M, 95Y

20M, 85Y —— 75C, 65M, 95Y

60

PREDOMINANT

PREDOMINANT

30M, 95Y —— 75C, 65M, 95Y

30M, 95Y —— 75C, 65MM, 95Y

60

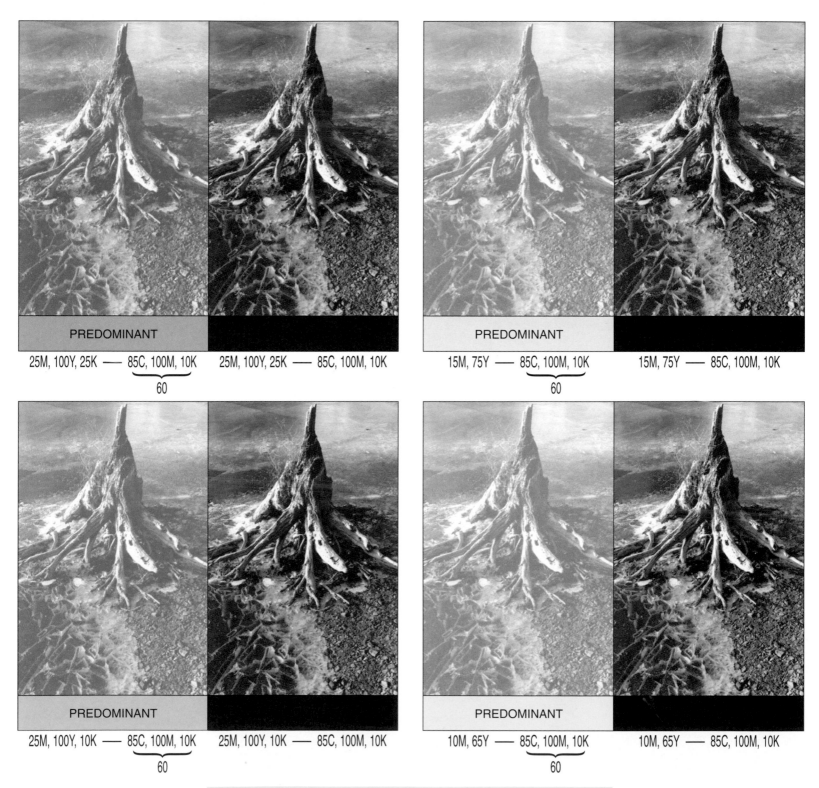

PREDOMINANT

25M, 100Y, 25K —— 85C, 100M, 10K
60

25M, 100Y, 25K —— 85C, 100M, 10K

PREDOMINANT

15M, 75Y —— 85C, 100M, 10K
60

15M, 75Y —— 85C, 100M, 10K

PREDOMINANT

25M, 100Y, 10K —— 85C, 100M, 10K
60

25M, 100Y, 10K —— 85C, 100M, 10K

PREDOMINANT

10M, 65Y —— 85C, 100M, 10K
60

10M, 65Y —— 85C, 100M, 10K

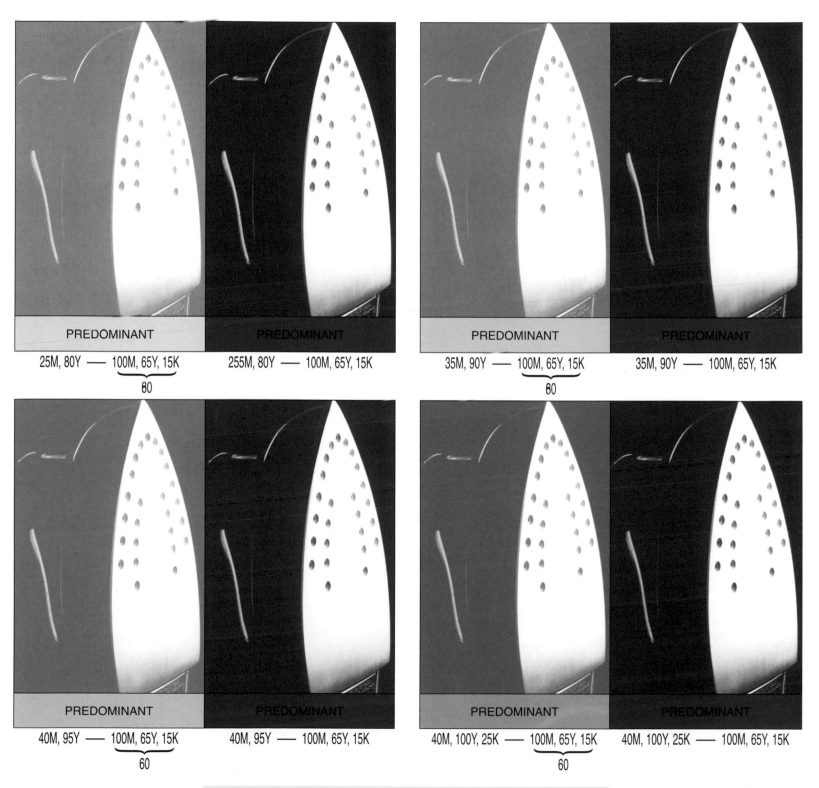

PREDOMINANT

25M, 80Y —— 100M, 65Y, 15K
80

PREDOMINANT

255M, 80Y —— 100M, 65Y, 15K

PREDOMINANT

35M, 90Y —— 100M, 65Y, 15K
60

PREDOMINANT

35M, 90Y —— 100M, 65Y, 15K

PREDOMINANT

40M, 95Y —— 100M, 65Y, 15K
60

PREDOMINANT

40M, 95Y —— 100M, 65Y, 15K

PREDOMINANT

40M, 100Y, 25K —— 100M, 65Y, 15K
60

PREDOMINANT

40M, 100Y, 25K —— 100M, 65Y, 15K

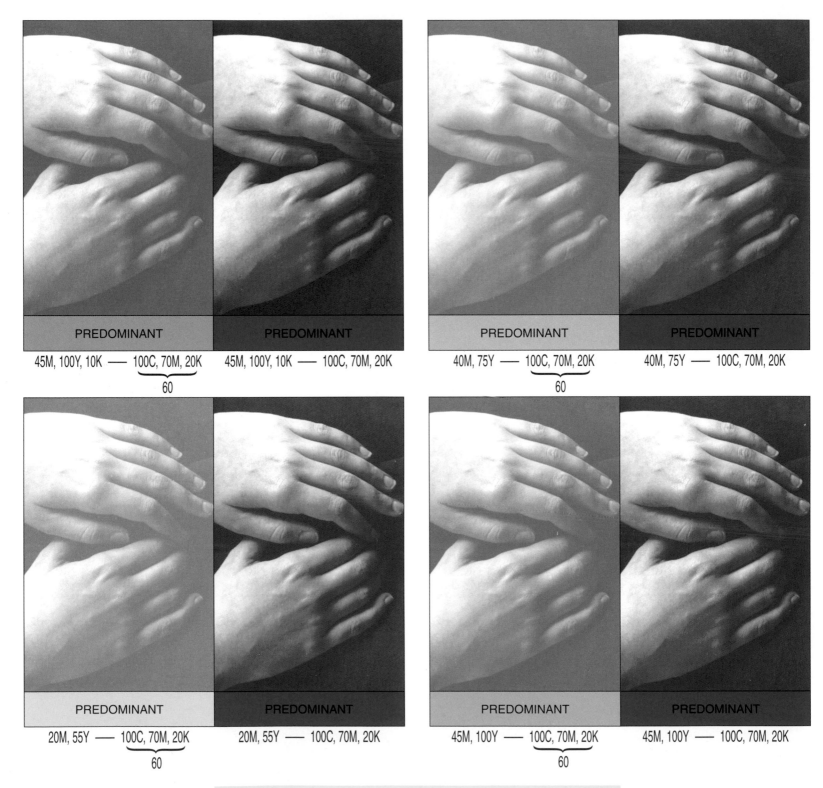

PREDOMINANT

PREDOMINANT

45M, 100Y, 10K —— 100C, 70M, 20K 45M, 100Y, 10K —— 100C, 70M, 20K

60

PREDOMINANT

PREDOMINANT

40M, 75Y —— 100C, 70M, 20K 40M, 75Y —— 100C, 70M, 20K

60

PREDOMINANT

PREDOMINANT

20M, 55Y —— 100C, 70M, 20K 20M, 55Y —— 100C, 70M, 20K

60

PREDOMINANT

PREDOMINANT

45M, 100Y —— 100C, 70M, 20K 45M, 100Y —— 100C, 70M, 20K

60

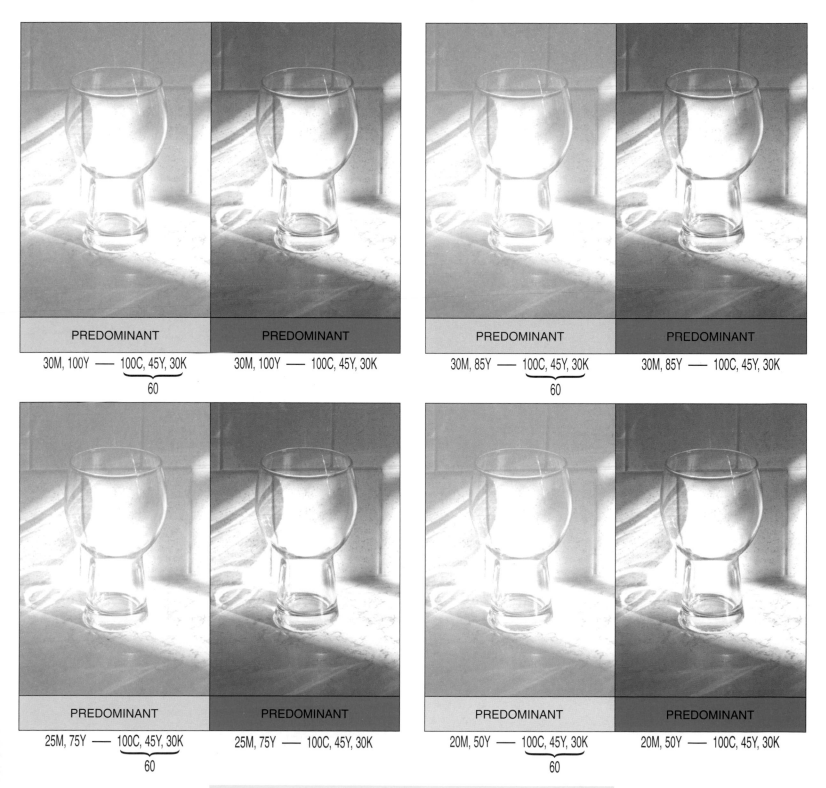

PREDOMINANT

PREDOMINANT

30M, 100Y —— 100C, 45Y, 30K
60

30M, 100Y —— 100C, 45Y, 30K

PREDOMINANT

PREDOMINANT

30M, 85Y —— 100C, 45Y, 30K
60

30M, 85Y —— 100C, 45Y, 30K

PREDOMINANT

PREDOMINANT

25M, 75Y —— 100C, 45Y, 30K
60

25M, 75Y —— 100C, 45Y, 30K

PREDOMINANT

PREDOMINANT

20M, 50Y —— 100C, 45Y, 30K
60

20M, 50Y —— 100C, 45Y, 30K

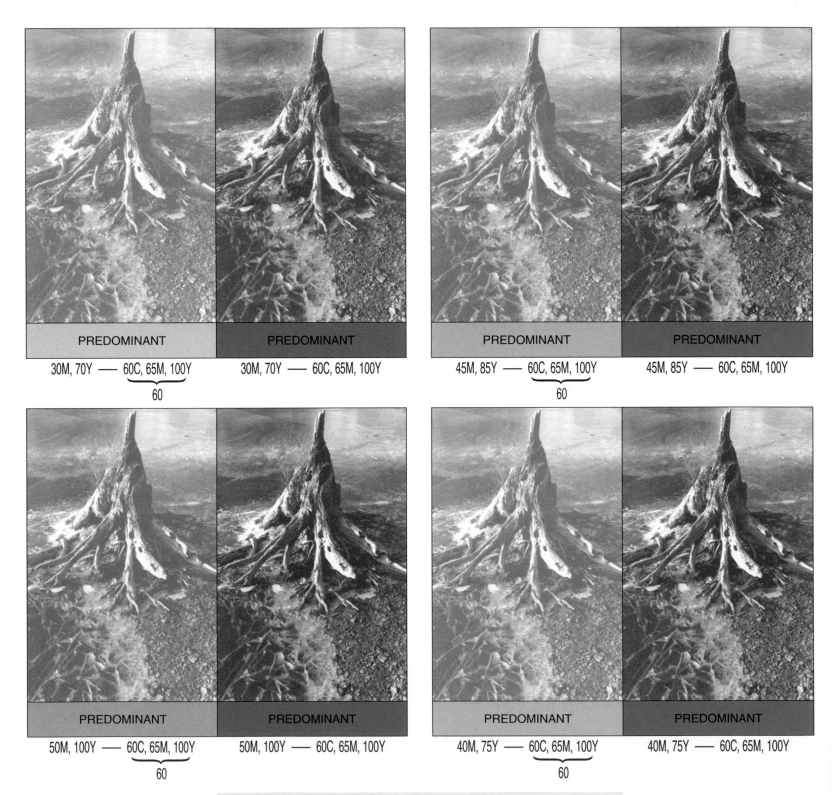

PREDOMINANT

30M, 70Y —— 60C, 65M, 100Y

60

PREDOMINANT

30M, 70Y —— 60C, 65M, 100Y

PREDOMINANT

45M, 85Y —— 60C, 65M, 100Y

60

PREDOMINANT

45M, 85Y —— 60C, 65M, 100Y

PREDOMINANT

50M, 100Y —— 60C, 65M, 100Y

60

PREDOMINANT

50M, 100Y —— 60C, 65M, 100Y

PREDOMINANT

40M, 75Y —— 60C, 65M, 100Y

60

PREDOMINANT

40M, 75Y —— 60C, 65M, 100Y

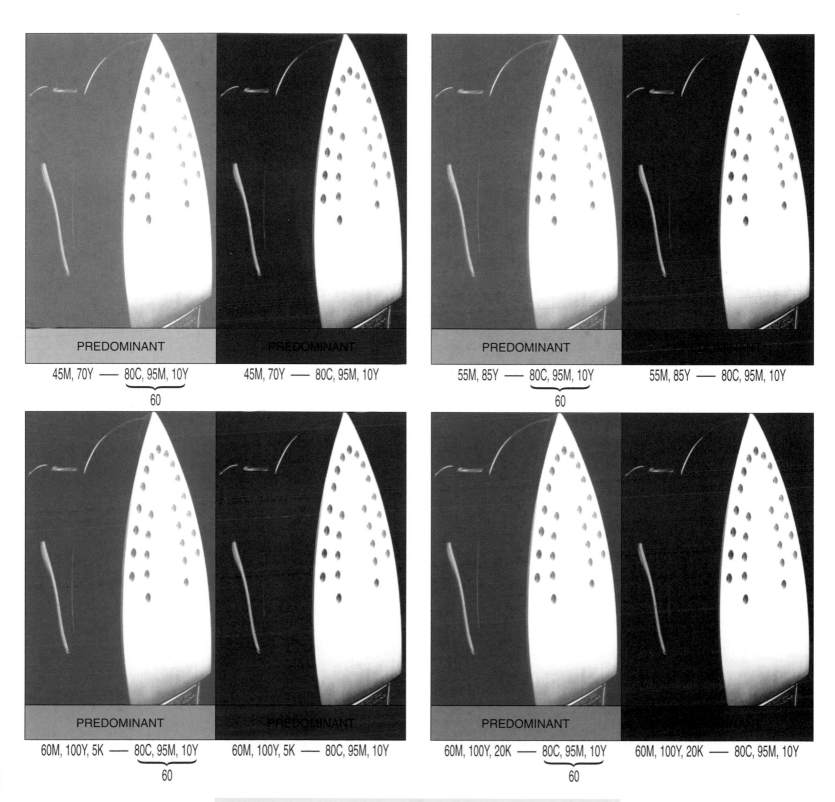

PREDOMINANT

45M, 70Y —— 80C, 95M, 10Y
60

PREDOMINANT

45M, 70Y —— 80C, 95M, 10Y

PREDOMINANT

55M, 85Y —— 80C, 95M, 10Y
60

PREDOMINANT

55M, 85Y —— 80C, 95M, 10Y

PREDOMINANT

60M, 100Y, 5K —— 80C, 95M, 10Y
60

PREDOMINANT

60M, 100Y, 5K —— 80C, 95M, 10Y

PREDOMINANT

60M, 100Y, 20K —— 80C, 95M, 10Y
60

PREDOMINANT

60M, 100Y, 20K —— 80C, 95M, 10Y

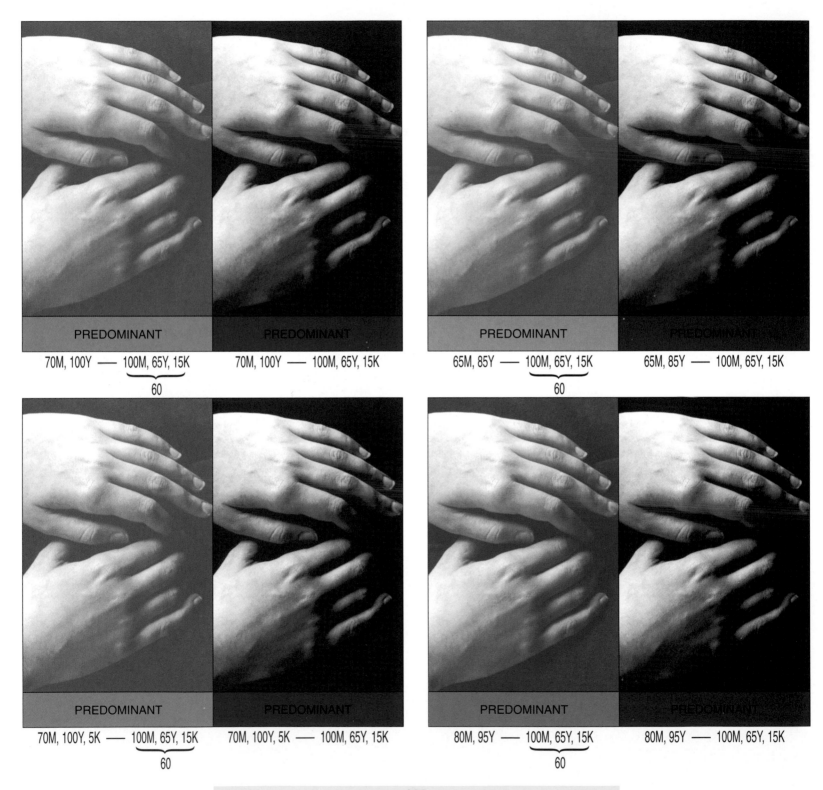

PREDOMINANT

70M, 100Y —— 100M, 65Y, 15K

60

PREDOMINANT

70M, 100Y —— 100M, 65Y, 15K

PREDOMINANT

65M, 85Y —— 100M, 65Y, 15K

60

PREDOMINANT

65M, 85Y —— 100M, 65Y, 15K

PREDOMINANT

70M, 100Y, 5K —— 100M, 65Y, 15K

60

PREDOMINANT

70M, 100Y, 5K —— 100M, 65Y, 15K

PREDOMINANT

80M, 95Y —— 100M, 65Y, 15K

60

PREDOMINANT

80M, 95Y —— 100M, 65Y, 15K

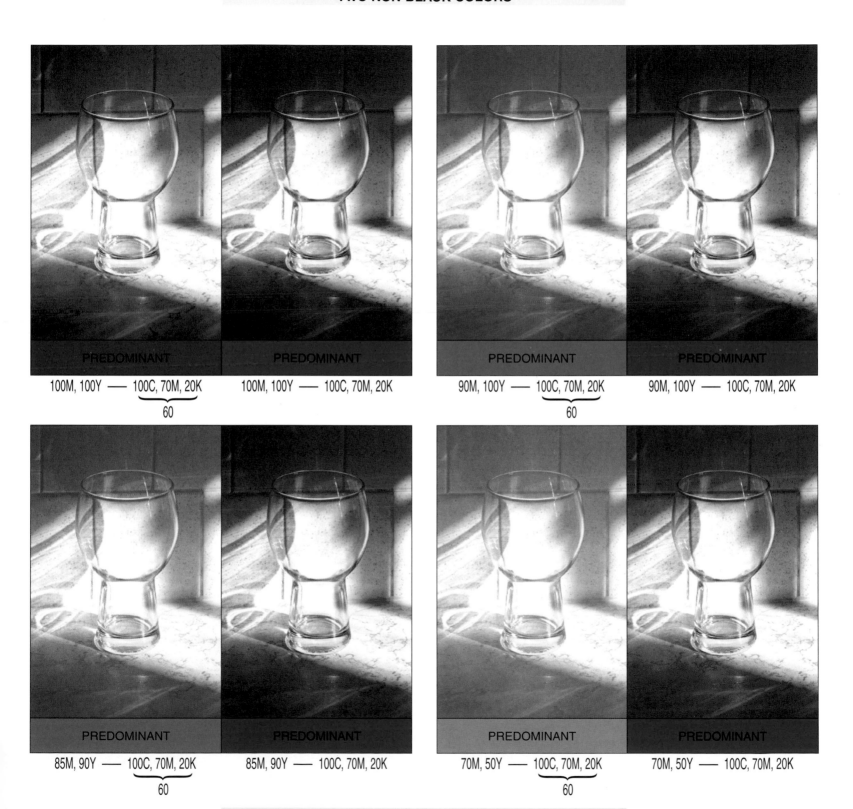

PREDOMINANT PREDOMINANT

100M, 100Y —— 100C, 70M, 20K 100M, 100Y —— 100C, 70M, 20K

60

PREDOMINANT PREDOMINANT

90M, 100Y —— 100C, 70M, 20K 90M, 100Y —— 100C, 70M, 20K

60

PREDOMINANT PREDOMINANT

85M, 90Y —— 100C, 70M, 20K 85M, 90Y —— 100C, 70M, 20K

60

PREDOMINANT PREDOMINANT

70M, 50Y —— 100C, 70M, 20K 70M, 50Y —— 100C, 70M, 20K

60

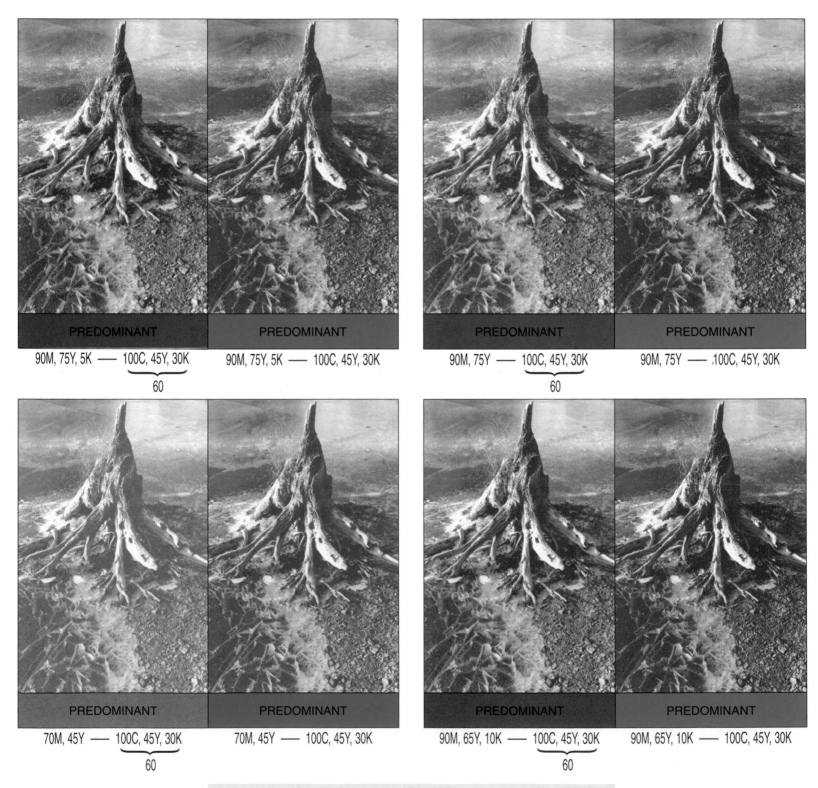

PREDOMINANT

90M, 75Y, 5K —— 100C, 45Y, 30K

60

PREDOMINANT

90M, 75Y, 5K —— 100C, 45Y, 30K

PREDOMINANT

90M, 75Y —— 100C, 45Y, 30K

60

PREDOMINANT

90M, 75Y —— ,100C, 45Y, 30K

PREDOMINANT

70M, 45Y —— 100C, 45Y, 30K

60

PREDOMINANT

70M, 45Y —— 100C, 45Y, 30K

PREDOMINANT

90M, 65Y, 10K —— 100C, 45Y, 30K

60

PREDOMINANT

90M, 65Y, 10K —— 100C, 45Y, 30K

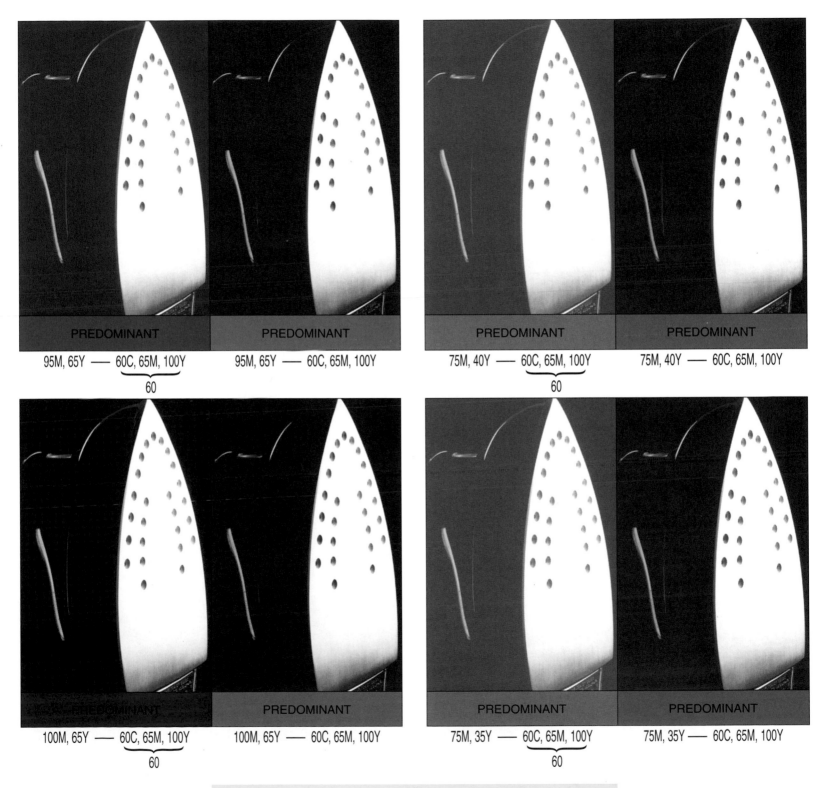

PREDOMINANT

95M, 65Y —— 60C, 65M, 100Y

60

PREDOMINANT

95M, 65Y —— 60C, 65M, 100Y

PREDOMINANT

75M, 40Y —— 60C, 65M, 100Y

60

PREDOMINANT

75M, 40Y —— 60C, 65M, 100Y

PREDOMINANT

100M, 65Y —— 60C, 65M, 100Y

60

PREDOMINANT

100M, 65Y —— 60C, 65M, 100Y

PREDOMINANT

75M, 35Y —— 60C, 65M, 100Y

60

PREDOMINANT

75M, 35Y —— 60C, 65M, 100Y

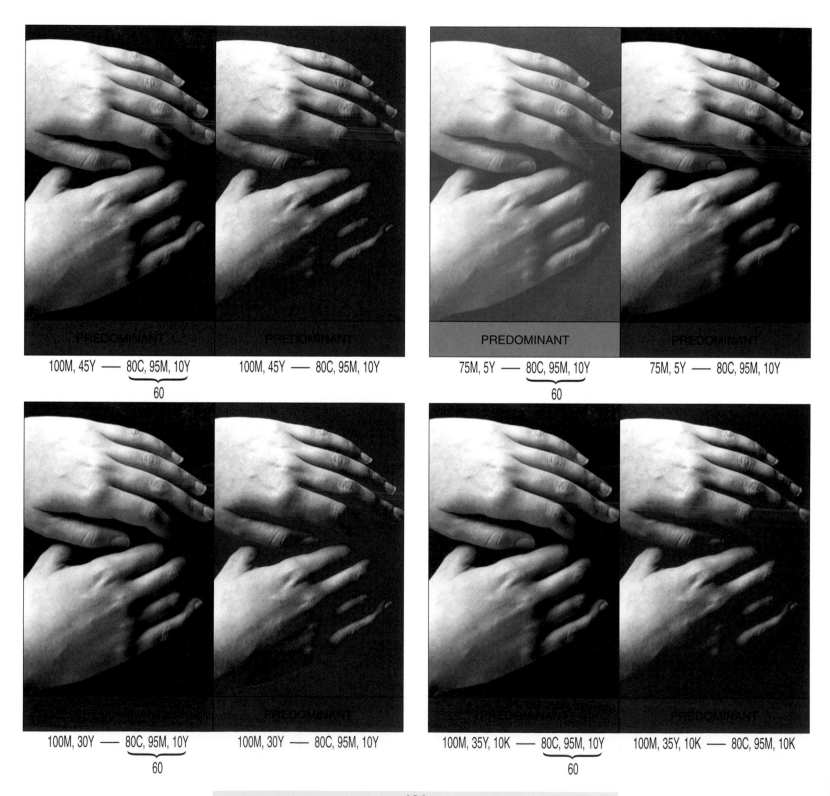

100M, 45Y —— 80C, 95M, 10Y
60

100M, 45Y —— 80C, 95M, 10Y

75M, 5Y —— 80C, 95M, 10Y
60

75M, 5Y —— 80C, 95M, 10Y

100M, 30Y —— 80C, 95M, 10Y
60

100M, 30Y —— 80C, 95M, 10Y

100M, 35Y, 10K —— 80C, 95M, 10Y
60

100M, 35Y, 10K —— 80C, 95M, 10K

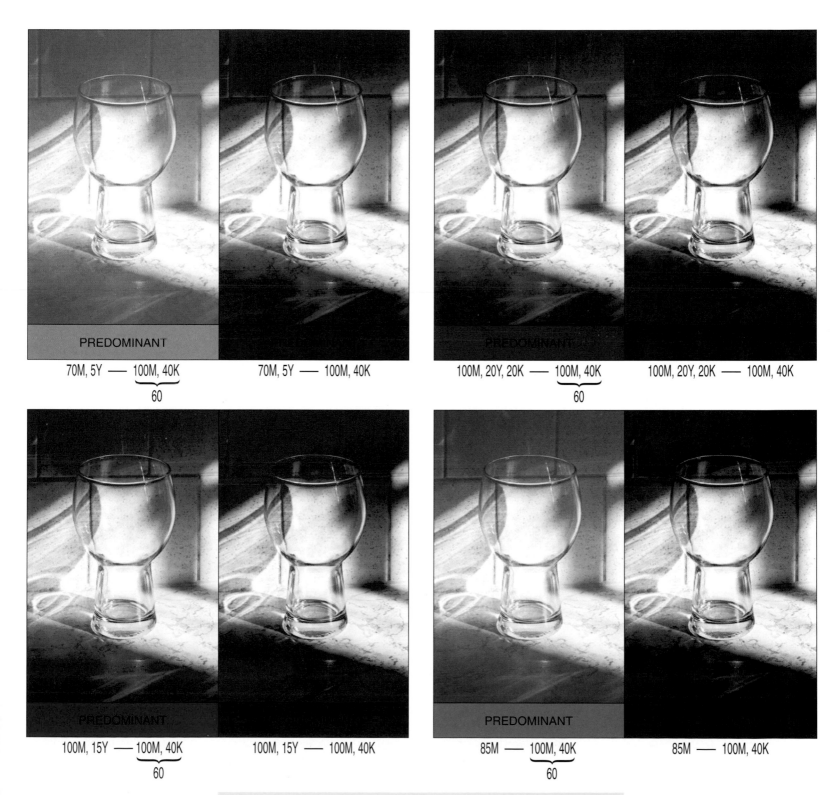

PREDOMINANT

70M, 5Y —— 100M, 40K
60

70M, 5Y —— 100M, 40K

PREDOMINANT

100M, 20Y, 20K —— 100M, 40K
60

100M, 20Y, 20K —— 100M, 40K

PREDOMINANT

100M, 15Y —— 100M, 40K
60

100M, 15Y —— 100M, 40K

PREDOMINANT

85M —— 100M, 40K
60

85M —— 100M, 40K

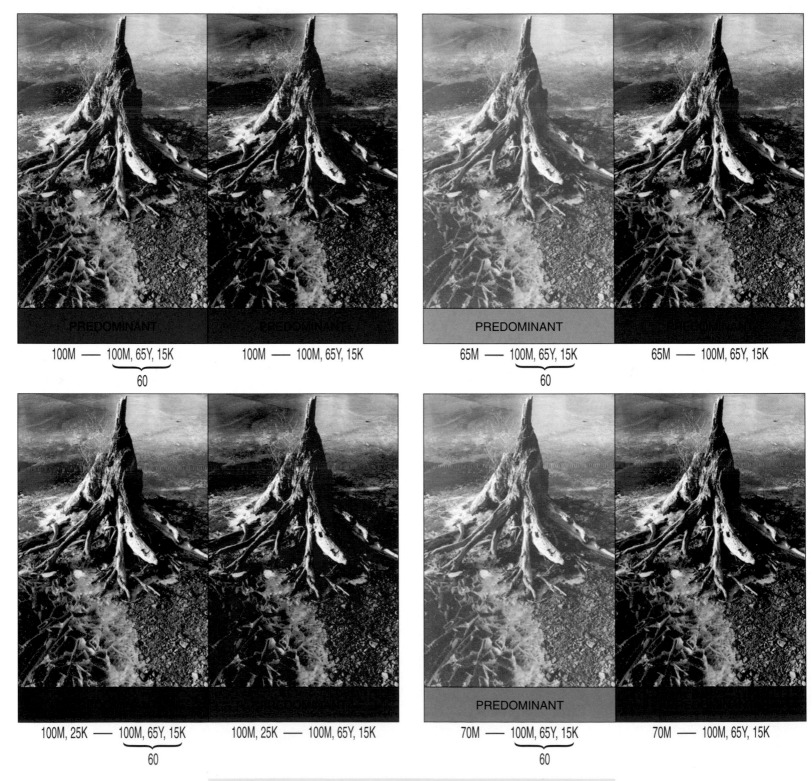

100M —— 100M, 65Y, 15K
60

100M —— 100M, 65Y, 15K

65M —— 100M, 65Y, 15K
60

65M —— 100M, 65Y, 15K

100M, 25K —— 100M, 65Y, 15K
60

100M, 25K —— 100M, 65Y, 15K

70M —— 100M, 65Y, 15K
60

70M —— 100M, 65Y, 15K

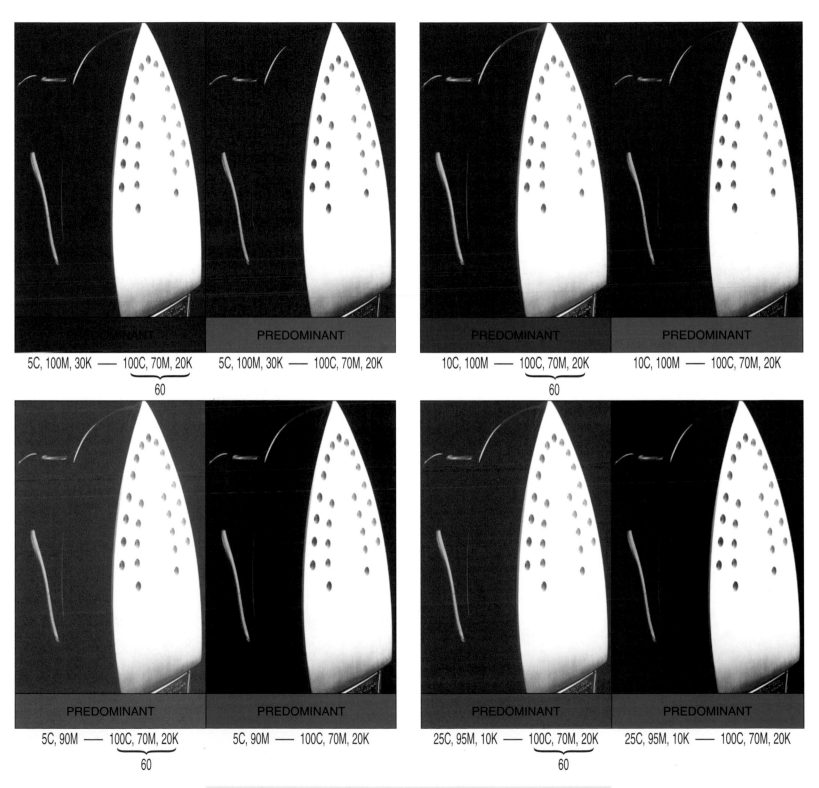

PREDOMINANT | PREDOMINANT

5C, 100M, 30K —— 100C, 70M, 20K
60

5C, 100M, 30K —— 100C, 70M, 20K

PREDOMINANT | PREDOMINANT

10C, 100M —— 100C, 70M, 20K
60

10C, 100M —— 100C, 70M, 20K

PREDOMINANT | PREDOMINANT

5C, 90M —— 100C, 70M, 20K
60

5C, 90M —— 100C, 70M, 20K

PREDOMINANT | PREDOMINANT

25C, 95M, 10K —— 100C, 70M, 20K
60

25C, 95M, 10K —— 100C, 70M, 20K

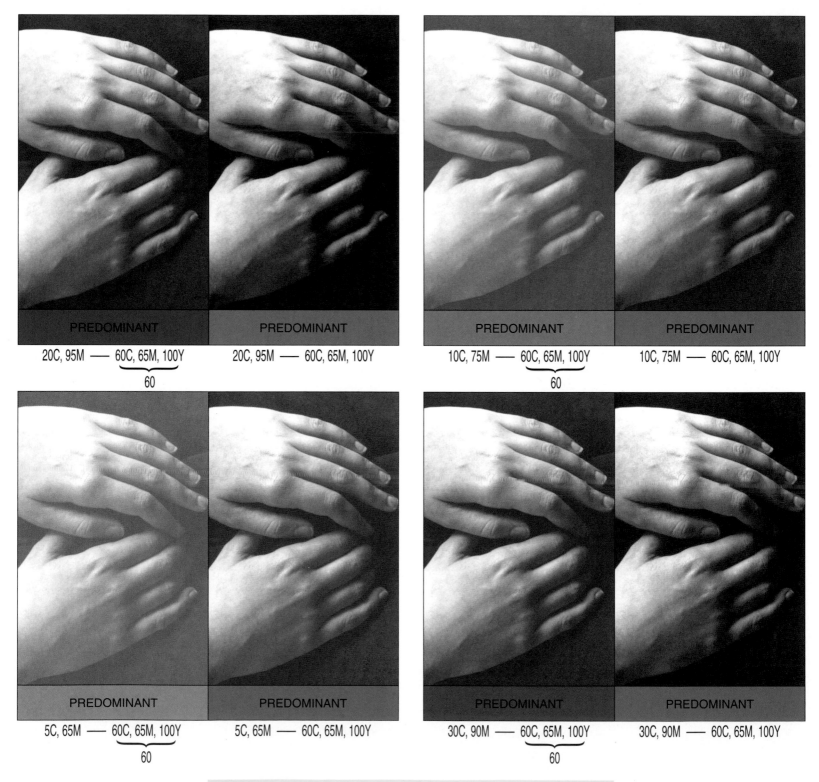

PREDOMINANT

20C, 95M —— 60C, 65M, 100Y

60

PREDOMINANT

20C, 95M —— 60C, 65M, 100Y

PREDOMINANT

10C, 75M —— 60C, 65M, 100Y

60

PREDOMINANT

10C, 75M —— 60C, 65M, 100Y

PREDOMINANT

5C, 65M —— 60C, 65M, 100Y

60

PREDOMINANT

5C, 65M —— 60C, 65M, 100Y

PREDOMINANT

30C, 90M —— 60C, 65M, 100Y

60

PREDOMINANT

30C, 90M —— 60C, 65M, 100Y

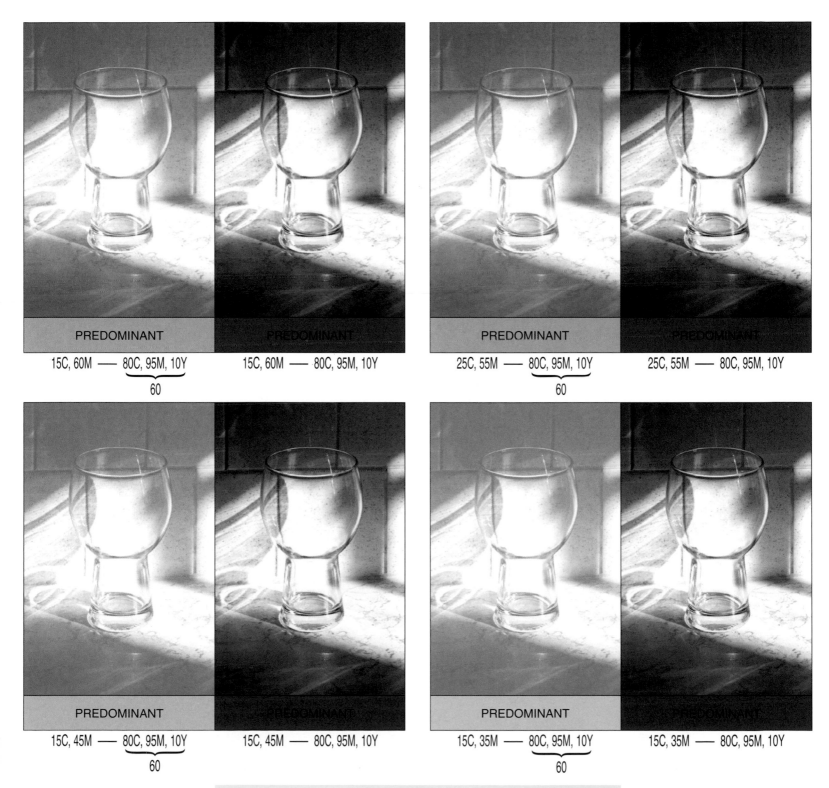

PREDOMINANT

15C, 60M —— 80C, 95M, 10Y
60

PREDOMINANT

15C, 60M —— 80C, 95M, 10Y

PREDOMINANT

25C, 55M —— 80C, 95M, 10Y
60

PREDOMINANT

25C, 55M —— 80C, 95M, 10Y

PREDOMINANT

15C, 45M —— 80C, 95M, 10Y
60

PREDOMINANT

15C, 45M —— 80C, 95M, 10Y

PREDOMINANT

15C, 35M —— 80C, 95M, 10Y
60

PREDOMINANT

15C, 35M —— 80C, 95M, 10Y

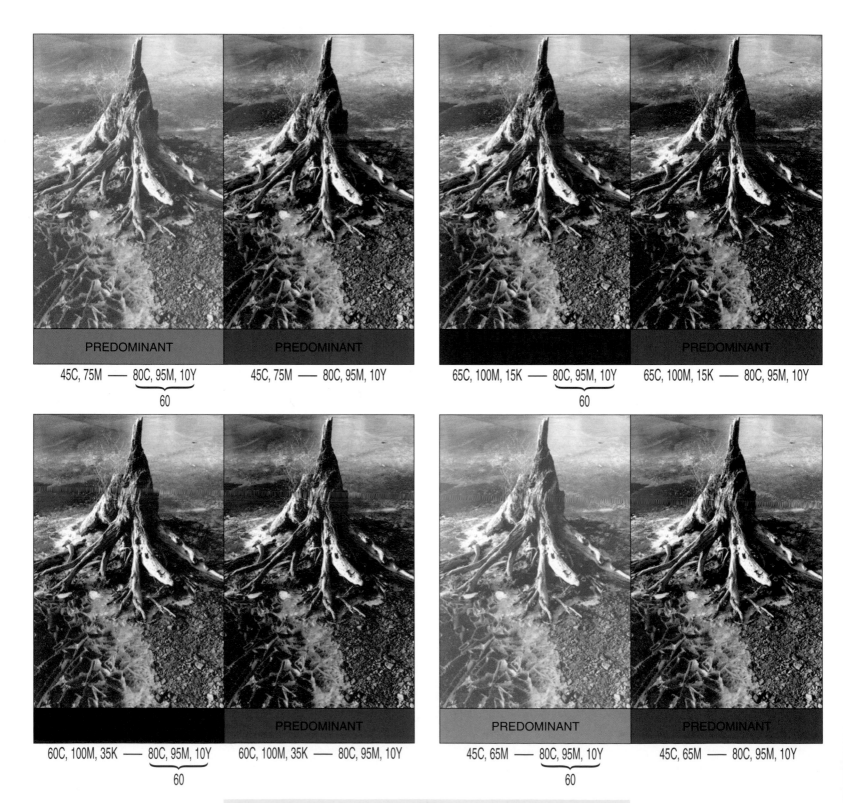

PREDOMINANT

PREDOMINANT

PREDOMINANT

PREDOMINANT

45C, 75M —— 80C, 95M, 10Y

45C, 75M —— 80C, 95M, 10Y

65C, 100M, 15K —— 80C, 95M, 10Y

65C, 100M, 15K —— 80C, 95M, 10Y

60

60

PREDOMINANT

PREDOMINANT

PREDOMINANT

PREDOMINANT

60C, 100M, 35K —— 80C, 95M, 10Y

60C, 100M, 35K —— 80C, 95M, 10Y

45C, 65M —— 80C, 95M, 10Y

45C, 65M —— 80C, 95M, 10Y

60

60

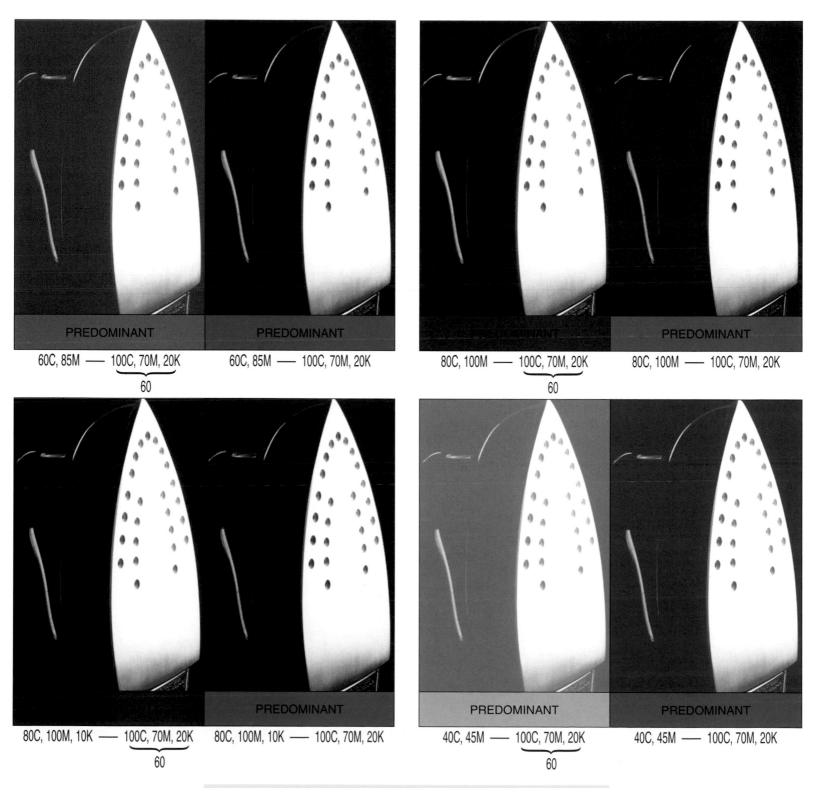

PREDOMINANT PREDOMINANT

60C, 85M —— 100C, 70M, 20K 60C, 85M —— 100C, 70M, 20K

60

PREDOMINANT PREDOMINANT

80C, 100M —— 100C, 70M, 20K 80C, 100M —— 100C, 70M, 20K

60

PREDOMINANT PREDOMINANT

80C, 100M, 10K —— 100C, 70M, 20K 80C, 100M, 10K —— 100C, 70M, 20K

60

PREDOMINANT PREDOMINANT

40C, 45M —— 100C, 70M, 20K 40C, 45M —— 100C, 70M, 20K

60

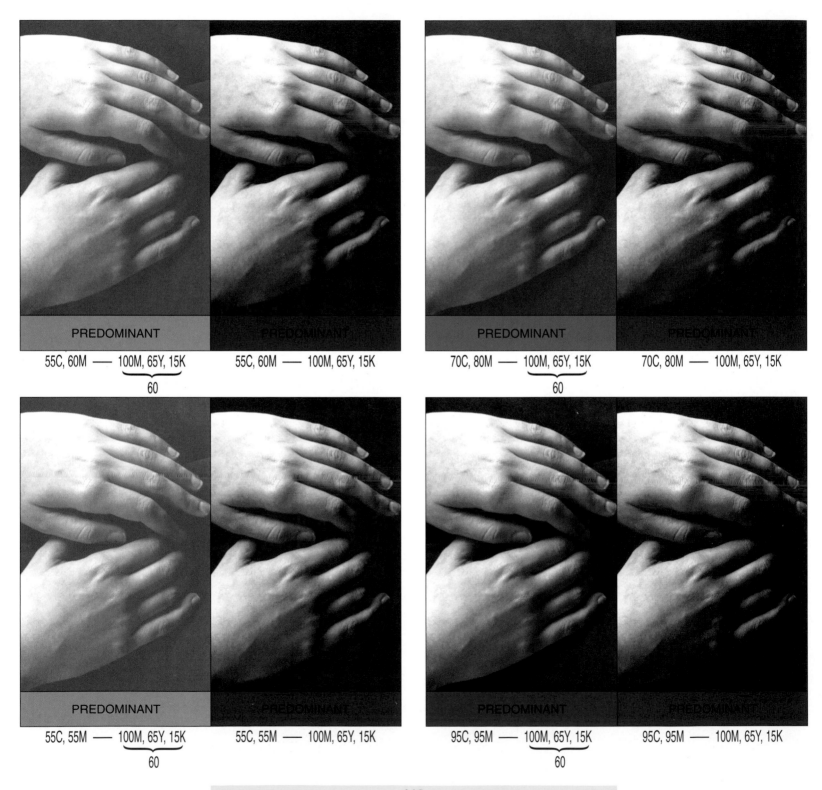

PREDOMINANT

55C, 60M —— 100M, 65Y, 15K

60

PREDOMINANT

55C, 60M —— 100M, 65Y, 15K

PREDOMINANT

70C, 80M —— 100M, 65Y, 15K

60

PREDOMINANT

70C, 80M —— 100M, 65Y, 15K

PREDOMINANT

55C, 55M —— 100M, 65Y, 15K

60

PREDOMINANT

55C, 55M —— 100M, 65Y, 15K

PREDOMINANT

95C, 95M —— 100M, 65Y, 15K

60

PREDOMINANT

95C, 95M —— 100M, 65Y, 15K

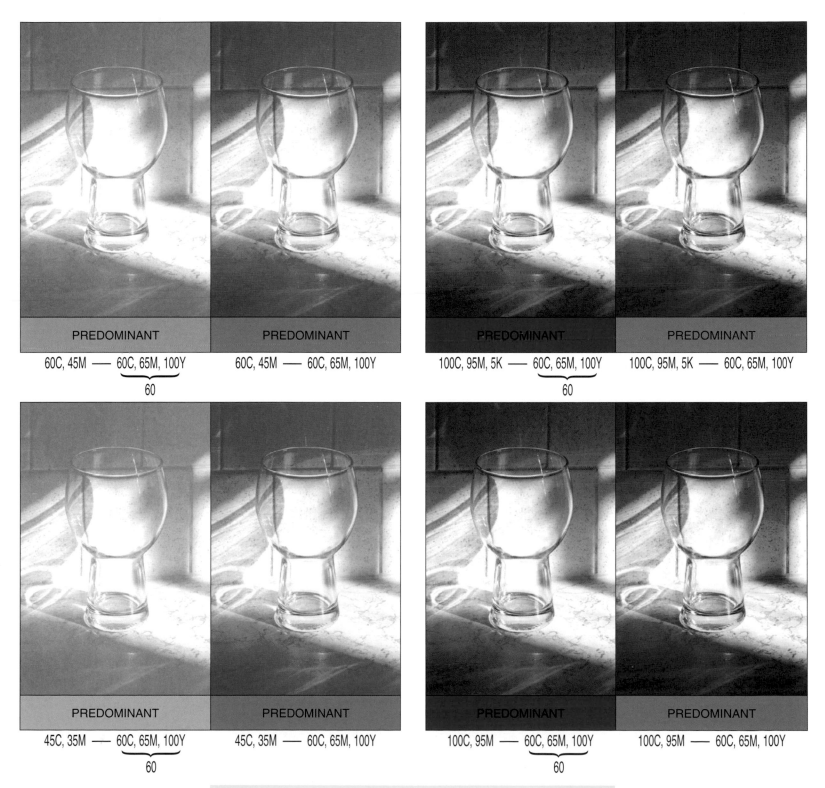

PREDOMINANT

PREDOMINANT

60C, 45M —— 60C, 65M, 100Y

60C, 45M —— 60C, 65M, 100Y

60

PREDOMINANT

PREDOMINANT

100C, 95M, 5K —— 60C, 65M, 100Y

100C, 95M, 5K —— 60C, 65M, 100Y

60

PREDOMINANT

PREDOMINANT

45C, 35M —— 60C, 65M, 100Y

45C, 35M —— 60C, 65M, 100Y

60

PREDOMINANT

PREDOMINANT

100C, 95M —— 60C, 65M, 100Y

100C, 95M —— 60C, 65M, 100Y

60

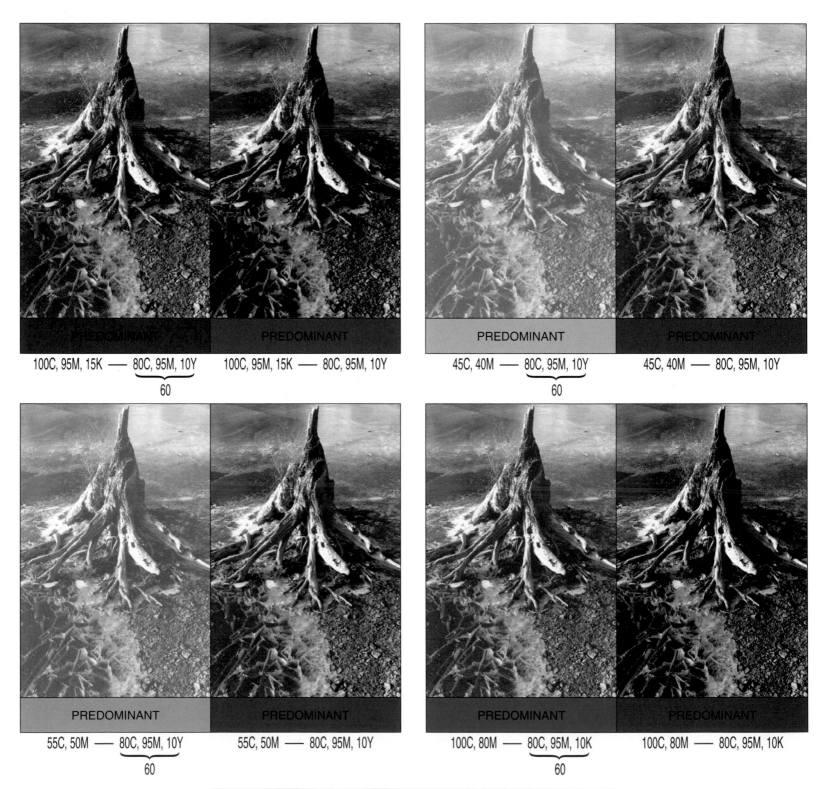

PREDOMINANT | PREDOMINANT

100C, 95M, 15K —— 80C, 95M, 10Y 100C, 95M, 15K —— 80C, 95M, 10Y
60

PREDOMINANT | PREDOMINANT

45C, 40M —— 80C, 95M, 10Y 45C, 40M —— 80C, 95M, 10Y
60

PREDOMINANT | PREDOMINANT

55C, 50M —— 80C, 95M, 10Y 55C, 50M —— 80C, 95M, 10Y
60

PREDOMINANT | PREDOMINANT

100C, 80M —— 80C, 95M, 10K 100C, 80M —— 80C, 95M, 10K
60

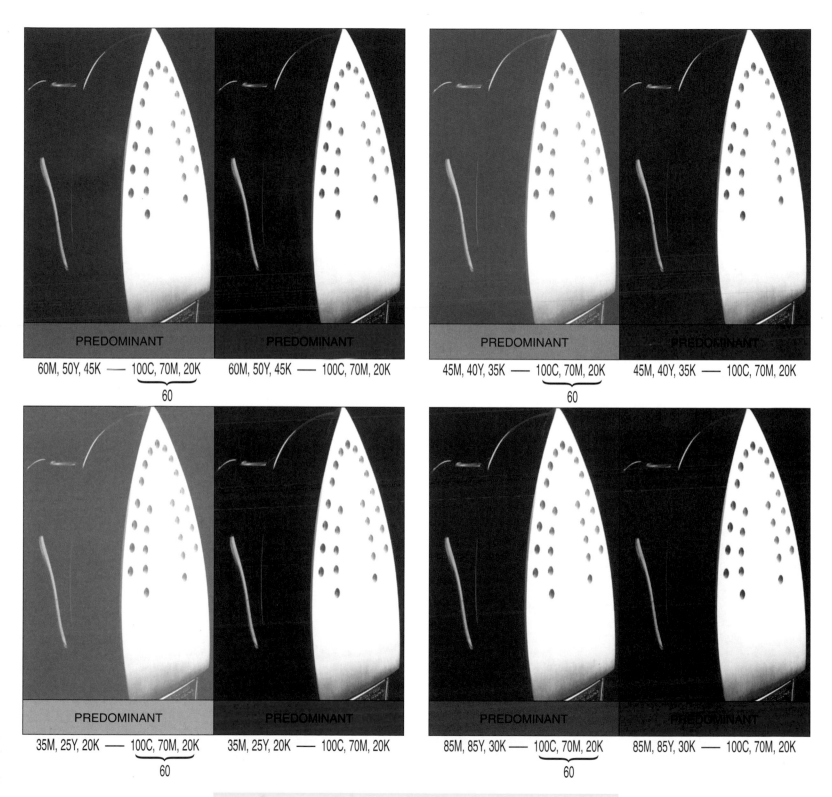

PREDOMINANT

60M, 50Y, 45K —— 100C, 70M, 20K
60

PREDOMINANT

60M, 50Y, 45K —— 100C, 70M, 20K

PREDOMINANT

45M, 40Y, 35K —— 100C, 70M, 20K
60

PREDOMINANT

45M, 40Y, 35K —— 100C, 70M, 20K

PREDOMINANT

35M, 25Y, 20K —— 100C, 70M, 20K
60

PREDOMINANT

35M, 25Y, 20K —— 100C, 70M, 20K

PREDOMINANT

85M, 85Y, 30K —— 100C, 70M, 20K
60

PREDOMINANT

85M, 85Y, 30K —— 100C, 70M, 20K

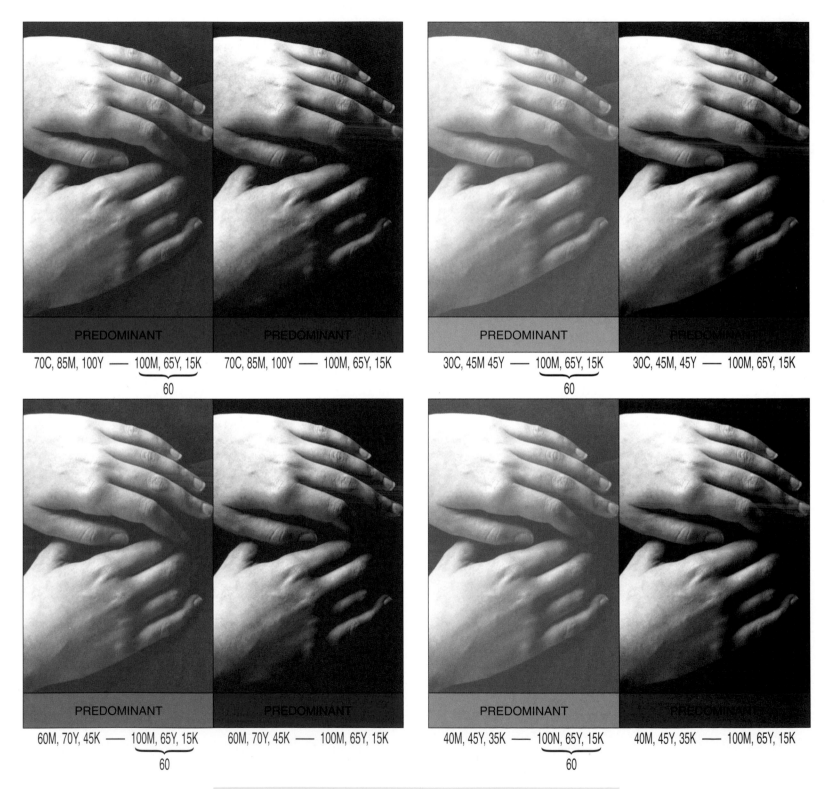

PREDOMINANT

70C, 85M, 100Y —— 100M, 65Y, 15K 70C, 85M, 100Y —— 100M, 65Y, 15K

60

PREDOMINANT

30C, 45M 45Y —— 100M, 65Y, 15K 30C, 45M, 45Y —— 100M, 65Y, 15K

60

PREDOMINANT

60M, 70Y, 45K —— 100M, 65Y, 15K 60M, 70Y, 45K —— 100M, 65Y, 15K

60

PREDOMINANT

40M, 45Y, 35K —— 100N, 65Y, 15K 40M, 45Y, 35K —— 100M, 65Y, 15K

60

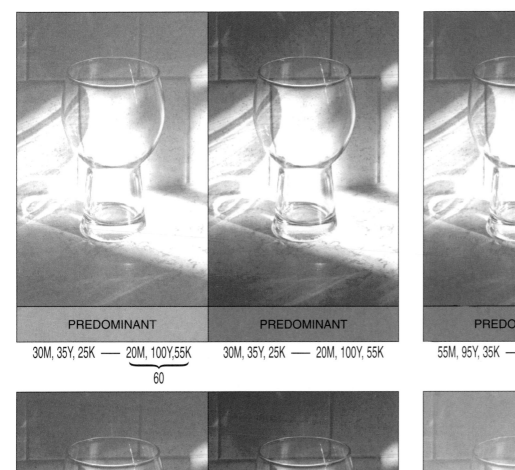

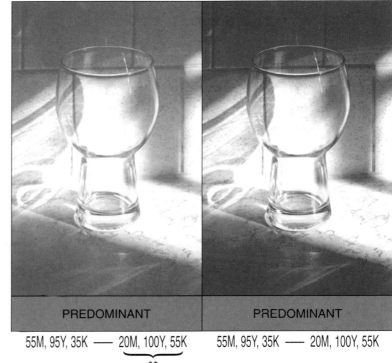

PREDOMINANT PREDOMINANT PREDOMINANT PREDOMINANT

30M, 35Y, 25K —— 20M, 100Y,55K 30M, 35Y, 25K —— 20M, 100Y, 55K 55M, 95Y, 35K —— 20M, 100Y, 55K 55M, 95Y, 35K —— 20M, 100Y, 55K

60 60

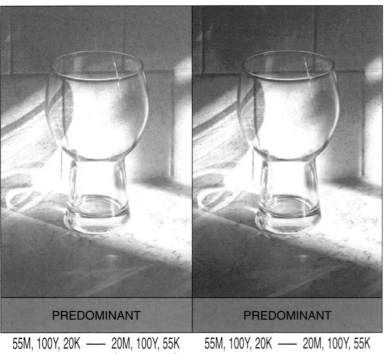

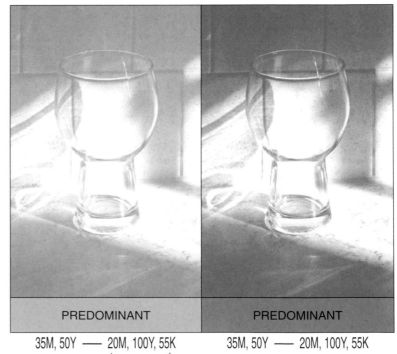

PREDOMINANT PREDOMINANT PREDOMINANT PREDOMINANT

55M, 100Y, 20K —— 20M, 100Y, 55K 55M, 100Y, 20K —— 20M, 100Y, 55K 35M, 50Y —— 20M, 100Y, 55K 35M, 50Y —— 20M, 100Y, 55K

60 60

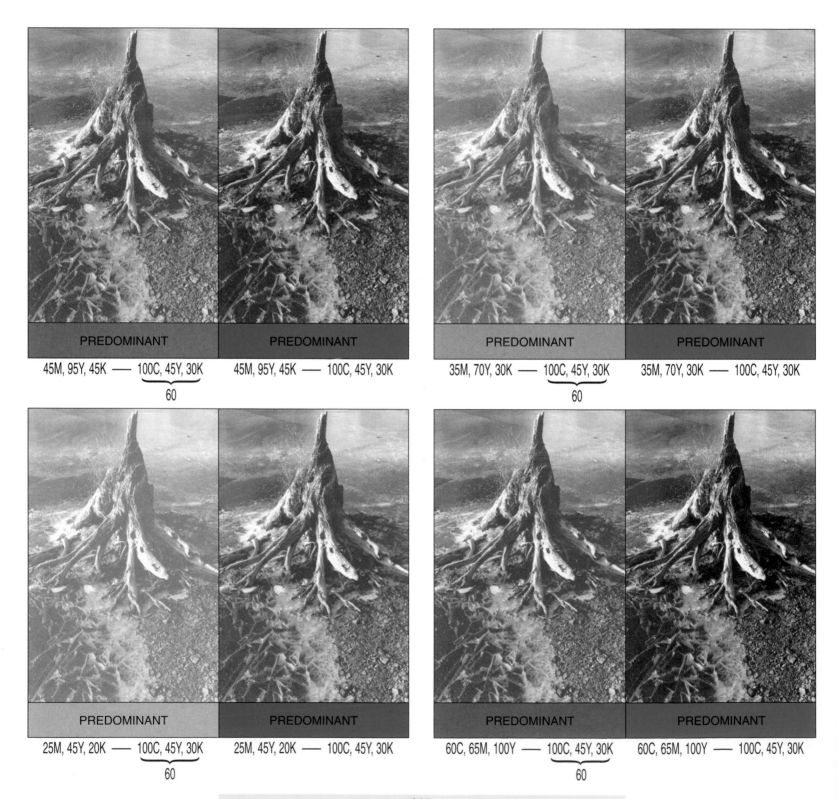

PREDOMINANT

45M, 95Y, 45K —— 100C, 45Y, 30K

60

PREDOMINANT

45M, 95Y, 45K —— 100C, 45Y, 30K

PREDOMINANT

35M, 70Y, 30K —— 100C, 45Y, 30K

60

PREDOMINANT

35M, 70Y, 30K —— 100C, 45Y, 30K

PREDOMINANT

25M, 45Y, 20K —— 100C, 45Y, 30K

60

PREDOMINANT

25M, 45Y, 20K —— 100C, 45Y, 30K

PREDOMINANT

60C, 65M, 100Y —— 100C, 45Y, 30K

60

PREDOMINANT

60C, 65M, 100Y —— 100C, 45Y, 30K

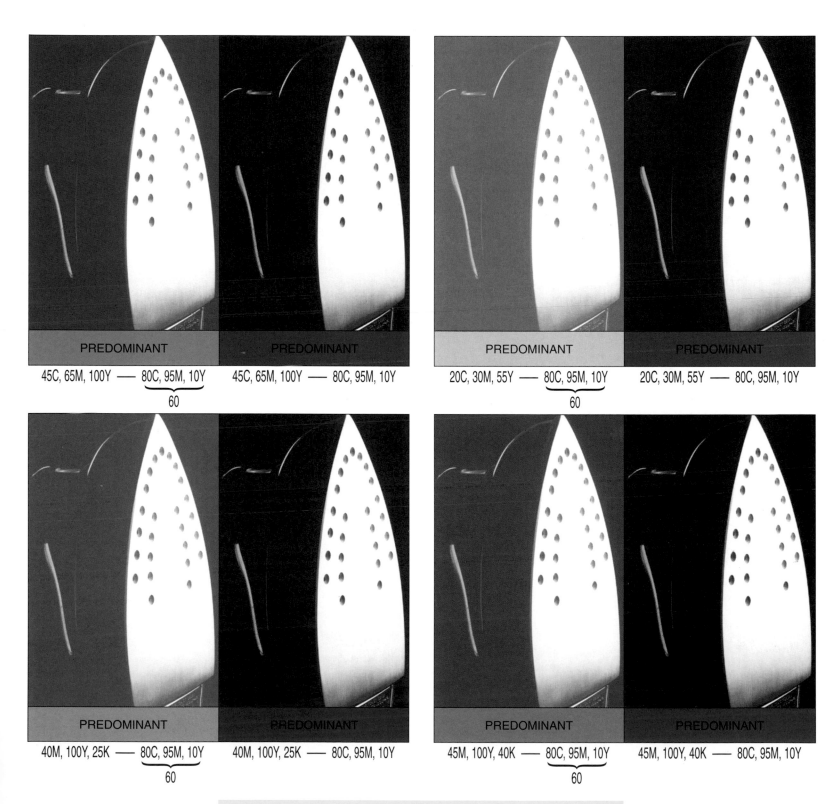

PREDOMINANT

45C, 65M, 100Y —— 80C, 95M, 10Y
60

PREDOMINANT

45C, 65M, 100Y —— 80C, 95M, 10Y

PREDOMINANT

20C, 30M, 55Y —— 80C, 95M, 10Y
60

PREDOMINANT

20C, 30M, 55Y —— 80C, 95M, 10Y

PREDOMINANT

40M, 100Y, 25K —— 80C, 95M, 10Y
60

PREDOMINANT

40M, 100Y, 25K —— 80C, 95M, 10Y

PREDOMINANT

45M, 100Y, 40K —— 80C, 95M, 10Y
60

PREDOMINANT

45M, 100Y, 40K —— 80C, 95M, 10Y

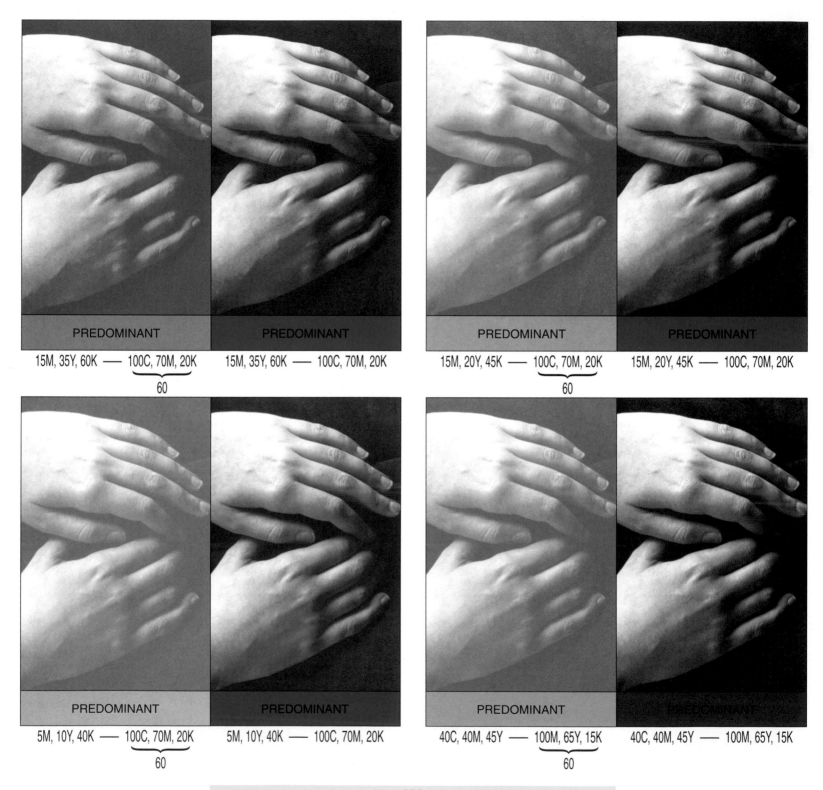

PREDOMINANT

15M, 35Y, 60K —— 100C, 70M, 20K

60

PREDOMINANT

15M, 35Y, 60K —— 100C, 70M, 20K

PREDOMINANT

15M, 20Y, 45K —— 100C, 70M, 20K

60

PREDOMINANT

15M, 20Y, 45K —— 100C, 70M, 20K

PREDOMINANT

5M, 10Y, 40K —— 100C, 70M, 20K

60

PREDOMINANT

5M, 10Y, 40K —— 100C, 70M, 20K

PREDOMINANT

40C, 40M, 45Y —— 100M, 65Y, 15K

60

PREDOMINANT

40C, 40M, 45Y —— 100M, 65Y, 15K

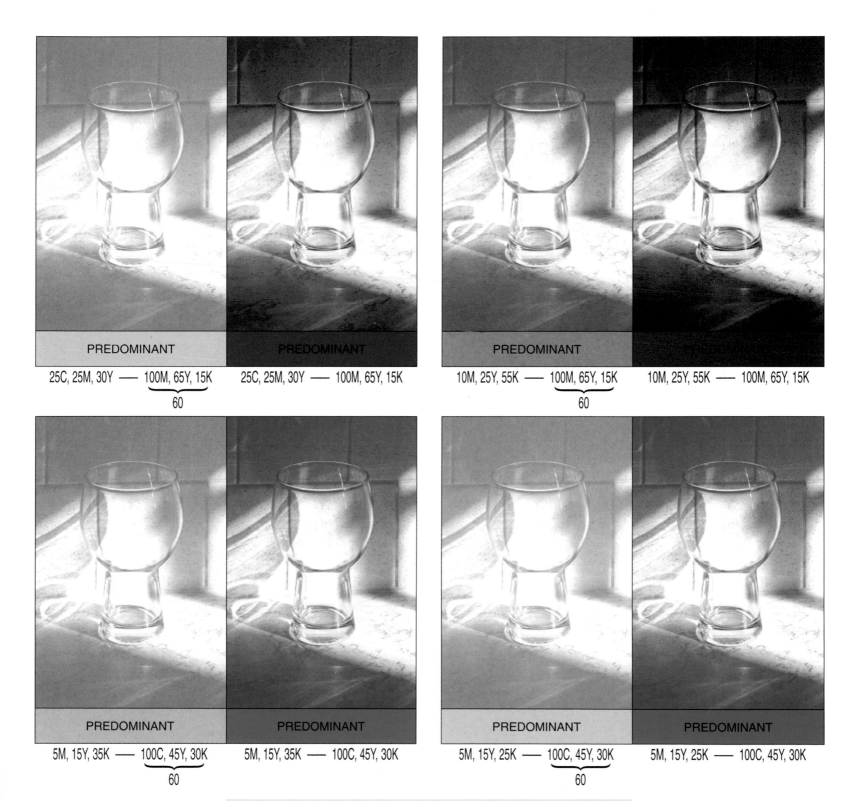

PREDOMINANT

25C, 25M, 30Y —— 100M, 65Y, 15K

PREDOMINANT

25C, 25M, 30Y —— 100M, 65Y, 15K

60

PREDOMINANT

10M, 25Y, 55K —— 100M, 65Y, 15K

PREDOMINANT

10M, 25Y, 55K —— 100M, 65Y, 15K

60

PREDOMINANT

5M, 15Y, 35K —— 100C, 45Y, 30K

PREDOMINANT

5M, 15Y, 35K —— 100C, 45Y, 30K

60

PREDOMINANT

5M, 15Y, 25K —— 100C, 45Y, 30K

PREDOMINANT

5M, 15Y, 25K —— 100C, 45Y, 30K

60

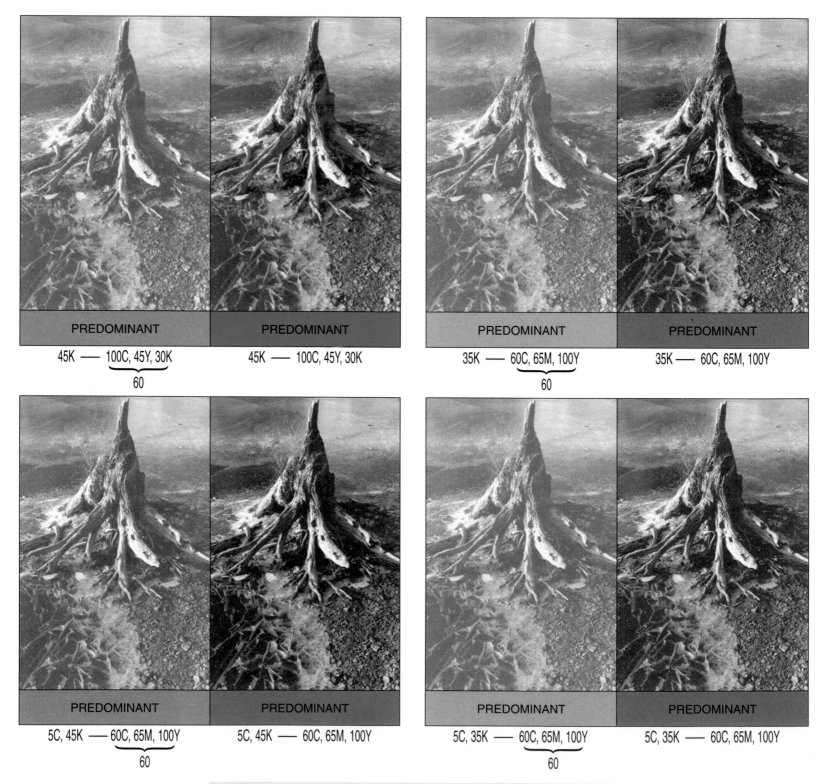

PREDOMINANT

PREDOMINANT

45K —— 100C, 45Y, 30K

45K —— 100C, 45Y, 30K

60

PREDOMINANT

PREDOMINANT

35K —— 60C, 65M, 100Y

35K —— 60C, 65M, 100Y

60

PREDOMINANT

PREDOMINANT

5C, 45K —— 60C, 65M, 100Y

5C, 45K —— 60C, 65M, 100Y

60

PREDOMINANT

PREDOMINANT

5C, 35K —— 60C, 65M, 100Y

5C, 35K —— 60C, 65M, 100Y

60

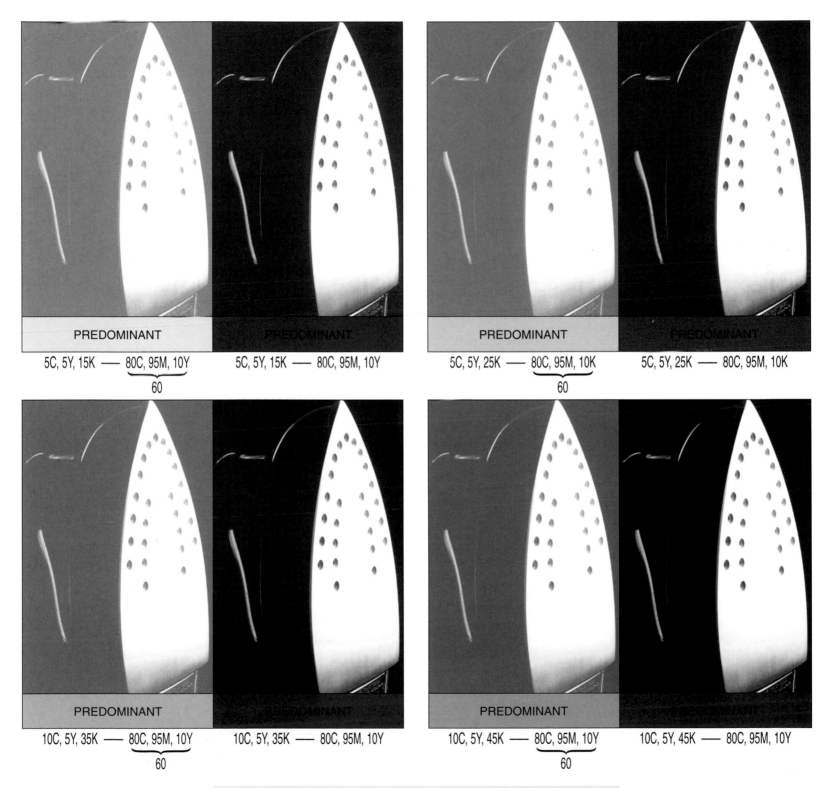

PREDOMINANT

5C, 5Y, 15K —— 80C, 95M, 10Y
60

PREDOMINANT

5C, 5Y, 15K —— 80C, 95M, 10Y

PREDOMINANT

5C, 5Y, 25K —— 80C, 95M, 10K
60

PREDOMINANT

5C, 5Y, 25K —— 80C, 95M, 10K

PREDOMINANT

10C, 5Y, 35K —— 80C, 95M, 10Y
60

PREDOMINANT

10C, 5Y, 35K —— 80C, 95M, 10Y

PREDOMINANT

10C, 5Y, 45K —— 80C, 95M, 10Y
60

PREDOMINANT

10C, 5Y, 45K —— 80C, 95M, 10Y

CREATIVE DUOTONE EFFECTS

A Visual Guide to Choosing Successful
Color Combinations

SELECTOR

Two-Color Ghosting

This section deals with the creation of ghosted images for use as background elements or for muted reproduction that serves whatever graphic purpose the designer has in mind. Ghosting requires that both colors, whether black-plus-second-color or two non-black colors, be significantly screened back.Therefore, you will notice that under each color, both left and right, there is a number indicating the level that the color is to be screened at. The color in the box below the photo represents the color at its full strength, and the bracketed number below it represents the percentage the color is screened to achieve the results shown in the photo. Because the effect of ghosting is subtle and the variations less obvious, each color combination is given four variations: two at the 50/30 percent ratio and two at 30/15 percent. As you can see, this section is divided into two halves: one with combinations of black-plus-second-color, the other with two non-black colors.

Again, remember, when designing in two colors match the color swatch shown below each combination to the color matching system you use. This will provide results that closely mimic the picture shown. If you are printing in four process colors and/or using the CMYK desktop system, use the percentages displayed below each picture to achieve the same results.

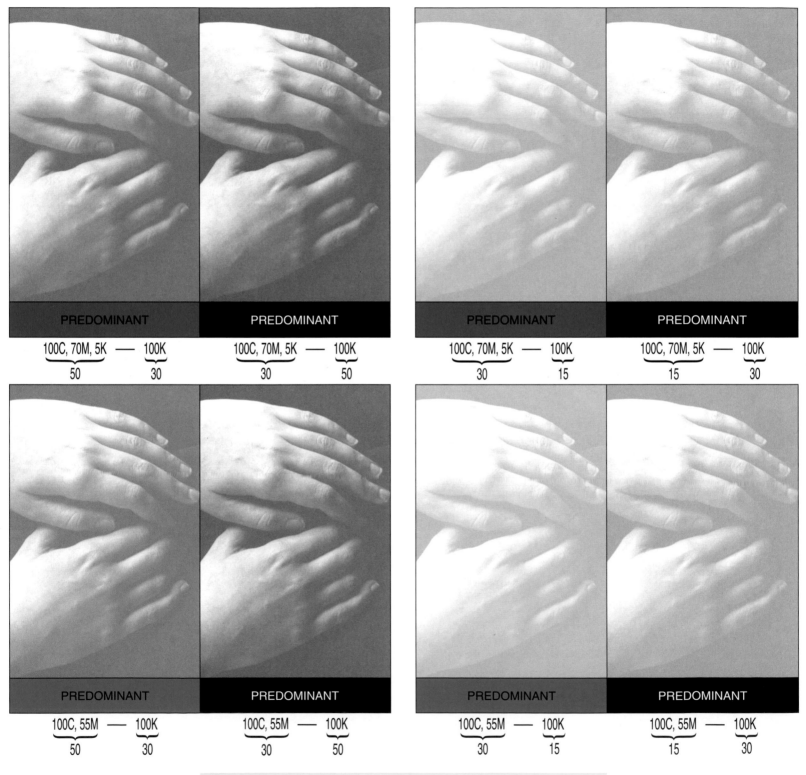

PREDOMINANT

100C, 70M, 5K — 100K
50 ___ 30

PREDOMINANT

100C, 70M, 5K — 100K
30 ___ 50

PREDOMINANT

100C, 70M, 5K — 100K
30 ___ 15

PREDOMINANT

100C, 70M, 5K — 100K
15 ___ 30

PREDOMINANT

100C, 55M — 100K
50 ___ 30

PREDOMINANT

100C, 55M — 100K
30 ___ 50

PREDOMINANT

100C, 55M — 100K
30 ___ 15

PREDOMINANT

100C, 55M — 100K
15 ___ 30

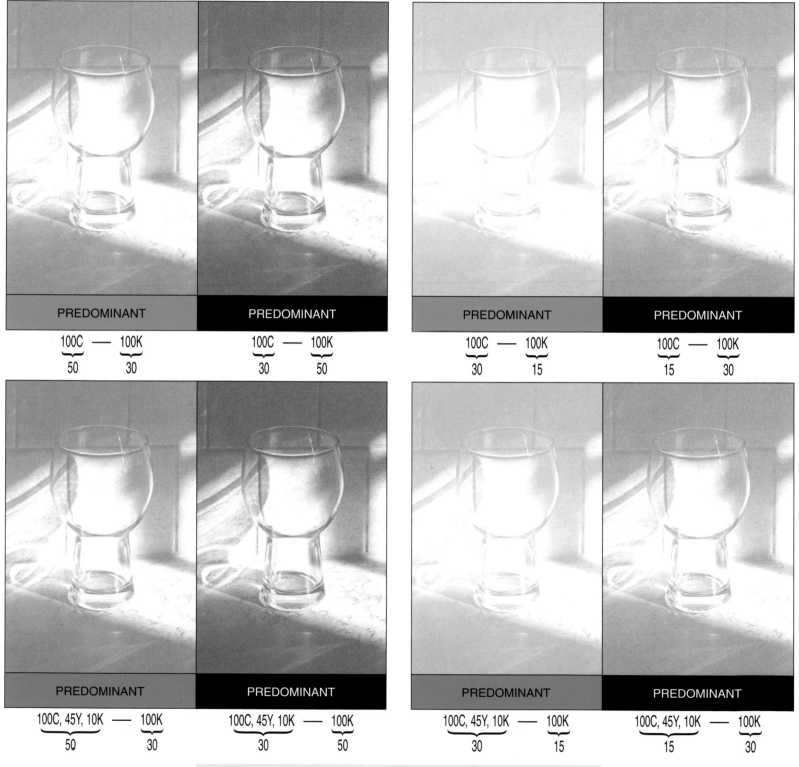

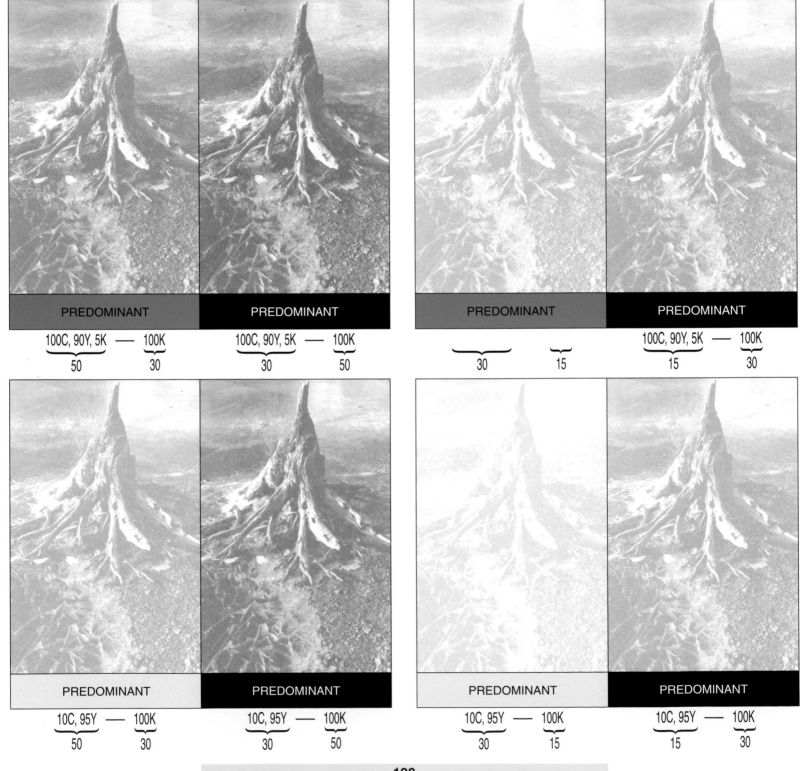

PREDOMINANT

100C, 90Y, 5K — 100K
50 — 30

PREDOMINANT

100C, 90Y, 5K — 100K
30 — 50

PREDOMINANT

30 — 15

PREDOMINANT

100C, 90Y, 5K — 100K
15 — 30

PREDOMINANT

10C, 95Y — 100K
50 — 30

PREDOMINANT

10C, 95Y — 100K
30 — 50

PREDOMINANT

10C, 95Y — 100K
30 — 15

PREDOMINANT

10C, 95Y — 100K
15 — 30

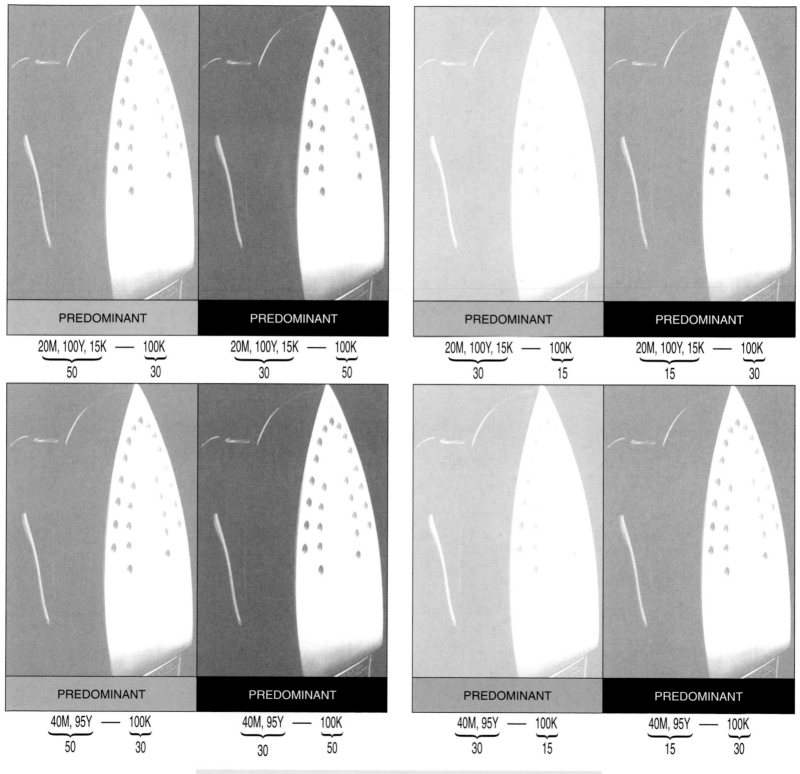

PREDOMINANT
20M, 100Y, 15K — 100K
50 30

PREDOMINANT
20M, 100Y, 15K — 100K
30 50

PREDOMINANT
20M, 100Y, 15K — 100K
30 15

PREDOMINANT
20M, 100Y, 15K — 100K
15 30

PREDOMINANT
40M, 95Y — 100K
50 30

PREDOMINANT
40M, 95Y — 100K
30 50

PREDOMINANT
40M, 95Y — 100K
30 15

PREDOMINANT
40M, 95Y — 100K
15 30

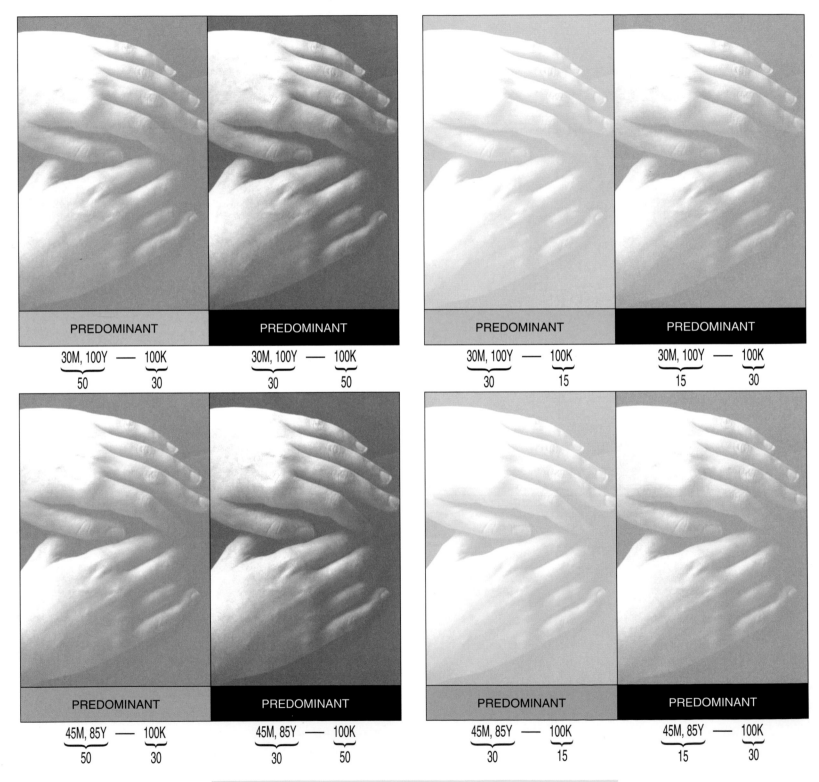

PREDOMINANT

$$\underbrace{30M, 100Y}_{50} \mathbf{---} \underbrace{100K}_{30}$$

PREDOMINANT

$$\underbrace{30M, 100Y}_{30} \mathbf{---} \underbrace{100K}_{50}$$

PREDOMINANT

$$\underbrace{30M, 100Y}_{30} \mathbf{---} \underbrace{100K}_{15}$$

PREDOMINANT

$$\underbrace{30M, 100Y}_{15} \mathbf{---} \underbrace{100K}_{30}$$

PREDOMINANT

$$\underbrace{45M, 85Y}_{50} \mathbf{---} \underbrace{100K}_{30}$$

PREDOMINANT

$$\underbrace{45M, 85Y}_{30} \mathbf{---} \underbrace{100K}_{50}$$

PREDOMINANT

$$\underbrace{45M, 85Y}_{30} \mathbf{---} \underbrace{100K}_{15}$$

PREDOMINANT

$$\underbrace{45M, 85Y}_{15} \mathbf{---} \underbrace{100K}_{30}$$

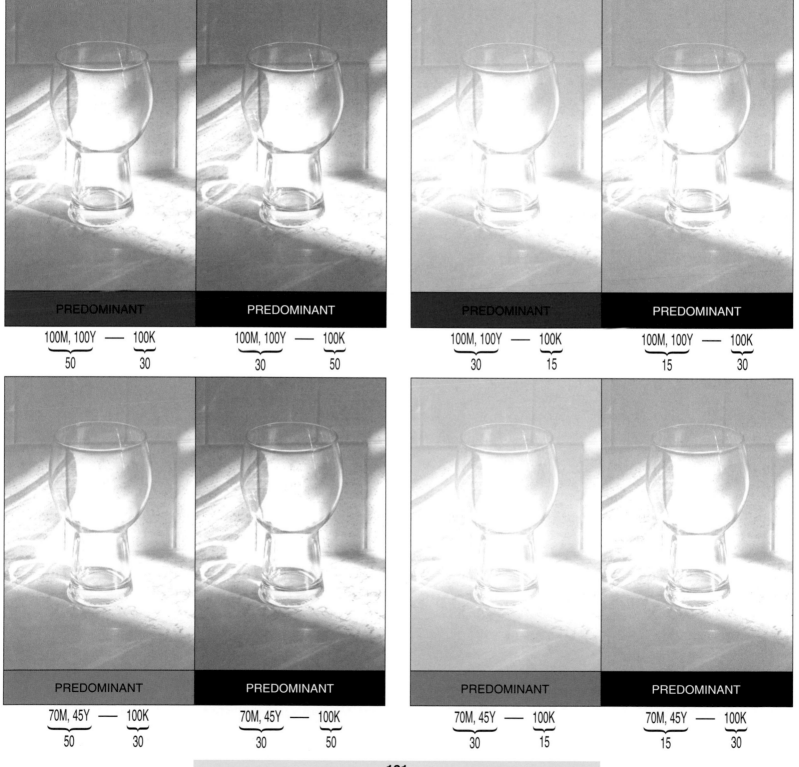

PREDOMINANT

100M, 100Y — 100K
50 30

PREDOMINANT

100M, 100Y — 100K
30 50

PREDOMINANT

100M, 100Y — 100K
30 15

PREDOMINANT

100M, 100Y — 100K
15 30

PREDOMINANT

70M, 45Y — 100K
50 30

PREDOMINANT

70M, 45Y — 100K
30 50

PREDOMINANT

70M, 45Y — 100K
30 15

PREDOMINANT

70M, 45Y — 100K
15 30

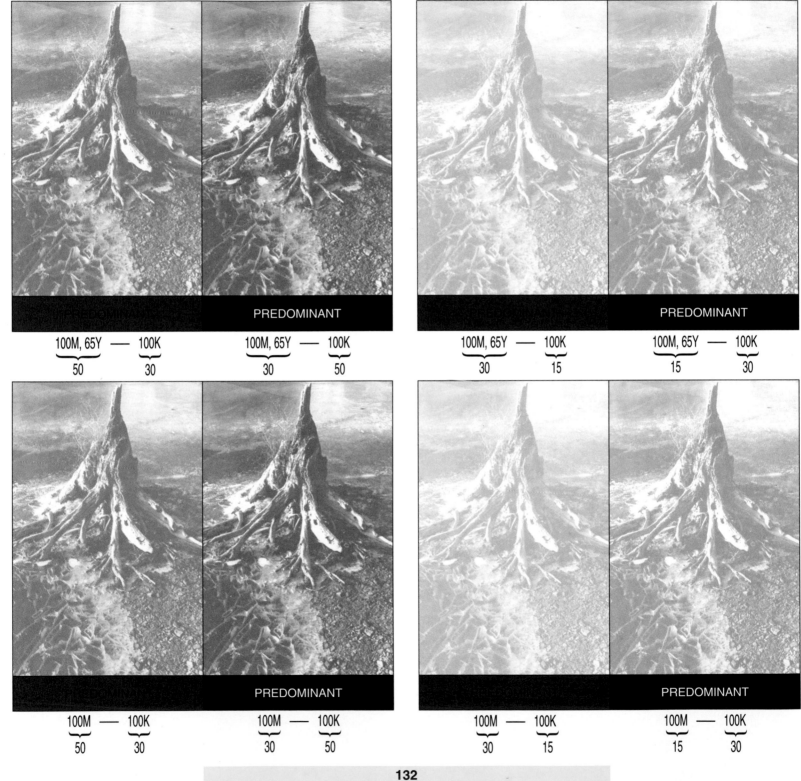

PREDOMINANT

100M, 65Y —— 100K

50　　　30

PREDOMINANT

100M, 65Y —— 100K

30　　　50

PREDOMINANT

100M, 65Y —— 100K

30　　　15

PREDOMINANT

100M, 65Y —— 100K

15　　　30

PREDOMINANT

100M —— 100K

50　　　30

PREDOMINANT

100M —— 100K

30　　　50

PREDOMINANT

100M —— 100K

30　　　15

PREDOMINANT

100M —— 100K

15　　　30

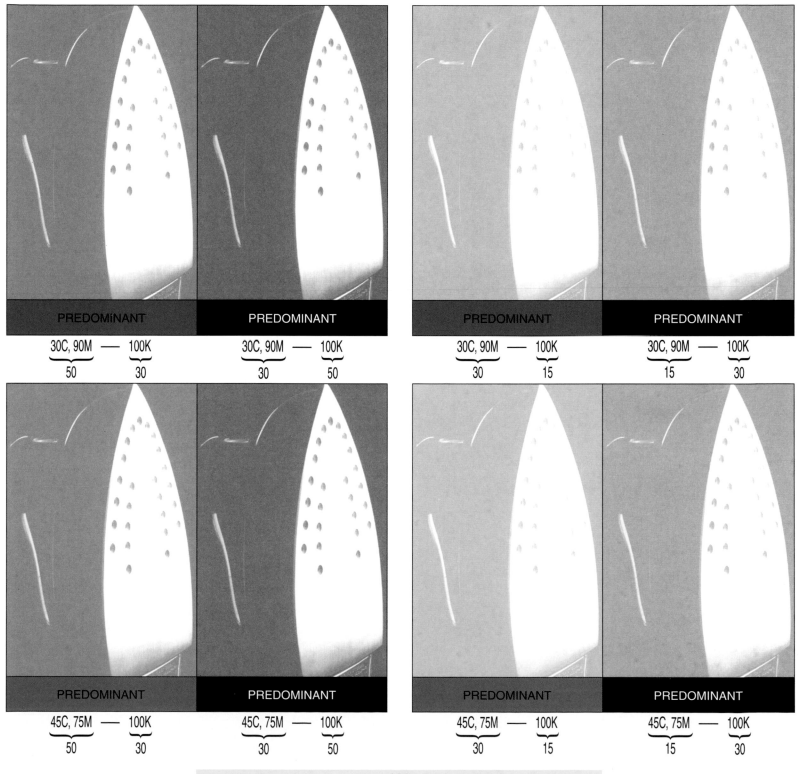

PREDOMINANT

30C, 90M — 100K
50 — 30

PREDOMINANT

30C, 90M — 100K
30 — 50

PREDOMINANT

30C, 90M — 100K
30 — 15

PREDOMINANT

30C, 90M — 100K
15 — 30

PREDOMINANT

45C, 75M — 100K
50 — 30

PREDOMINANT

45C, 75M — 100K
30 — 50

PREDOMINANT

45C, 75M — 100K
30 — 15

PREDOMINANT

45C, 75M — 100K
15 — 30

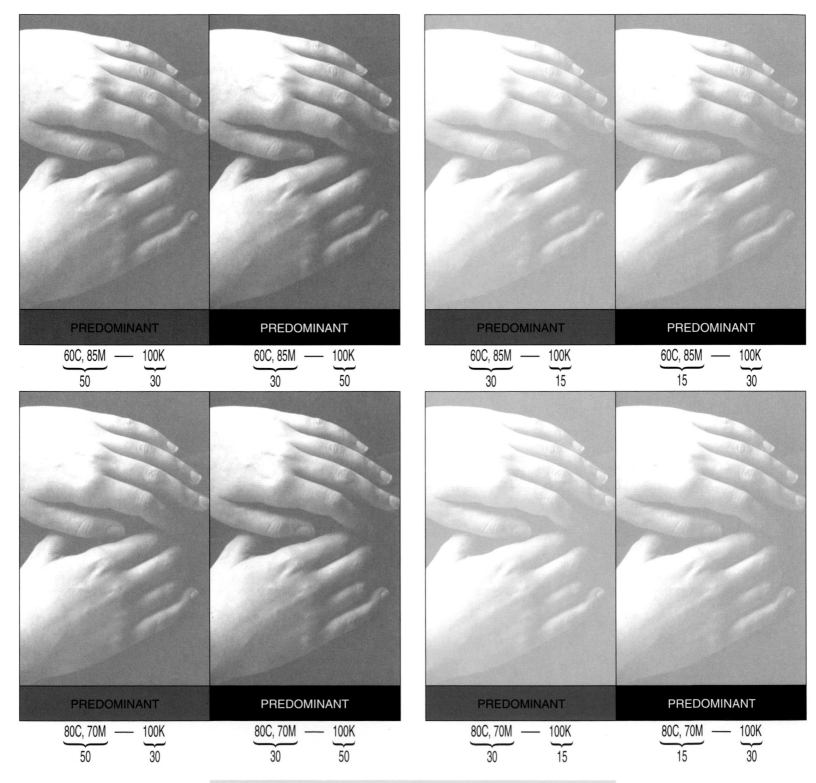

PREDOMINANT

60C, 85M — 100K
50 30

PREDOMINANT

60C, 85M — 100K
30 50

PREDOMINANT

60C, 85M — 100K
30 15

PREDOMINANT

60C, 85M — 100K
15 30

PREDOMINANT

80C, 70M — 100K
50 30

PREDOMINANT

80C, 70M — 100K
30 50

PREDOMINANT

80C, 70M — 100K
30 15

PREDOMINANT

80C, 70M — 100K
15 30

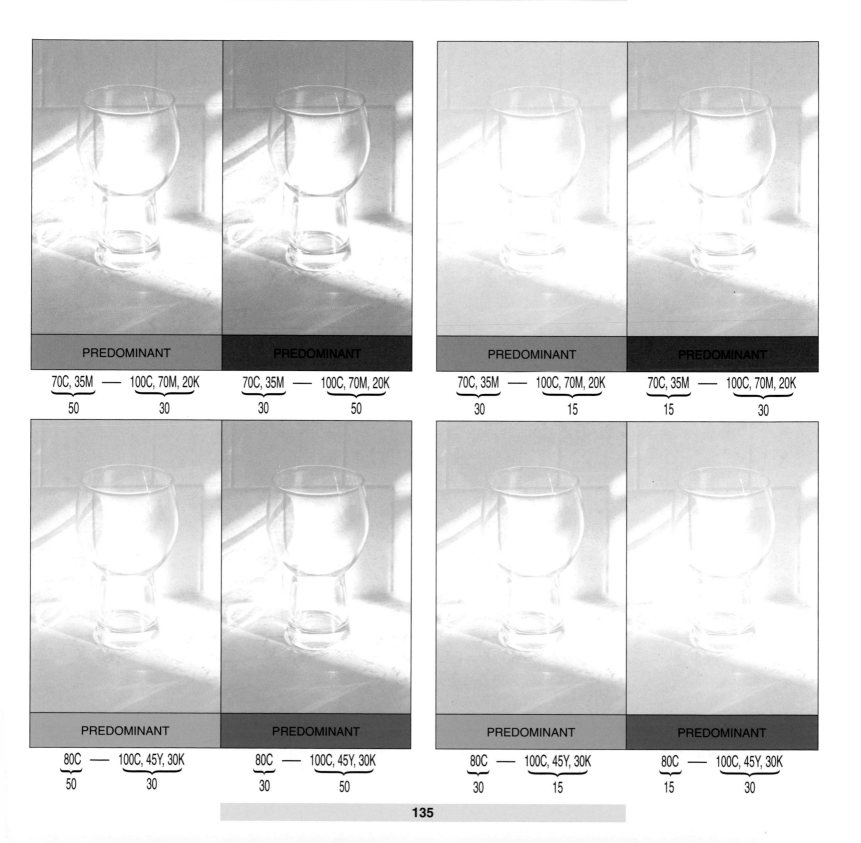

PREDOMINANT

70C, 35M —— 100C, 70M, 20K

50 30

PREDOMINANT

70C, 35M —— 100C, 70M, 20K

30 50

PREDOMINANT

70C, 35M —— 100C, 70M, 20K

30 15

PREDOMINANT

70C, 35M —— 100C, 70M, 20K

15 30

PREDOMINANT

80C —— 100C, 45Y, 30K

50 30

PREDOMINANT

80C —— 100C, 45Y, 30K

30 50

PREDOMINANT

80C —— 100C, 45Y, 30K

30 15

PREDOMINANT

80C —— 100C, 45Y, 30K

15 30

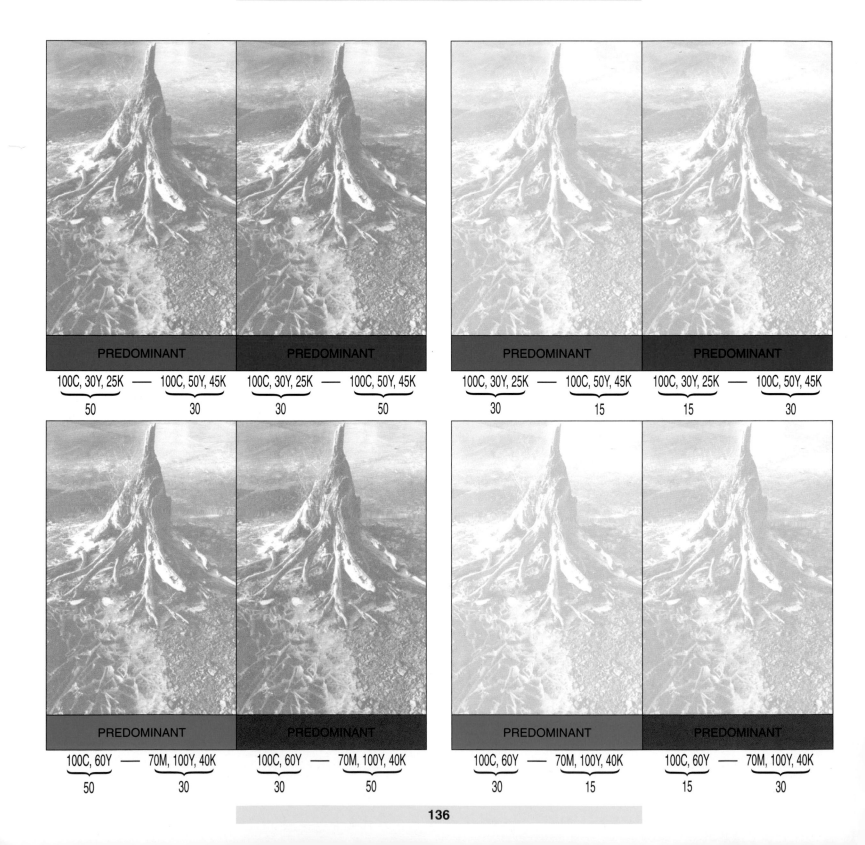

PREDOMINANT

100C, 30Y, 25K —— 100C, 50Y, 45K
50 — 30

PREDOMINANT

100C, 30Y, 25K —— 100C, 50Y, 45K
30 — 50

PREDOMINANT

100C, 30Y, 25K —— 100C, 50Y, 45K
30 — 15

PREDOMINANT

100C, 30Y, 25K —— 100C, 50Y, 45K
15 — 30

PREDOMINANT

100C, 60Y —— 70M, 100Y, 40K
50 — 30

PREDOMINANT

100C, 60Y —— 70M, 100Y, 40K
30 — 50

PREDOMINANT

100C, 60Y —— 70M, 100Y, 40K
30 — 15

PREDOMINANT

100C, 60Y —— 70M, 100Y, 40K
15 — 30

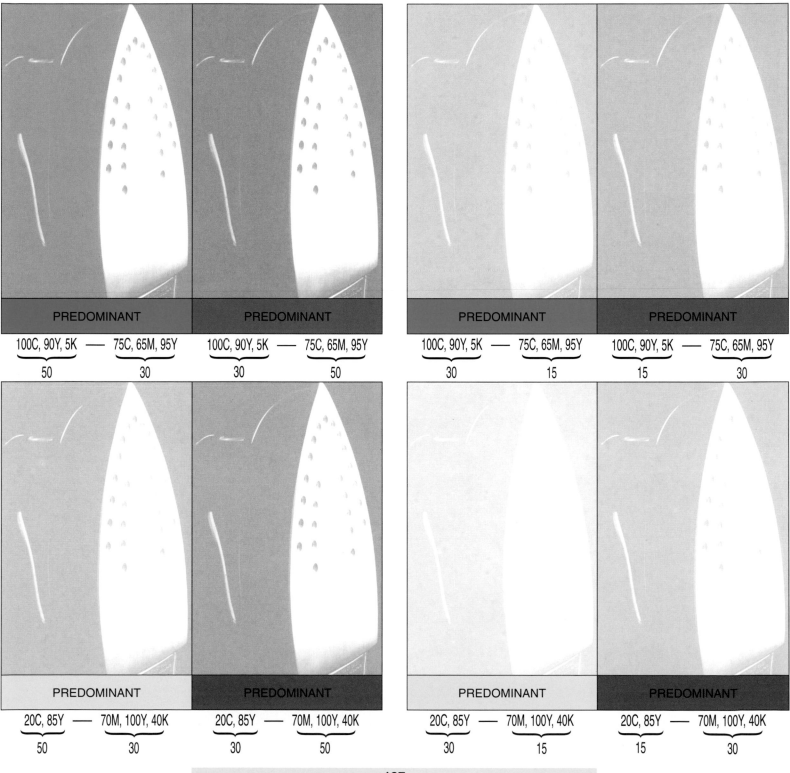

PREDOMINANT

100C, 90Y, 5K —— 75C, 65M, 95Y
50 — 30

PREDOMINANT

100C, 90Y, 5K —— 75C, 65M, 95Y
30 — 50

PREDOMINANT

100C, 90Y, 5K —— 75C, 65M, 95Y
30 — 15

PREDOMINANT

100C, 90Y, 5K —— 75C, 65M, 95Y
15 — 30

PREDOMINANT

20C, 85Y —— 70M, 100Y, 40K
50 — 30

PREDOMINANT

20C, 85Y —— 70M, 100Y, 40K
30 — 50

PREDOMINANT

20C, 85Y —— 70M, 100Y, 40K
30 — 15

PREDOMINANT

20C, 85Y —— 70M, 100Y, 40K
15 — 30

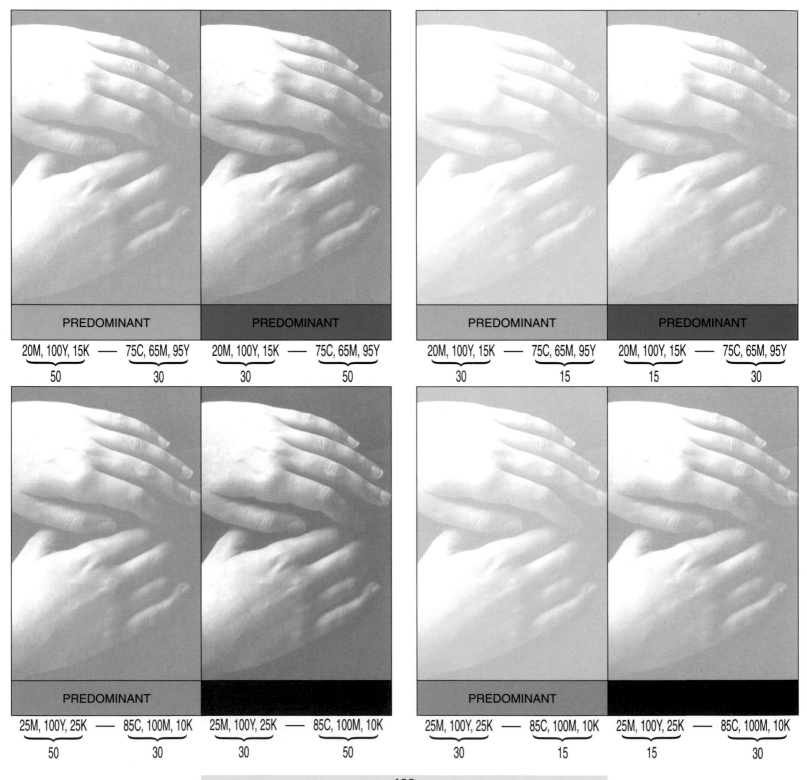

PREDOMINANT — PREDOMINANT

20M, 100Y, 15K — 75C, 65M, 95Y 20M, 100Y, 15K — 75C, 65M, 95Y
 50 30 30 50

20M, 100Y, 15K — 75C, 65M, 95Y 20M, 100Y, 15K — 75C, 65M, 95Y
 30 15 15 30

PREDOMINANT — PREDOMINANT

25M, 100Y, 25K — 85C, 100M, 10K 25M, 100Y, 25K — 85C, 100M, 10K
 50 30 30 50

25M, 100Y, 25K — 85C, 100M, 10K 25M, 100Y, 25K — 85C, 100M, 10K
 30 15 15 30

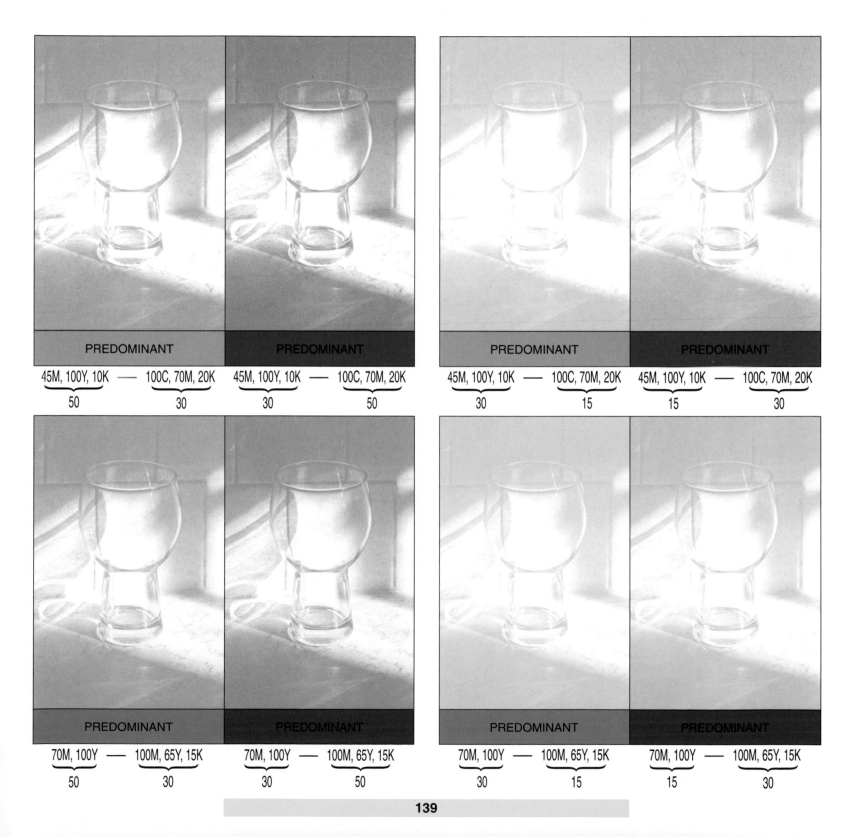

PREDOMINANT

45M, 100Y, 10K — 100C, 70M, 20K
50 30

PREDOMINANT

45M, 100Y, 10K — 100C, 70M, 20K
30 50

PREDOMINANT

45M, 100Y, 10K — 100C, 70M, 20K
30 15

PREDOMINANT

45M, 100Y, 10K — 100C, 70M, 20K
15 30

PREDOMINANT

70M, 100Y — 100M, 65Y, 15K
50 30

PREDOMINANT

70M, 100Y — 100M, 65Y, 15K
30 50

PREDOMINANT

70M, 100Y — 100M, 65Y, 15K
30 15

PREDOMINANT

70M, 100Y — 100M, 65Y, 15K
15 30

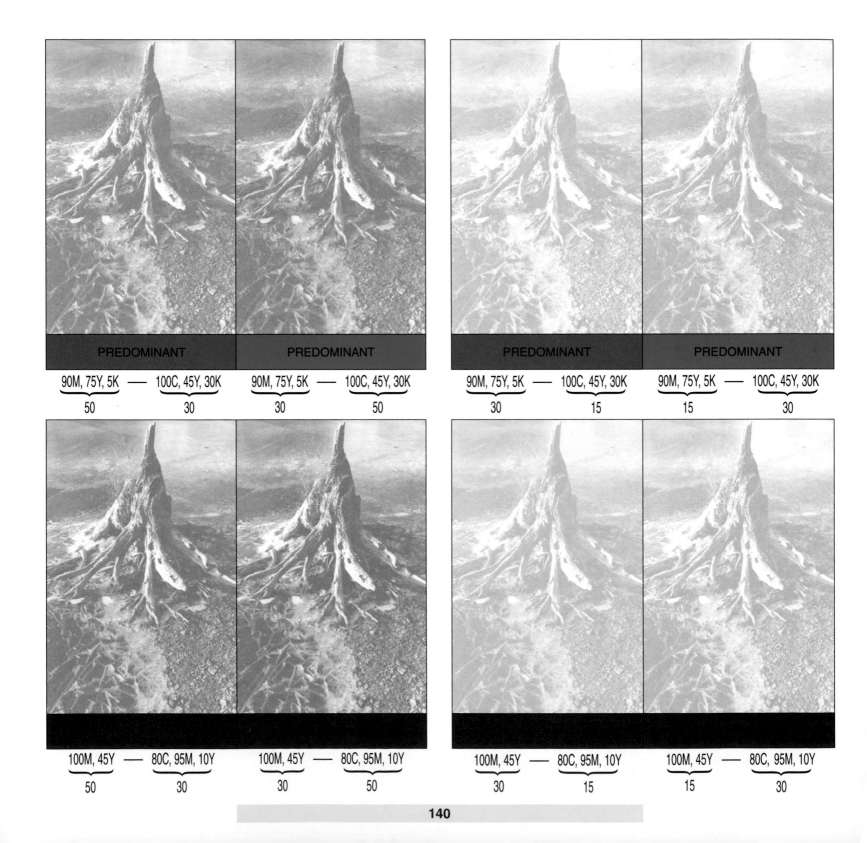

PREDOMINANT

90M, 75Y, 5K —— 100C, 45Y, 30K

50 —— 30

PREDOMINANT

90M, 75Y, 5K —— 100C, 45Y, 30K

30 —— 50

PREDOMINANT

90M, 75Y, 5K —— 100C, 45Y, 30K

30 —— 15

PREDOMINANT

90M, 75Y, 5K —— 100C, 45Y, 30K

15 —— 30

100M, 45Y —— 80C, 95M, 10Y

50 —— 30

100M, 45Y —— 80C, 95M, 10Y

30 —— 50

100M, 45Y —— 80C, 95M, 10Y

30 —— 15

100M, 45Y —— 80C, 95M, 10Y

15 —— 30

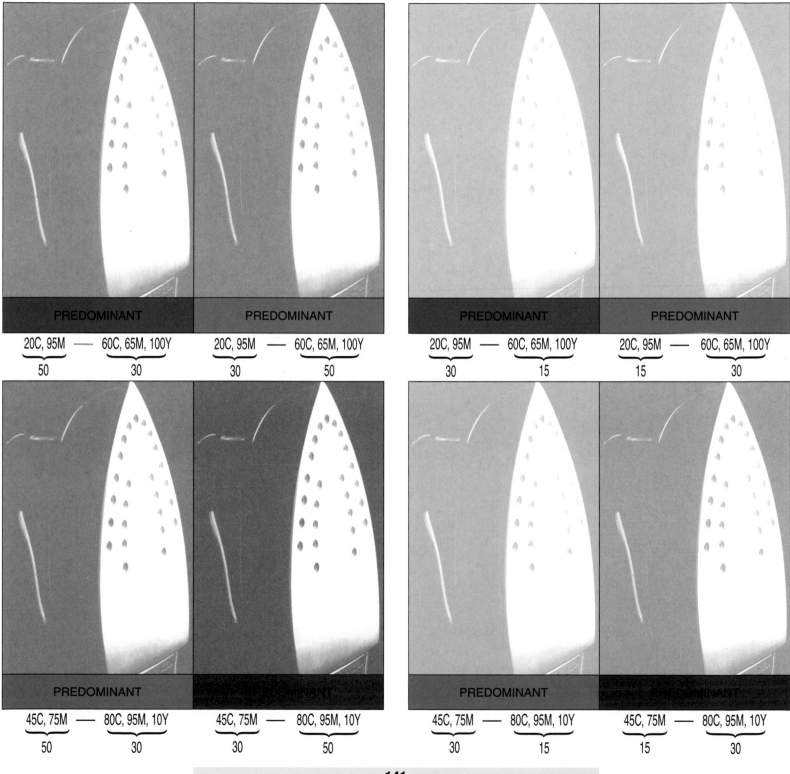

PREDOMINANT

$\underbrace{\text{20C, 95M}}_{50}$ — $\underbrace{\text{60C, 65M, 100Y}}_{30}$

PREDOMINANT

$\underbrace{\text{20C, 95M}}_{30}$ — $\underbrace{\text{60C, 65M, 100Y}}_{50}$

PREDOMINANT

$\underbrace{\text{20C, 95M}}_{30}$ — $\underbrace{\text{60C, 65M, 100Y}}_{15}$

PREDOMINANT

$\underbrace{\text{20C, 95M}}_{15}$ — $\underbrace{\text{60C, 65M, 100Y}}_{30}$

PREDOMINANT

$\underbrace{\text{45C, 75M}}_{50}$ — $\underbrace{\text{80C, 95M, 10Y}}_{30}$

PREDOMINANT

$\underbrace{\text{45C, 75M}}_{30}$ — $\underbrace{\text{80C, 95M, 10Y}}_{50}$

PREDOMINANT

$\underbrace{\text{45C, 75M}}_{30}$ — $\underbrace{\text{80C, 95M, 10Y}}_{15}$

PREDOMINANT

$\underbrace{\text{45C, 75M}}_{15}$ — $\underbrace{\text{80C, 95M, 10Y}}_{30}$

ALSO AVAILABLE FROM ROCKPORT PUBLISHERS

Rockport Publishers, Inc., 146 Granite Street, Rockport, Massachusetts 01966-1299
(508)546-9590 FAX (508)546-7141
Call or write for our free catalog.

AIRBRUSH ACTION 4

The Best New Airbrush Illustration
Compiled in association with Airbrush Action *magazine*

The fourth edition of the best-selling *Airbrush Action* series, this volume presents the best new work being done by both noted and up-and-coming airbrush artists. Each of the 400 images in this volume was selected from among thousands of entries, and chosen as the most innovative and creative airbrush design in a wide range of categories. A visual compilation that includes fine art, T-shirt illustration, self-promotion projects, book jackets, packaging, and magazine advertisements, the work featured in these pages helped elevate the airbrush to the well-respected and commercially viable art form it is today.
192 pages Paper-laminated cover
1-56496-208-3

3-DIMENSIONAL ILLUSTRATION AWARDS ANNUAL 5

The Best in 3-D Advertising and Publishing Worldwide
Compiled by Dimensional Illustrators, Inc.
This title presents the winners of the fifth annual Dimensional Illustrators Awards Show. Containing more than 600 full-color images, this inspiring collection presents the talents of creative directors, model-makers, animators, photographers, and students producing visuals in the form of advertisements, brochures, posters, magazine covers, annual reports, calendars, book covers, newspapers, greeting cards, and television animation.
192 pages Hardcover w/dustjacket
1-56496-132-x

THE BEST OF BROCHURE DESIGN II

Compiled by the editors at Rockport Publishers
A unique, practical collection of hundreds of ideas, *The Best of Brochure Design II* will help designers create compelling and effective corporate tools for their clients, as well as inspire successful self-promotional projects. An essential guide to the dynamics of brochure cover design and ways to grab a reader's attention with eye-catching inner pages, this is the essential reference for designers, corporate executives, and small businesses looking for new ways to promote companies, products, and services.
192 pages Hardcover w/dustjacket
1-56496-092-7

LETTERHEAD & LOGO DESIGN 3

Creating the Corporate Image
Compiled by the editors at Rockport Publishers
The third volume in the best-selling series on letterhead and logo design, this book features more of the newest and best in graphic design for the corporate image. Letterhead and logo design is one of the most popular areas of graphic design, and this book presents a wealth of ideas for designers and their clients. Including ideas for letterheads, business cards, envelopes, logos, and stationery supplies, this is a valuable resource for small and large businesses.
192 pages Hardcover w/dustjacket
1-56496-111-7

BREAKING THE RULES IN GRAPHIC DESIGN

Supon Design Group
The unexpected deserves a closer look. Its creators take risks, challenge the norm, and pave the way for new ideas. This book presents design that is truly innovative—in hopes of encouraging all designers to "break the rules." Sections based on project type include everything from brochure design to magazine layout, posters, books, and more. Each project is discussed in depth, with its design elements arranged as a visual reference, providing an exciting, in-depth study of the most creative and inspiring designs being produced today.
192 pages Hardcover w/dustjacket
1-56496-167-2

THE BEST OF NEWSPAPER DESIGN SIXTEENTH EDITION

Produced in collaboration with the Society of Newspaper Design, this 16th volume continues to document the world's best newspaper designs, as selected by the Society. Over 1,000 entries, judged in the categories of overall design, page design, portfolio, magazine cover design, art and illustration, photo-journalism, informational graphics, and much more, make this collection unequaled as a reference and an essential for anyone involved in print media, graphics, photography, design, journalism, or communications.
256 pages Hardcover w/dustjacket
1-56496-202-4

ECO DESIGN

Environmentally Sound Packaging and Graphic Design
Compiled by Richard Roat
Package design in the twenty-first century has adopted a new approach—environmental sensitivity and safety. This volume celebrates designers whose creations meet the challenges of the environmental movement in innovative and dynamic ways. Talented designers from around the world reveal the techniques and inspirations of design strategies that appeal to an environmentally sensitive consumer through elements such as recyclable paper and material, and environmentally safe inks. A current directory of environmentally friendly materials, resources, and manufacturers makes this volume an essential tool for all designers, art directors, corporate executives, and green organizations.
160 pages Paper-laminated cover
1-56496-083-8

LABEL DESIGN 4

The Best U.S. & International Design
Compiled by the editors at
Rockport Publishers
This book presents a comprehensive and inspirational collection of the best label designs on the market today. With over 400 full-color images in a wide variety of product categories, this is an essential resource for all package designers and manufacturers.
240 pages Hardcover w/dustjacket
1-56496-069-2

SIGN DESIGN GALLERY 2

Compiled by the editors at
Signs of The Times *magazine*
This volume presents the best of sign design from around the world as judged by *Signs of the Times* magazine's annual Best Sign Design contest. Each featured sign was selected as the best, most creative, or most effective in categories including ground signs, projecting or hanging signs, post- or pole-mounted signs, entry monuments, sign systems, wall mounted or facia signs, electric, illuminated, glass, carved, and specialty signs. As well as providing information on fabrication, design, and materials, these images present a variety of styles—everything from art deco to art nouveau, and from Victorian to modern—making this a valuable reference for all designers, marketers, and business owners.
160 pages Hardcover w/jacket
1-56496-196-6

COLOR HARMONY 2

A Guide to Creative Color Combinations
Bride M. Whelan
Already selling over 70,000 copies around the world, Color Harmony 2 has become a worthy companion to the best selling Color Harmony. Providing over 1400 new color combinations, this little book is packed with colors and color schemes matched to specific color theories and moods. This volume is the definitive visual guide to selecting the perfect colors any project, from graphic design to interiors and from product design to gardening.
160 pages Paperback
1-56496-066-8

CYBERDESIGN: PHOTOGRAPHY

Compiled by the editors at
Rockport Publishers
This volume from the editorial and design team at Rockport Publishers presents new, creative work in the field of computer manipulated photography. The advanced technologies of the computer are making it possible for designers to alter photographs in just about any way they wish. Here, more than 150 noted designers and photographers from around the world display finished designs created on a variety of software systems—including Adobe Photoshop, Fractal Design Painter, and many others. Captions specify designer, hardware, software, special techniques, and design inspiration.
144 pages Hardcover w/dustjacket
1-56496-218-0

THE BEST CALENDAR DESIGN & GRAPHICS

Compiled by the editors at Rockport Publishers
Produced in association with the Calendar Marketing Associations's world and national calendar awards, this volume features over 350 of the best and most creative calendars from all over the world. The categories range from commercial to photographic calendars, and from fine art to corporate identification and promotional calendars. Functional as well as fun, these images offer creative inspiration for designers, marketers, and hobbyists alike.
160 pages Paper-laminated cover
1-56496-164-8